Revolt of the White Athlete

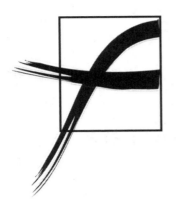

Intersections in Communications and Culture

Global Approaches and Transdisciplinary Perspectives

Cameron McCarthy and Angharad N. Valdivia
General Editors

Vol. 14

PETER LANG
New York • Washington, D.C./Baltimore • Bern
Frankfurt am Main • Berlin • Brussels • Vienna • Oxford

Kyle Kusz

Revolt of the White Athlete

Race, Media and the Emergence
of Extreme Athletes in America

PETER LANG
New York • Washington, D.C./Baltimore • Bern
Frankfurt am Main • Berlin • Brussels • Vienna • Oxford

Library of Congress Cataloging-in-Publication Data

Kusz, Kyle.
Revolt of the white athlete: race, media and the emergence
of extreme athletes in America / Kyle Kusz.
p. cm. — (Intersections in communications and culture; v. 14)
Includes bibliographical references and index.
1. Masculinity in sports—United States. 2. Whites—Race identity—United States.
3. Mass media and sports—United States. I. Title. II. Series.
GV706.5.K87 796'.081—dc22 2004011675
ISBN 978-0-8204-7251-5
ISSN 1528-610X

Bibliographic information published by **Die Deutsche Bibliothek**.
Die Deutsche Bibliothek lists this publication in the "Deutsche
Nationalbibliografie"; detailed bibliographic data is available
on the Internet at http://dnb.ddb.de/.

Cover art by Jeffery W. Kusz

The paper in this book meets the guidelines for permanence and durability
of the Committee on Production Guidelines for Book Longevity
of the Council of Library Resources.

© 2007 Peter Lang Publishing, Inc., New York
29 Broadway, 18th floor, New York, NY 10006
www.peterlang.com

"Play your own game"
(The best piece of advice I've ever received.)

╫ TABLE OF CONTENTS

╬ PREFACE

This book offers readers critical analyses of the meanings and politics of a number of youthful white masculinities which were made to matter in American sport and popular culture throughout the 1990s to the present. I take these sporting representations and embodiments of white masculinity seriously as often overlooked, yet incredibly important, politicized contested terrains through which contemporary battles over how race, gender, social class, and nation have been constructed and imagined within our culture over the last decade and a half. In particular, this book examines media representations of popular sport celebrities like Andre Agassi and Lance Armstrong, sports media texts like *Sports Illustrated*'s 1997 cover story, 'Whatever Happened to the White Athlete?' and the skateboarding documentary on *Dogtown and Z Boys*, and the emergent sports formation of extreme sports. In general, I argue that each of these cultural sites is shaped by, and generative of, a conjuncturally specific reactionary cultural politics which seeks to disavow and deny the existence of the racial and gender privileges of white men, just as it attempts to re-secure a central, normative, and privileged position for white men and their perspectives, experiences, and interests in American culture.

Why did I write this book? The short and more convenient answer: Cameron McCarthy provided me with an opportunity to turn my doctoral dissertation into a book. The longer, more interesting and relevant answer (the one which often gets glossed over, hidden, and carefully concealed by the choices of some academics and the conventions of the profession) is that I wrote this book, following the lead of C. Wright Mills (1959) to better understand the relation between my inner life—my motivations, my virtues, my faults, my desire to be different, my anxieties, my coming of age in the 1990s, my place in the world, my need to ask 'why?' and 'why not?', my significant relationships, my reason for wanting to teach, my need to play soccer, my responsibilities to myself, my family, my community—and the social formation in which I live.

Critics of whiteness studies might read this confessional as proof of their claim that the narcissism of some white people is the root of the field of whiteness studies (or at least my contribution here to the field). Perhaps they might be

partially right. I still wrestle daily with that aspect of my work. Still, I find solace in knowing in my heart how this 'narcissistic' journey has altered the path of my life in what I consider to be good ways. This 'altered' and unchartered path which I travel is now guided by the maxim: 'with privileges come responsibilities.' After hearing this phrase for perhaps the millionth time, its implications for the critical study of racial and gender privilege became clear to me. If responsibilities can be bound to the granting of privileges (as teachers and parents often assert they can) in a general sense, then why shouldn't this rule hold true when discussing a particular: white male privilege. So then, I hope this book inspires others who may or may not identify as white and/or male not only to recognize the many daily benefits which they receive, and do not earn from being 'white' and male, but to recognize their responsibility to always choose to work at building communities through embracing both our differences and our common bonds as humans and to always work to eliminate social inequalities and asymmetries of power to produce a level playing field for all.

How might this book be used? I hope this book will appeal to all those interested in taking a critical look at white masculinity, specifically how white privilege and the normativity of whiteness is reproduced in society through the various stories we tell in American culture at particular times in history. I also hope that this book will further allow readers to recognize the instrumental and increasingly political roles which sports, and media stories about sports (celebrity-athletes, films, reality TV shows, video games, etc.) regularly play in promoting, popularizing, and garnering consent for ideologies and discourses which may at first glance seem benign and innocent enough, yet which ultimately serve the interests of dominant social groups. Optimistically, I wish this book will facilitate readers' own 'narcissistic' journeys of self/social-discovery and personal transformation, so they too will recognize and take up their social responsibilities.

╫ ACKNOWLEDGMENTS

This book is the product of the support and help of many people, and I would be remiss if I did not single them out by name: Steve Mosher, Ellen Staurowsky, Synthia Sydnor, Cameron McCarthy, Norman Denzin, CL Cole, Nancy Spencer, Robert Rinehart, Toni Bruce, Becky Beal, Maureen Smith, Dave Andrews, Steve Jackson, Jennifer Metz, Belinda Wheaton, Karen Hand, Jan Rintala, Judy Bischoff, Moira Stuart, Bryan and Anne Blissmer, Deb Riebe, Stephanie Champlin, Jane Schmitz, Susan Greendorfer, Heidi-Mai Talbot, Kristin Kane, Donna Kane, Ollie Gilmore and family, Ken Michael, Bill McDonald and family, Dick Beal, Tom Cosenza, Kristin Kaupang, Matt Picardo, Brian and Jackie Nail, Matt and Christine Downs, Gabe Logan, C. Richard King, and David Leonard. Each of the people above either nourished me with knowledge that enabled the writing of this book or nurtured me over the past years through a variety of other ways. Some did both. I thank the latter especially.

I must also give special thanks to my parents, Susan and Jeffery, and sister, Vikki, for all of their guidance and support over the years. In each of their own unique ways, their significance in my life can be traced throughout this book.

I thank Cameron McCarthy for his encouragement, scholarly example, and the opportunity to convert my dissertation into this book.

Finally, I have to thank Damon Zucca and Sophie Appel for their incredible patience, support, and help with completing this project.

Grateful acknowledgment is hereby made to copyright holders for permission to use, or to adapt significant parts of, the following copyrighted material:

Kusz, K. (2001). Andre Agassi and Generation X: Reading white masculinity in 1990s America. In D. Andrews & S. Jackson (Eds.) *Sport Stars: The Politics of Sport Celebrity*. New York: Routledge.

Kusz, K. (2001). 'I want to be the minority': The cultural politics of young white males in sport and popular culture. *Journal of Sport and Social Issues*, *25(4)*: 390–416.

Kusz, K. (2004). Extreme America: The cultural politics of extreme sports in 1990s America. In B. Wheaton (Ed.) *Understanding lifestyle sports: Consumption, identity, and difference.* London: Routledge.

Kusz, K. (2006). *Dogtown and Z-Boys:* White particularity and the new, *new* cultural racism. In C.R. King & D. Leonard's (Eds.) *Visual economies of/in Motion: Sport and film.* New York: Peter Lang.

╬ CHAPTER ONE

Introduction: The Revolt of the White (Male) Athlete Will Be Televised

> *"Sporting spectacles structure and are structured by an insidious, if largely invisible, white supremacy"*
>
> *(King & Springwood, 2001, p.9).*

The title of this introductory chapter is meant to be alarming and provocative. It is meant to suggest a thesis that may surprise many ardent sport fans. Since at least the 1990s, a largely silent revolt has been subtly taking place right before our eyes. On American television and movie screens, as well as its newspaper sports pages, stories about specific white male sport stars (like Andre Agassi and Lance Armstrong) and emergent sport formations dominated by white male participants (like extreme sports, NASCAR, and the Great Outdoor Games) became integral cultural sites involved in the generation, dissemination, and naturalization of various retrogressive racial and gender discourses that serve 'as basically an insidious effort to reestablish white hegemony' both within and beyond the world of sports during the 1990s (Kincheloe & Steinberg, 2000, p. 189).

Admittedly, the title might also seem a bit misleading. In the post-civil rights era of American history, the term 'revolt' often carries with it images and notions of social protests being held in the streets by the historically marginalized groups like African Americans, women, gays, and lesbians seeking redress of the histories of discrimination they had endured, better political representation, and fuller access to social and material resources.

Yet, the revolt I identify and critically examine in this book is more cultural than social. It has taken place subtly, in measured tones, veiled rhetoric, and carefully crafted imagery. Yet, as mentioned above, it has also taken place right before our eyes through the images and stories we see regularly in American sport media culture. Its goals and ends are conservative and reactionary, not progressive and liberatory.

The title of this chapter is also chosen purposefully to connect this book with Harry Edwards' (1970) well-known and important sport sociology text entitled, *The Revolt of the Black Athlete*. Edwards is perhaps best known as the one who, as a graduate student at the University of California at Berkeley, helped sow the seeds for the Olympic Project for Human Rights and the now infamous black power salute performed by Tommie Smith and John Carlos on the victory podium during the 1968 Summer Olympics in Mexico City (for an excellent analysis of the history and dynamic meanings and politics articulated with Smith and Carlos' salute from 1968 to the present, see Hartmann's (2004) book, *Race, Culture, and the Revolt of the Black Athlete: The 1968 Olympic Protests and Their Aftermath*). In *The Revolt of the Black Athlete*, Edwards offered his behind-the-scenes account of the history of the revolt of the black athlete in 1968, as well as (at the time) arguably the most thorough analysis of the systemic inequalities embedded in the structure of American sports for African Americans.

By invoking and tweaking the rhetoric of Edwards' title (particularly the notion of 'revolt'), I call attention to a shift that has taken place in the American racial politics from 1968 to the present. Across this time span, our national ideologies about race have shifted to such an extent that by the late 1990s whites were increasingly portraying and imagining themselves as unprivileged, disadvantaged, and socially marginalized, while African Americans (particularly male athletes) were being portrayed as an excessively (and undeservingly) privileged, entitled, and socially protected group in American culture and society (especially through stories about black male athletes). Accordingly, by the 1990s, it was not unusual to see feature stories in the American sports media of individual white athletes portrayed as disadvantaged and unprivileged, or of figures like extreme sports participants who are said to have authentically come from the margins of society to initiate sporting and cultural revolutions in the United States and across the globe. Ironically, these types of stories have enabled whites, on an ideological level, to lay claim to the position of a victimized and disadvantaged social subject much like African Americans did thirty years earlier during the civil rights movement to highlight their systemically marginalized and disadvantaged position within American society.

Much like the storyline of the 1980s comedy *Trading Places*, where an impoverished African American male (played by Eddie Murphy) switches socio-economic places with an old-moneyed white male (Dan Aykroyd), American sport media culture during the 1990s became an important cultural space where a rather strange reversal of the American racial order took place. Indeed, in this era where the 'myths of whiteness' (Dyson, 2004) were exposed

and brought under public scrutiny and where white people were increasingly imagined as monolithically privileged and oppressive relative to people of color, there emerged a countertrend of seemingly 'authentic' and 'real-life' media stories about whites which emphasized their lack of social or economic privilege and their coming from the margins of American society. Examples of this trend are popular television shows like *Roseanne* and *Married with Children*, and films like *Good Will Hunting, Forrest Gump*, and even *Gladiator*, all of which featured stories of white men who were coded in some way as unprivileged or disadvantaged. The term 'white trash' also began to roll easily off the tongues of many white Americans during the 1990s. Used in a number of ways, but especially as a term of derision toward poor whites and as a way for economically comfortable whites to disavow their relation to white privilege (often by claiming 'white trash' roots), 'white trash' eventually was rather liberally applied as a descriptive term to a diverse range of white people from Anna Nicole Smith to former President Bill Clinton. The popularity of grunge music (especially that of Nirvana, headed by Kurt Cobain) and the grunge esthetic fostered, as they were a part of, a broader popular trend of the early 1990s where being 'alternative' and 'different' from a notion of whiteness as economically and socially normative, privileged, and economically comfortable became a valued subject position for many white Americans to claim or adopt (beginning first with young Americans, but extending later to Babyboomers if one agrees with David Brooks' thesis in *Bobos in Paradise*).

Not only did such images of white people represent the way in which many whites wanted to imagine themselves in this era of a crisis of whiteness, but such portrayals of whites as victimized or marginalized 'others' served the collective interests of whites (even those who did not make such claims) by defusing the public challenge to white normativity and supremacy that was taking place between the agents of the historically marginalized populations and culturally conservative whites through the culture wars of the late 1980s and 1990s.

So then, one of the main goals of this book is to critically examine and detail how the specific media coverage of particular white male American sport stars and emergent white-dominated sport formations during the 1990s participated in the construction of popular cultural narratives which often featured (or implicitly relied upon) a dramatic discursive reversal of the American racial order and of racial power in the United States that disavowed systemic white privilege, while it simultaneously and paradoxically worked to restore and re-secure white hegemony.

At the same time, I want to be clear that the goal of this book is not to illuminate, document, and detail in an ethnographic fashion the existence and activities of an organized body of actual professional and/or elite amateur white male athletes who are working together today beyond the glare of the television camera to initiate a 'pro-white rights' social movement within, or even beyond, American sports. Nor do I mean to suggest that there exists today a group of white athletes who consciously wish to perform even a symbolic revolt against any perceived racial inequities experienced by whites within the social world of sports like the one demonstrated at the 1968 Olympics by Tommie Smith and John Carlos on the victory podium for the 200-meter race.

Although, on one level, the very idea of the actual existence of a group of white athletes advocating for 'white rights' in sports seems utterly ridiculous to me, some recent events that have taken place in the United States suggest that the existence of such a group might not be completely outside the realm of possibility. For example, the 1990s saw a disturbing rise in membership in white supremacist groups, as well as, the ascendancy of the Patriot movement, a largely rural-based, grass-roots movement led by whites whose agenda of recovering civil liberties from an ever-encroaching federal government also contained a barely concealed desire to recover white privilege and even white supremacy in the United States. Even as recent as January 2004, a College Republicans group at Roger Williams University in Rhode Island garnered national attention when they created a whites-only scholarship as a way to compensate for scholarships designed specifically for people of color which, from their perspective, unfairly discriminated against whites.

Yet, these white desires to protect and maintain a privileged social position for themselves are also apparent, even if they are more cleverly disguised and indirectly expressed, in American sport culture through such things as the University of Mississippi's struggle to maintain the use of the Confederate flag as a 'unifying' sporting symbol during its football games (see King & Springwood, 2001), or the controversial racist comments made by white athletes during the last decade and a half such as the former Atlanta Braves reliever, John Rocker, Fuzzy Zoeller (toward Tiger Woods' menu choices for the dinner honoring the current Master's champion), and, of course, Rush Limbaugh (toward Donovan McNabb's quarterbacking abilities) during his short-lived tenure as a football analyst for ESPN.

Nonetheless, this book makes no claim that white athletes are actually mobilizing in the United States to consciously pursue a pro-white rights agenda. Instead, this book attempts to shed light on how particular narratives and sites of American sporting popular culture, whether knowingly or even unwittingly,

were constituted by, and constitutive of, a more pervasive white cultural revolt to re-secure white normativity and supremacy in American culture and society that had been taking place at least since the 1990s.

Contextualizing the 'Revolt of the White (Male) Athlete' in American Sports Media Culture

The 'revolt of the white (male) athlete' that I call attention to is neither one which originated in, nor is it exclusive to, the world of sports. Instead, as many cultural critics and sociologists have already pointed out, this revolt took place all across American popular culture during the 1990s (Giroux, 1997; Hartigan, 1997b; Kincheloe & Steinberg, 1998; 2000; Robinson, 2000; Savran, 1998; Weigman, 1999). Undoubtedly, most Americans have been exposed to this revolt through the airwaves of AM talk radio; most notably, through the rhetoric of Rush Limbaugh; through the music of popular white rapper, *Eminem,* and groups like *Limp Bizkit* and *Insane Clown Posse*; and through popular 1990s films like *Rudy, Falling Down, Forrest Gump, Gladiator, 8 Mile,* and *Fight Club.* It is a revolt that is usually opposed to such things as affirmative action and multicultural and cultural diversity initiatives because they are imagined by many white people as compromising the rights of (white) individuals or as being excessively punitive toward white people generally. At the same time, this white revolt often promoted a racial world view which trumpeted a new colorblind post-civil rights racial order where race was said to no longer matter in terms of influencing one's life opportunities.

Although the origins of this white revolt surely trace back much before the 1990s, I focus my attention on how it materialized in 1990s American sport media culture, especially as a response to what many cultural observers have called the 'crisis of whiteness' that emerged during roughly the same time period and which significantly shaped the cultural life and politics of the decade.

While the work of the sociologists and cultural critics cited above has been quite insightful and comprehensive—and highly influential in my analyses in the chapters which follow—it has almost completely ignored how media and public discourses about American sports and sport celebrities have become a key cultural space involved in the dissemination, popularization, and perpetuation of the ideas and logics of this white revolt. So then, this book seeks to rectify this oversight by highlighting the key role which media representations of sports during the 1990s increasingly played in promoting the ideas and reactionary politics of this white revolt.

American Sports Media Culture and the White Revolt

An important initial question that needs to be asked is: How and why has this white revolt found a place in American sport media culture during the 1990s?

Throughout this book, I show how American sports and white athletes have been mobilized in this white revolt because of the strategic political value of the stories about whiteness, race, and race relations that could be told (and largely believed) through specific narratives about certain sports and white (male) athletes who became popular during this time period. Some key reasons for the prominent role that sport discourses are subtly playing in this white revolt are first, the dominance of African American male athletes on the athletic stages of the 'big three' American mainstream sports of baseball, football, and basketball over the past twenty years is highly amenable to the construction of seemingly 'factual' and 'authentic' claims of victimization, lack of privilege, and social disadvantage for white men in the highly public world of sports (even though white men's power 'behind the scenes' of sports—in coaching, management, and ownership—is still firmly entrenched). As sports are assumed to be an important and influential social institution in American society, such stories can then be highlighted and mobilized as seemingly irrefutable empirical evidence to make public disavowals of the institutionalization of white male privilege in American society.

Second, sport has become a key site of this white revolt because its increasingly pervasive and prominent cultural visibility and reach within American popular culture at the end of the millennium provides large, ready-made audiences for the reactionary ideas of this cultural politics. Even further, the passionate affective investment of many white sport fans in the fortunes of their teams and key players makes it likely that they will absorb the reactionary ideas constitutive of these sport 'texts' without being fully (or perhaps even partially) aware of it. Thus, sports operate here as perhaps the ideal ideological mechanism for those seeking to purvey these reactionary ideas for it is not only able to disseminate its ideas and messages virtually inconspicuously, but it is able to articulate them with and through the pleasures of consuming sports. And since sports has long been a key social institution in the maintenance of white male hegemony, perhaps it is little surprise that the sport arena and sport media become fertile grounds for this contemporary white cultural revolt.

Third, as the culture wars of the late 1980s and early 1990s appeared to lose their steam in the political arena and on college campuses, this white revolt (and its corresponding rhetoric, logics, and aims) began to more thoroughly pervade and constitute the popular discourses about various American sports and sport celebrities. With the racial interests of reactionary arguments about protecting

'individual rights' and 'traditional American values' becoming too readily apparent and ripe for criticism from multicultural opponents in the context of discussions about such things as affirmative action, multiculturalism, and California's Proposition 187 at the end of the twentieth century, this white revolt required new cultural sites to disseminate and popularize its ideologies, namely ones where the reactionary pro-white dominance politics of their worldview were more cleverly masked and disguised. Yet, at the same time, 'popular' sites that appealed to many Americans and which could seem to make legitimate claims to represent the contemporary 'social reality' of race in America were also needed. Interestingly, at some point during the mid-1990s a shift occurred. The very same reactionary sentiments of white revolt against the white-perceived loss of social power that were criticized in the context of discussions of affirmative action, multiculturalism, and political correctness found new life and popular support as they were more covertly expressed through popular sport discourses.

At some time in the mid- to late 1990s, stories about sports and American sport stars began playing an increasingly important role in this revolt of the white centre against the ideologies of the 'new multicultural era.' As this reactionary white desire to protect and re-secure white normativity and supremacy in American culture and society was expressed in sport discourses, its political interests seem to have been more easily mystified, denied, overlooked, or simply ignored than when they were expressed on college campuses in defenses of the Eurocentric canon and of Western Civilization, or in political and social policy debates over the continuance or elimination of such things as cultural diversity initiatives or affirmative action policies. Surely, this is partly due to the common notion that sports are apolitical and somehow separate and unaffected by broader society. This common sense, depoliticized way of thinking about sports, implicitly makes it difficult for people to read sport media stories about white-dominant sport formations like extreme sports and NASCAR, and white American sport celebrities like Andre Agassi and Lance Armstrong as inherently political sites that always already participate in cultural politics by privileging, legitimating, and garnering public consent for particular ideas about race, class, gender, sexuality, and nation (in most cases, ones that support and reinforce the interests of whites) over others.

Media stories about American sports and sport figures become crucial to this objective because they are too often read as seemingly apolitical and unbiased sport journalism; stories which simply report 'facts' and 'truths' about the contemporary American sports world which are divorced from the social and political struggles of broader American society. Yet, when these sport

media stories are read closely and through a critical lens informed by the critical race theory of whiteness studies, one begins to easily see how these stories are predicated on, as they serve to enflame, white anxieties and fears about declining white power and social normativity in 1990s America, a time period Cameron McCarthy has called 'the era of the Multicultural' (1998a, p. 334).

By way of example, the racial politics of sport discourses which regularly denounce the exorbitant salaries and highly publicized criminal transgressions of black athletes (particularly NBA and NFL players, though not exclusively) or which ask 'innocent' questions about the increasing absence of white athletes in mainstream American professional sports seemed to go largely unnoticed and uncriticized in the American mainstream during the late 1990s and into the new millennium. Few observers seemed to regard such sport discourses as racial discourses. More specifically, few saw these sport discourses as veiled expressions of white anxieties about a perceived loss of white supremacy as well as sites where the normativity and privileged position of whiteness was being discursively restored.

Or, perhaps one might take a second look at the award-winning feature story about Marcus Jacoby produced in a *New York Times* special report on race in America (which has been reprinted in several books about race and sports since its original appearance). Jacoby is a white quarterback who always dreamed of earning a scholarship to play college football. But, after completing high school, the only school to offer him a football scholarship was the historically black institution, Southern University. After a difficult and disappointing first season, Jacoby led Southern to a black college football championship in his sophomore year. Just one year later, Jacoby decided to withdraw from Southern because he felt that he could no longer take the extreme isolation, stress, and anxiety he experienced due to his being a racial minority in the Southern University community.

Written by well-respected *New York Times* sportswriter, Ira Berkow, the tone of this story was sympathy for Jacoby's plight as a white racial minority. Read within the broader context during the 1990s of public criticisms of white privilege and white cries of reverse racism due to affirmative action programs, the story is not only a prime example of a sport narrative which positions a white male as a victimized and unprivileged racial subject, but it also implicitly promotes a logic of racial equivalence where his experiences of being unfairly stigmatized by black racial prejudice against whites suggest that black people can be racist too (thereby, apparently negating any examples of white racism that the critics of white privilege might highlight, as well as the institutional character of white racism/white privilege). At the same time, Jacoby's story

deftly seems to lend credible empirical evidence through the narration of this 'actual story' that systemic white privilege does not exist (for if it did, how could Jacoby possibly have experienced racial discrimination?). Additionally, the story fails to even mention how the isolation, stress, and anxiety experienced by Jacoby has long been (and in many cases, continues to be) the disconcerting, normative experience of many black athletes who play Division I football at traditionally white institutions of higher learning. Tellingly, such a contemporary story of a young black male quarterback's experiences of white racial prejudice on the campus of a big-time Division I college football (or basketball) program did not seem to get imagined as a worthy topic for an in-depth story during the 1990s.

Additionally, media stories which celebrated extreme sports (or alternative or action sports as they are now increasingly called) as a contemporary extensions of the hearty, pioneering, masculinizing, democratic ideals first espoused by our (white male) American forefathers, expressed contemporary white desires not only to re-center white masculinity within mainstream American sport culture at a time when it had been challenged, but also they rearticulate white masculinity with American national identity at a time when this link also had been threatened by revisionist histories and multicultural advocates. Similarly, this skillfully and carefully veiled desire to protect white male privilege and reaffirm white supremacy has also avoided popular criticism when it is expressed in rhetoric which identifies the United States as a 'NASCAR Nation' in the new millennium or through media narratives which celebrate America's purported overwhelming consensus of support and admiration for seven-time Tour de France champion and cancer survivor, Lance Armstrong.

The Stakes of the White Revolt in the United States

Broadly conceived, what I am calling the 'white revolt' involves a public struggle over the meanings articulated with whiteness (particularly white masculinity) in mainstream American popular culture during the 1990s and extending into the new millennium. This white cultural revolt is a struggle over the minds of the public. It is a struggle to shape, limit, and organize how Americans imagine whiteness and race more generally; how race relations and racial inequalities are imagined; how responsibility for America's checkered racial past and continued racial inequities in the present are explicated, remembered, and/or strategically forgotten or elided. In short, this white revolt is an important socio-cultural force of new millennium America involved in a struggle over what ideas get defined as the 'reality' of race in American society.

While I spend most of my space here trying to document and expose how media stories about sport celebrities like Andre Agassi and Lance Armstrong, and new sport formations that emerged in the American sporting mainstream during the 1990s like skateboarding and extreme sports participated in this struggle over the meanings articulated with whiteness in the 1990s, I also want to stress that this struggle over ideas is inextricably and importantly related to the decisions which get made in our society over the distribution of material resources, how social inequalities are exacerbated or minimized, and the development of social policies involving race in American society. Thus, critical examination of the media representations and discourses about American sports and sport figures should not be considered a trivial and meaningless endeavor that has little to do with contemporary racial politics. Instead, and especially because representations of race in the American sporting media culture play such an important role in forming and shaping many white Americans ideas about race, this book's critical look at the subtle ideas conveyed about whites and African Americans in the American sport media should be recognized as absolutely essential to interrogating how many Americans think about race in the present historical moment.

I also assume that the white revolt in American culture is one that many white people will probably be reluctant to acknowledge or accept because it has been so cleverly disguised and has not accompanied by placards and parades of protest in the streets. Yet, many white people have participated in this revolt. Some have done so knowingly, while the large majority of white people have been tacitly consented with the ideologies of this white revolt.

One prominent recent example of conscious participation in this white revolt taking place in the sport media is Rush Limbaugh's comments about Philadelphia Eagles' African American quarterback Donovan McNabb which ended his brief tenure as an in-studio football commentator for ESPN. As many will recall, Limbaugh, the disturbingly popular conservative radio talk-show host, essentially explained Donovan McNabb's Pro Bowl accolades as a sporting brand of affirmative action where the National Football League was, in his words, 'desirous' to have a successful black quarterback, most likely, so that the NFL's long and conspicuous history of informally excluding African Americans at that key position could be overlooked and forgotten. Of course, implicit in Limbaugh's statement is the notion that African American quarterbacks in the NFL are undeservingly being privileged, and given opportunities and disproportionate media attention because of their racial identity (to the detriment of more deserving white quarterbacks) rather than their abilities. But, what we also learn from Limbaugh's statements is the way in

which this white revolt (both in and outside of sports) operates without any explicit mention of protecting or re-securing white normativity and supremacy. At the same time, to the extent in which white members of ESPN's audience agree with and consent to (even if only by failing to object to) the racial logic of Limbaugh's comments, one can also see how whites might unknowingly participate in this white revolt.

Many whites will also no doubt downplay or perhaps even try to dismiss the existence and influence of this reactionary white revolt that has taken form in the sport media since the 1990s because of the incendiary racist politics associated with it or simply because it is in their collective social, economic, and political interests to do so. As many workers in the relatively new field of whiteness studies have illuminated, the maintenance and perpetuation of the normativity and privilege of whiteness are enabled by the systemic mystification of the subtle and complex ways in which public stories and imagery of white people construct ideas about whiteness (and other racial and ethnic groups) which maintain and perpetuate the social, economic, and political privileges that go along with being defined as 'white' in American society.

Additionally, it is precisely because this white revolt is not taking place in the streets, and is so cleverly disguised in the construction and coding of the imagery and narratives selected for viewing through the mainstream media, that the reactionary politics of this white revolt have been largely effective in garnering the position of many white people's 'common sense' ideas about race today. Thus, this book seeks to make an important contribution to the critical work being done in sport studies and in critical race studies by illuminating the reactionary racial politics that are regularly disseminated and invisibly at work through various media representations and discourses about American sports and sport celebrities.

It should also be said that this white revolt also is not one that seeks to overthrow the 'powers that be.' In fact, this white cultural revolt is largely endorsed and spearheaded by white men of economically comfortable, if not affluent backgrounds. Yet, its beneficiaries are all of those who benefit from the construction and circulation of racial discourses which help to perpetuate a racial hierarchy in the United States that locates whiteness at its apex. This revolt also has important allies in people of color whose voices and/or images it often strategically mobilizes (sometimes unbeknownst to those individuals) in an attempt to mask the reactionary racial content and limited interests served by its politics.

The 'Revolt of the White (Male) Athlete' and the Development of a Critical Media Literacy

In order to begin to 'see' this white revolt (and to hopefully struggle against its aims and goals), white Americans must learn how to develop critical media literacy—to begin to 'read between the lines' so to speak and recognize the implicit racial messages that popular images and narratives about athletes convey about race, race relations, and racism in the United States. Such critical media literacy would enable white viewers to be aware of how such sporting media representations of race facilitate the maintenance of the power and privilege of being white in American culture and society.

For example, developing such a critical media literacy would urge white people to self-reflexively interrogate the affective pleasures they might feel when reading a media story about American Lance Armstrong's record seven victories at the Tour de France after recovering from cancer, or when warmly remembering the unlikely heroics of the 1980s United States Olympic Hockey team as they were re-told via the recent film, *Miracle*. In this multicultural context where the racial identity of the nation in the past and present has become a contested terrain, we need to consider how these stories about Armstrong and *Miracle* are implicitly political. They subtly work to naturalize a connection between whiteness and American national identity that responds to, as it cultivates, a popular contemporary white desire to express 'authentic' ownership of the United States that has been destabilized by the emergent emphasis on multiculturalism. The political character of these media stories involving sports further gets revealed when one contrasts these feel-good nationalistic sport stories of Armstrong and *Miracle* with the stories and imagery constructed around the United States 4 x 100 men's track team's (who incidentally were four African Americans) celebratory posturing following their victory in the 2000 Olympics in Sydney, Australia. The images of the victorious African American male athletes flexing their muscles and posturing for cameras, while being wrapped in American flags, came under heavy criticism as a negative representation of what the United States stood for back in 2000. Derogatory commentaries regarding their victory displays were revived in 2004 as their actions were shown to American Olympians, prior to leaving for Athens, as an example of how they should not act in Athens if they were to win gold in their respective events (considering the anti-American sentiments of many foreigners since 9/11 with the institution of the 'Bush Doctrine').

Or, one can also see this struggle over the racial meanings of American national identity when one examines the vociferous criticism levied against the 2004 United States Men's Olympic Basketball team after they returned home

from Athens having won only a bronze medal. This team was, of course, overwhelmingly made up of African American NBA stars. Rather than properly situate the United States' poor showing in the context of the globalization of basketball over the past twenty years and how it has narrowed the gap in ability between the United States and the rest of the world, or discuss how the timing of the Olympics conflicted with the NBA off-season, a time when NBA players try to recover and replenish themselves for the arduous grind of the long NBA season, the bronze medal-winning performance of the United States was largely understood as a product of the (black) United States team's lack of fundamentals (i.e., their poor jump shooting, passing, and defense—incidentally, all of which are imagined in the United States to be qualities of a competent white player) and by the notion that overpaid, ungrateful, prima-donna black NBA stars were unpatriotic and simply could not be bothered to play for their country in the Olympics. The amazing aspect of such sporting discourses is that race is rarely, if ever, explicitly mentioned and can even be rather easily denied or projected back as a manifestation of racism (for raising the 'race-card') onto the person who dares to bring up the role that race might play in contouring the rather derogatory public discourse which emerged about the United States Men's Basketball team following their disappointing result at the Olympics.

Most white Americans must also take note of the vitriolic comments regularly expressed in sport television and especially on sport talk radio against African American male athletes (which usually do not mention race) as comments that are implicitly about race and maintaining white normativity and white supremacy. Most white Americans need to begin to recognize and bear witness to the way in which a disproportionate amount of media attention and media spectacles involving sports go toward narratives vilifying the supposed greed, criminality, selfishness, and ungratefulness of well-compensated African American NBA and NFL players whose economic fortunes and fame are often explained by more than a few irate (presumably white) callers on sport talk radio as the fortuitous product of black male athletes being the lucky winners in a genetic lottery. Many white people must begin to recognize how the ills of contemporary professional American sports are often projected onto the bodies and stories of African American athletes, while all that is good and virtuous in American sports are frequently attributed to white athletes like Cal Ripken Jr, Brett Favre, Pat Tillman, or Lance Armstrong (or through 'good blacks,' to use Brian Wilson's term, like Michael Jordan or Tiger Woods whose popularity with many white Americans is often held up as proof of America's

colorblindness to race and the end of racial discrimination in post-civil rights United States).

White people are usually unaware of both their participation in this cultural revolt and their tacit endorsement of its ideas about whiteness. Participation in this white revolt can often simply mean deciding to read or watch particular stories about specific figures in sport media (i.e., film, television, magazines, and adverts), and accepting and internalizing the ideas and worldviews outlined in the texts as fairly accurate representations of the racial reality of American society. Through the repetitive consumption of stories of whites as economically unprivileged or as authentically coming from the margins of society where these whites often proclaim their difference from the normative white middle class, white consumers of these texts of the American sport media can (and often do) develop distorted world views about the 'reality' of race relations and racial inequalities in contemporary America.

But, the success of this white cultural revolt is not necessarily defined by the number of people who swallow the racial ideas of such texts wholly. Rather, it is determined by the manner in which the ideas crafted and fostered in and by this white revolt became hegemonic in American culture, implicitly shaping a large majority of Americans' common sense ideas about race and race relations, while simultaneously making alternative ideas and viewpoints about race and race relations scarce. In fact, it might even be said that the success of this white revolt is largely determined behind the scenes so to speak, at the moment of the production of media texts; that is, at those moments when these texts of white revolt were created and selected over and against other texts offering different and differing viewpoints of race to repetitively appear all across American popular culture (across film, television, books, magazines, and pop music), those were the times when this white revolt took shape and gained momentum.

By way of conclusion, I should also say that as a white person who has lived during the time period in which I write, I include myself as one of those white people who have, at times, unknowingly participated in this revolt. For many years, my participation, like the participation of many white people, was beyond my perception (but not beyond my comprehension). But, at a certain point, as my studies allowed me to become better educated about race and the power of whiteness to invisibly shape and constitute the social (including the messages frequently told through the mass media), I realized my twisted relation with this white revolt. Most notably, I became conscious of my contradictory complicity with and desired opposition to it. I began to contemplate how I felt as I watched the first 'Extreme Games' (as they were then called) on espn2. I remembered experiencing what felt like a more

'authentic' affective connection to the participants and the sports featured on the telecasts (than say watching the NBA) even though I had only skateboarded a few times in my life and did not have the guts to even dare attempt to drop into and skate a half-pipe (even more peculiar considering I played playground basketball regularly as a youth). I recalled sitting down at my computer to write about these feelings, to explore and try to better understand this peculiar identification with these sports which I had never performed. I thought about the overwhelming whiteness of the male competitors; the metaphor of flight which was central to many of the marquee sports (skateboarding, BMX dirt jumping, bungee jumping, and sky surfing); the white male competitors distancing of themselves from mainstream, middle class normative values; the inclusion of an African American play-by-play announcer whose use of hip-hop rhetoric seemed to authenticate the apparent difference of these particular young white guys from those 'dreaded' 'old white guys' who feared Dennis Rodman's and Charles Barkley's impact as a role model on America's (white male) youth. In short, I thought about why these white guys were being portrayed as 'cool' and why I found pleasure in also seeing them that way.

I mention these memories not to claim an elitist position as a white person who 'gets it'—that is, one who recognizes and understands how race and racism shape contemporary American life. But, rather to highlight how the process of developing a critical media literacy and racial consciousness requires continuous hard work for most white people, even those who are supposedly 'educated' on the subject. Since whiteness is the normative racial identity in most spaces and places in the United States, many whites are largely unaware of how every aspect of their lives is invisibly shaped by their racial identity and whiteness as an invisible social system. Although seeing how race shapes every social interaction, sport narrative, television commercial, etc., in American cultural life does seem easier to me today, I must admit that getting to this position has taken me quite a while. In all honesty, it has taken me about ten years to be able to 'see' and comprehend the many-layered ways in which race operates as a social structure. And every time I temporarily delude myself into thinking that I do 'get it' or think that I understand the social force of race in a specific American practice, space, or interaction, discussions with students, colleagues, friends, or family members humbly remind me that racial power is ever so dynamic and fluid, constantly remaking itself in multiple ways so as to reproduce and re-secure racial divisions and hierarchies that my knowledge has just barely scratched the surface. Since they are crafted in the hearts, minds, and acts of humans, concepts of race and racial formations are dynamic, 'living and breathing things,' and there is always something more to know and to learn

about the various forms of racism and its effects on both people of color and whites.

I hope that this book will help others to recognize how these reactionary white politics which significantly shaped American sports and cultural life throughout the 1990s are still at work in so many places across American popular culture even today in 2006 (even if in slightly different forms). But, recognition of these politics is not enough. Becoming conscious of the existence of white privilege and how it materially, socially, and psychically shapes American social life must be only a first step for white people to do the right thing, and actively resist the use of racial stereotypes and ideologies as well as to challenge racial discourses and social policies that perpetuate racial barriers and inequalities. I hope that reading this book will help others choose to embark on such a personal process of discovery, resistance, and transformation.

╬ CHAPTER TWO

Image Is Not Everything: Andre Agassi, Generation X, and White Masculinity

Before his recent retirement following his third round exit in the 2006 US Open, American tennis player Andre Agassi was undoubtedly one of the most well-known sport celebrities in the United States sporting landscape during the past two decades. Agassi's extraordinary run to make the finals of the 2005 US Open at the age of thirty-five seemed to rejuvenate American sports fans' interest in professional tennis for two weeks. At the same time, his amazing run reminded some of his Babyboomer predecessor, Jimmy Connors' similarly astounding run to the quarterfinals of the Open in 1991. Agassi's impressive accomplishments on the tennis court include winning eight Grand Slam titles[1] as well as becoming the first male tennis player in the modern era to win all four Grand Slam tournaments on three different surfaces (grass, hard court, and clay). Beginning with his notorious "Image Is Everything," television commercial with Canon cameras, Agassi became one of the most commercially successful American athlete endorsers during the 1990s and continuing into the new millennium (today, often featured with his wife, former women's tennis champion, Steffi Graf). He has peddled products for a number of corporations like Swiss Army, Gillette, Pepsi, and perhaps most notably, Nike. Agassi's significant marketability is perhaps best exemplified by Nike's decision in 1995 to sign him to a lucrative endorsement deal which was reportedly worth anywhere between $100 and $150 million depending upon performance incentives. The deal is especially noteworthy because it was much bigger than the one Nike offered to Pete Sampras who, at the time, was considered by many tennis experts to be the greatest male tennis player of all-time.[2]

But, Agassi's popularity within American culture is also evidenced by more than just his on-court accomplishments and endorsement deals. His courtship, marriage, and subsequent divorce with actress, Brooke Shields, as well as, his second marriage with tennis legend, Steffi Graf, and births of their two children

have been frequent fodder for tabloid news outlets like *Star, People, E! List, Access Hollywood*, and *Entertainment Tonight*. Even further, stories of Agassi's amazing comeback in 1999 to become the number one ranked male tennis player in the world after his ranking had fallen to number 141 and tennis experts were ready to write him off were feature stories on sport programs like ESPN's *Sportscenter*, Fox Sports' *The Last Word*, and HBO's *Real Sports*, as well as, non-sporting magazines like *Time* and *People*. In short, it seems that American audiences had a peculiar fascination with this amazing tennis showman from Las Vegas.

In his critical examination of the "white guy" identities of musicians, Bruce Springsteen and Axl Rose, Pfeil (1995) argues that although the meanings inscribed onto their sweaty and writhing bodies could not seem to be more "true" or self-evident when one looks at them (whether on television or in magazines), how we come to see and make sense of their bodies/identities is a much more complex cultural process. More specifically, at that instance of looking, the meanings articulated to their white male bodies are a complex effect of the peculiar, yet hardly innocent or apolitical, combination of a myriad of codes, conventions, and discourses (both categorical and conjunctural) which frame and constitute our popular understanding of their identities. In this chapter, I use Pfeil's critical analytical method to illuminate the codes, conventions, and discourses which implicitly organized the seemingly self-evident "true" identity of American tennis player, Andre Agassi during the early to mid-1990s. I contend that Agassi's celebrity (by which I mean his combined cultural prominence, his popularity with the American public, and his marketability) is not at all self-evident, not easily explainable through facile references to his "charisma" (Dyer, 1991) or his extraordinary athletic talents on the tennis court. Instead, to properly make sense of Agassi's celebrity during this historical moment, one must become aware of how his mediated identity has been constituted through the meanings and logics of the discourses constitutive of Generation X—a supposed new American generation who were said to be coming-of-age in the early 1990s. So, in this chapter, I show how the meanings articulated with Agassi in the early to mid-1990s were always constituted by, and constitutive of, the codes, meanings, and logics produced in and through the popular discourses being espoused about Generation X at that specific moment during in 1990s America.

In order to accomplish the above goal, I must first outline the rather derogatory image of "Generation X" produced within American culture during the early to mid-1990s. Then, I will critique some of the popular and academic

discussions of Generation X and briefly sketch a more critical reading of the Generation X discourses, one which will begin to make visible the conjunctural politics through which the discourse was produced, as well as the often overlooked racial and gender politics of Generation X discourses. In terms of excavating the implicit racial and gender aspects of Generation X discourses, I focus my attention on critically interrogating the main simulated figure that has been produced through the discourse, the slacker, who has almost exclusively been coded as white and male. Drawing on Wallach's (1997) insightful work on the cultural politics of generational discourses in American history, I argue that the Generation X discourse should be read as a discourse which is implicitly concerned with producing a normative white masculinity which is articulated as a uniquely American figure. Finally, I scrutinize the three main media incarnations of Agassi's white masculinity during this time period: Agassi as teen idol/rebel, Agassi as Generation X slacker, and Agassi as anti-slacker, to show how Agassi's imaged identity came to be articulated in and through the codes, meanings, and logics of the Generation X discourses.

Interrogating the Generation X Discourse

In the early 1990s, a discourse about a supposed new generation of coming-of-age Americans who were described as a "lost generation, an army of aging Bart Simpsons, possibly armed and dangerous" was produced and quickly popularized through American media culture (Barringer, 1990, quoted in Strauss & Howe, 1991, p. 317). Within this discourse, this supposed new generation of Americans was cast as a "symbol ... of America in decline" (Howe & Strauss, 1993, p. 19). Labeled "Generation X" with the "X" meant to symbolize the purported, alienated, and confused character of this generation; this derogatory discourse was widely generated, reproduced, and legitimated throughout American media culture—in magazines, television news programs, newspapers, Hollywood and independent films, popular music, and even academia. Together, these texts constitute a set of knowledges, narratives, logics, power relations, and identities that I call the "Generation X discourse."

A *U.S. News & World Report* article provides a quick summary of the rather negative way in which Generation X was characterized in the early to mid-1990s:

> Twentysomethings are a generation in need of a press agent. Their elders think of them (when they think of them at all) as a generation of uppity, flesh-and-blood Bart Simpsons, so poorly educated that they can't find Vietnam on a map or come within 50 years of dating the Civil War. With their MTV-rotted minds and sound-bite attention

spans, they are a whiny cohort with the moral compass of street gang Blood and Crips, a bunch of apathetic slackers who don't vote and couldn't care less (Shapiro, 1993, p. 50).

This disparaging construction of the Generation X identity of this supposed new generation of Americans was, by many, enthusiastically embraced as an accurate representation of the characteristics and sensibility of this new generation of all American youth coming-of-age at this time in history. For those few who did contest (or object to) the accuracy of this Generation X description, they often contended that it was simply a fabrication of the media or merely a hip, new consumer category contrived by American marketers (see Giles, 1994).

What such narrowly simplistic economic explanations for the creation and widespread popularization of the Generation X discourse (and slacker identity) fail to adequately explain is how and why this belittling characterization of this supposed new generation of Americans came to be produced, widely circulated, and popularly accepted as "true" about American twenty-somethings in the early 1990s. In order to develop a more sophisticated explanation of the Generation X discourses, one which recognizes its political character, we must situate it within the historical conjuncture in which it was produced and consumed as the "common sense" way of imagining American youth.

To begin to understand the conjunctural politics of the Generation X discourses one must understand how it was produced at the intersection of widely circulated crisis narratives about disintegrating families, about a nation in decline and at risk (supposedly from weakening traditional values and an increasingly fragmented national culture), about a radically changing domestic economy which was widening the gap between the rich and poor and eroding the middle class, and finally, about anxieties over the continued efficacy of the American dream in the present and future due to these economic and social changes. Although it has gone largely unnoticed, the derogatory portrayal of Generation X was crucially instrumental in constructing and legitimating these conservative-inflected crisis narratives about the American family, the nation, the middle classes, and the economic and cultural position of white males in the early 1990s. In addition, each of these crisis narratives has been instrumental within a conservative backlash project seeking to re-secure the normative and central cultural position of white masculinity in the United States.

For example, contemporary conservative-inflected proclamations of the crisis of the American family and of disintegrating "family values" relied upon (indeed required) the derogatory characterization of the next generation of

American coming-of-age youth produced in and through the Generation X discourses. While the unflattering representation of Generation Xers as a bunch of irresponsible, apathetic, and uncaring slackers "choosing" to "slack-off" in temporary or part-time jobs (as opposed to choosing well-paid, career-oriented jobs) served as an imaginary solution to the economic anxieties and tensions (what Ehrenreich (1989) has called the "fear of falling") being felt by older members of the white, middle classes who could not comprehend the younger generation's inability to procure upwardly mobile, career-oriented (read: middle class) work as their elders did during their twenties. Characterizing Generation X as a bunch of uneducated and inarticulate slackers who did not acquire, what Hirsch Jr. (1988) called a basic American cultural literacy, was used to construct national panic narratives about the perception of the United States' global position "falling" relative to Japan and Germany (in terms of economic productivity and educational achievement) in the late 1980s. Such a pejorative view of the alleged poor academic achievements and cultural literacy of supposed Generation Xers was also employed within the discourses of the "culture wars" of the early 1990s to construct multicultural and feminist scholarship as threats to "traditional American values" and a "national common culture"; carefully coded phrases used to mask the goal of these discourses and the culture wars—to re-secure the cultural normativity of whiteness and patriarchy in American society which had been de-stabilized by the civil rights and women's movements of the 1950s and 1960s. In each of these cases, Xers are offered as embodied evidence of the so-called disintegration of "traditional American values" and a "national common culture" under threat from the "un-American" demands of historically marginalized "others" (feminists, multiculturalists, gays and lesbians, and illegal immigrants). Of course, the "traditional values" under threat are not traditional at all; instead they represent a set of knowledges, social relations, and subjectivities employed historically to secure and reproduce the normative and central cultural position of white masculinity. Thus, the unflattering Generation X representation of an imagined coming-of-age generation of Americans was mobilized, in various ways, to implicitly demonize feminist and multicultural forces and to proclaim a nostalgic desire to return to "traditional" American values, a proclamation which is part of an implicit project to secure and reproduce the normative and central cultural position of white masculinity in the United States.

Although these are some of the political functions of the Generation X discourse and its negative portrayal of the next American generation, I want to turn my attention to explain how the Generation X discourse operates as a

technology of white masculinity which first produced and demonized the practices, values, and investments of an "abnormal" youthful white masculinity, the slacker, and then through representations of public figures like Andre Agassi (post-1994) forwarded an image of a docile and productive white, middle class, masculinity (one which is familial, entrepreneurial, and invested in liberalism). My study of the Generation X discourses—specifically, the main subjectivity produced within it—is guided by the notion that "scientific and popular modes of representing bodies are never innocent but always tie bodies to larger systems of knowledge production and, indeed, to social and material inequality" (Terry & Urla, 1995, p. 3). Read in this way, the Generation X discourse becomes an important site involved in the struggle over the meanings being articulated with white masculinity in 1990s America. In order to envision the racial and gender aspects of the Generation X discourse, a brief discussion of the knowledges and identities constituted in and through the category of a generation is required.

Interrogating the Racial, Gender, and Nationalistic Aspects of the Generation X Discourse

Strauss and Howe (1991) in their seminal text, *Generations*, which might be described as the cultural text most responsible for influencing how Generation X was imagined during the 1990s, subtly and unknowingly reveal the racial and gender politics which implicitly organize the present-day generational discourse:

> We could not always feature a totally representative sample of the population. Sometimes, for example, we had to limit the attention given to women and minorities—either because not as much is known about them or because we wanted to refer to actors and events that most readers would recognize (p. 16).

Framed in the guise of a novel and "refreshing historical narrative," a conservative-inflected, generationally oriented historiography of American history was produced by Strauss and Howe which implicitly privileged the contributions, perspectives, and interests of white men over and against all others (ibid., back cover). In his study of the cultural and political meanings articulated with generational discourses, Wallach (1997) argues that generational discourses in America, although seeming to be inclusive (in terms of race, class, and gender), have historically been implicitly constituted through, and centered around, the perspectives, experiences, and interests of white, middle class, masculine subjects. Wallach goes on to say that generational discourses have long been implicitly involved in articulating white, middle class, masculinity as a

symbol of American national identity (ibid., p. 8). I want to employ Wallach's insights about the function of generational discourses in the United States to argue that the Generation X discourses function, on at least one level, as a technology concerned with organizing the practices, values, and ideological investments of white, middle class male youths, and their social and cultural positions in American culture and society. The Generation X discourse initially produced a white masculine figure—the slacker—whose practices, values, and investments were marked as different and abnormal relative to the hegemonic cultural expectations of white men in post-World War II (post-WWII) America. Through the demonization of the slacker's white masculinity, the invisible but present, even if only in shadow form, normative American white masculinity of the 1990s is produced (Terry & Urla, 1995, p. 5).

Interrogating the Generation X slacker

The Generation X slacker is the main symbolic figure produced within the Generation X discourse up until about 1994. In short, the slacker was represented as an almost alien and incomprehensible figure that was exclusively coded as white and male. His apparent difference was inscribed onto his body through his grunge clothing, long hair, goatee, tattoos, and body piercings. Older generations' public derision of the slacker came from his disinvestment in the practices, ideologies, social relations, and affective investments expected of white, middle class, males after 1945. Within this social formation, the proper white masculinity for coming-of-age white, middle class, males was to be invested in striving for upward economic mobility, getting married, having children, and securing a comfortable suburban lifestyle. Additionally, this normative form of white masculinity is thoroughly constructed through the logic of American liberalism (i.e., life outcomes are solely the product of hard work and making the "right" choices, unaffected by one's social conditions). Although these practices and the "normative" white, middle class, masculinity constituted by them are imagined as being transhistorical, we must recognize they are not transhistorical at all. In fact, they are effects of particular economic, cultural, and political arrangements, namely, a Fordist era of mass production and consumption within an economic boom economy during post-WWII America (until about 1973). This normative white masculinity was not only encouraged in American society, but was officially subsidized by the United States government through legislation such as the Servicemen's Readjustment Bill of 1944 (popularly known as the GI Bill of Rights), the Interstate Highway

Act of 1956, and government-sponsored programs which allow federally insured home loans and tax deductions for mortgages (Corber, 1997, p. 7).

By the early 1990s, the specific set of cultural, social, political, and economic forces and conditions of the post-WWII United States which enabled this normative image of white masculinity to be produced were no longer available to as many twenty-something white males coming-of-age in the early 1990s. By this time, the economic conditions of the United States had shifted away from being organized by a Fordist logic to a post-Fordist logic characterized by the global flight of production from the United States with manufacturing sector jobs being replaced by service economy jobs which had lower pay and fewer benefits. Americans under the age of twenty-five were said to have been most severely affected by these changes, with their median income declining by 10.8% from 1980 to 1990, while all other age groups' median incomes rose by 6.5% during the same time period (Shapiro, 1993). These changes in the American economy significantly changed the economic opportunities available to young, coming-of-age, white, middle class males, as compared with their generational elders. Consequently, some young white males did not invest in the practices, values, and identifications which constitute this expected normative white masculinity.

The slacker represents a spectacular white masculinity whose appearance in American media culture during the early 1990s functioned as an embodiment of the practices, values, and identifications which young white males should not invest in. The slacker appears in public culture so that his form of white masculinity can be disciplined and marked as abnormal. So then, how was the slacker's white masculinity constituted as abnormal and deficient?

The slacker's abnormality was most often produced through stories of his failure to be a productive working white masculine body. In her book, *The Official Slacker Handbook,* Dunn writes that a "real job" is "anathema to a slacker" (1994, p. 22). The slacker's poor work ethic is frequently conveyed through stories of Xers choosing not to climb the corporate ladder or to opt out of the corporate rat race, with the corporate "ladder" and "rat race" representing shorthand signs of displaying a desire for upward mobility (Martin, 1993). Within these stories, the slacker's unproductive (and abnormal) white male body gains its meaning from its difference from a primary imaginary figure: a modestly upwardly mobile, hard working, family oriented figure who is usually coded as a Babyboomer. This figure is imagined as a productive (normative) white male figure who shares the economic aspirations of the Yuppie, but is distanced from the Yuppie's excessive narcissism, disinvestment

in traditional notions of family, and interest in conspicuous consumption and materialism. Implicitly revealed through the criticism of the poor work ethic of the slacker are the characteristics of a "normal" and productive white, middle class, masculine body, which, in this case, means being invested in work which has the potential to yield an upwardly mobile economic position.

The abnormality of the slacker's white masculinity is also conveyed through his reluctance to enter into a committed heterosexual relationship directed toward eventual marriage. In the film, *Reality Bites*, the under-employed, goateed, and grunge-clothed Troy Dyer (marvelously performed by Ethan Hawke) is cast as the quintessential Generation X slacker figure. In the film's opening scene, we are introduced to Troy as he is leaving a sexy co-ed's apartment after a one-night stand. The purpose of the opening scene gets revealed later in the film when Lelaina (played by Winona Ryder), Troy's best friend and secret love, angrily voices her disappointment in Troy after they've had a falling out. Within this scene, Lelaina's critique of Troy renders visible the foundations of Troy's slacker white masculinity. The scene goes like this: after not seeing each other for weeks, Troy enters Lelaina's apartment (where he had been staying because he had been evicted from his own place) with a new "girl-of-the-moment" in tow whose name he can't remember. After trading some incisive barbs with one another, Lelaina lashes out verbally at Troy for "dicking around with her (meaning the girl who accompanies him) and dicking around with me." Throughout the film Lelaina's implicit role is to act as a disciplinary agent of Troy; here, she emasculates Troy's slacker white masculinity for not being invested in a marriage-directed, familial life path and for not dedicating himself to a productive career path. The scene reveals how the abnormality of the slacker's white masculinity is not solely constituted in relation to his aversion to being a productive worker but is also secured through his unwillingness to invest in a heterosexual marriage-oriented relationship.

Finally, I want to argue that the abnormality of the slacker is also produced through his apparent disinvestment in American liberalism. On the one hand, the slacker's white masculinity is demonized for problematizing the link between white masculinity and liberalism which was secured in post-WWII America. In the economic boom of post-WWII America, economically successful middle class white men were able to construct their identities through a liberalist logic which represented their economic success as the sole effect of their hard work, dedication, perseverance, and capable will. American liberalist ideology claims that that one's will, absent of any structural privileges or constraints, is the sole determining force for whether one is successful or

unsuccessful (Flax, 1998). Such stories prevent any thought or discussion of the structural conditions, discussed previously, which significantly enabled (and constrained) the economic prosperity experienced by many white males in post-1945 America. Additionally, it does not consider how the institutional structures and arrangements implicitly advantage most whites and males. The prosperous economic and social conditions of the post-WWII economic boom enabled a link to be formed between white masculinity and American liberalism which, by the 1990s, became a "naturalized" characteristic of a productive and docile white masculinity. White masculinities which do not reproduce this link are marked as deficient, inadequate, incomplete, or abnormal.

The slacker displayed his apparent disinvestment in American liberalism when he claimed, unlike these older generations of white men (all of whom came of age after WWII), that contemporary economic conditions were unfairly impairing his work opportunities. The slacker broke the liberalist code of white masculinity by claiming that his will was limited or constrained by, in this case, radically changing economic conditions which were making it difficult for him to achieve the same levels of economic comfort, prosperity, and stability which previous generations of white men, at least since WWII, are imagined as having enjoyed. His claims are problematic for two reasons: first, they had the potential to make visible the historical character of the articulation of white masculinity and American liberalism by calling attention to differences between the economic conditions in the early 1990s and those of the late 1960s and early 1970s; and the slacker's proclamations threatened the identities of older generations of white men by exposing their investment in liberalist ideologies. In this light, an article like Martin's (1993) editorial in *Newsweek* where he angrily and resentfully attacks Generation Xers for whining about the poor employment opportunities and wages available to them might be read as Martin's anxious reaction to the way in which the slacker's identity exposes the historical character of the economic, as well as, the racial and gender privileges of older generations of white men.

Thus, the Generation X slacker's white masculinity was marked as abnormal because of his poor work ethic, his reluctance to invest in a marriage/family directed heterosexual relationship, and his disinvestment in American liberalism. In variously coded ways, these themes, which were employed to demonize the white masculinity of the slacker, are conspicuously reproduced through the various representations of Andre Agassi, particularly through the early to mid-1990s. In the next sections, I show how the mediated white masculinity of Agassi is subtly constituted in and through the codes of

the Generation X slacker through this time period. In order to most clearly see how Agassi's imaged identity is constituted by, and constitutive of, the codes, conventions, and logics of the Generation X discourses which emerged at this historical moment, we must first contrast media representations of Agassi prior to 1990 with those produced from 1990 to the mid-1990s.

Agassi as Teen Dream and Rebellious Youth

Andre Agassi first garnered national media attention in 1987. In these early articles, written in the midst of Agassi's meteoric rise up the tennis rankings and prior to the development of high public expectations about his performances, much attention was given to Agassi's flamboyant style (his hair—which was described as "teen dream perfect," and his non-traditional, un-country club-like denim shorts garnered most of the focus in these articles) and his on-court flair and charisma (where Agassi would often joke with the audience or blow kisses to women or applaud his opponents winning shots during a match) (Leerhsen, 1988, p. 82). *Newsweek* wrote of Agassi in 1988, "He doesn't just talk and blow kisses between points; he winks, mugs, and fluffs that famous hair in a way that sets off squeals from teenage girls in the upper reaches" (Leerhsen, 1988, p. 82). At this time, Agassi's imaged identity was largely constituted through the conventional post-WWII American categories of the "teen idol" and "rebellious youth."[3] Additionally, Agassi was repeatedly represented and valorized as an "athletic throwback" and as the potential savior of American (men's) tennis since the careers of the former male flagbearers of American tennis, Jimmy Connors and John McEnroe, were in their twilight. These categories of teen idol, rebellious youth, athletic throwback and as the savior of American tennis are instructive about the way in which Agassi's white masculinity was represented and understood prior to 1989.

In the articles written about Agassi prior to 1989, much attention was given to his good looks, flowing hair, distinctive, un-country club-like sartorial style (denim shorts and long hair), matinee idol status, and his desire to be an entertainer as well as athlete. The categories of "teen idol" and "rebellious youth" call to mind images of The Beatles, Elvis Presley, and James Dean. Such figures represent charismatic, youthful figures, predominantly coded as white and male, whose appeal is derived from their ability to represent a different, seemingly resistive, white male subjectivity which is able to achieve an "alternative" position in relation to other older generations of normative white male subjectivities. The white, male, teen idol/rebellious youth figure can often cause an initial panic for the guardians of mainstream mores because the values,

ideologies, practices, and social relations seemingly affirmed by his different style may appear to be "transgressive" (Pfeil, 1995, p. 75). But ultimately, the "transgressive" style of the teen idol/rebellious youth, especially by 1990, does not represent a real threat to white, middle-class norms of masculinity because, in the end, the "different" style of the rebellious white male teen has been turned into a commodity by late capitalism, and the subjectivity of the white male teen rebel is still one which seeks an empowered, dominant position in a social hierarchy (only it is usually in a subculture different from middle American normative culture). By the 1990s this teen figure (in most of its forms) is easily recognizable to most audiences and is implicitly read as a relatively non-threatening, highly commodified, and culturally sanctioned white masculinity. In order for the teen idol/rebellious youth and the alternative (resistive, defiant) style which he displays to be deemed culturally acceptable, his identity must be completely mixed with meanings which are aligned with and confirm normative white, middle class, masculine values, practices, and norms even as he appears to resist such things. Consequently, the unique, non-conformist "style" of teen idol/rebellious youth figures can be displayed, but it must be rigorously surveilled and policed so that it is rendered innocent and non-threatening; in other words, it must be constituted in particular ways so that it doesn't challenge or threaten the normative values and investments through which the hegemonic white masculinities are produced.

Within these early articles on Agassi, we can see this process of cultivating his apparently resistive "teen rebel" identity, while still reassuring audiences of his ultimate investment in the acts expected of productive and docile white men in American society. It is precisely Agassi's early "teen dream" style—rebellious, different, but implicitly aligned with dominant norms of behavior and liberalist values—which was said to appeal to American teens (both boys and girls) and put on display. But these articles also defuse the potentially threatening aspects of his rebellious image/style by highlighting how his "teen rebel" white masculinity was invested in the values, norms, and ideologies expected of a hegemonic white masculinity in early 1990s America. One *Sports Illustrated* article assures the reader that despite Agassi's rebellious sartorial style and on-court behavior, "he plays with old time decorum ... [and] is quite different from his image" (Sullivan, 1987, p. 10). Agassi's own confessions, where he proclaims to readers, "I'm nothing like the image" and "I have limited friends and a love for my family," are utilized in these stories to further reinforce to American readers his alignment with, and investment in, the dominant values, norms, and ideologies expected not only of professional athletes (as I think most people

read these stories), but also white men (Sullivan, 1987, p. 10). Subtle remarks made in these early articles indicate an awareness of Agassi's potentially problematic past, his rebellious antics as a junior player (throwing rackets, wearing a Mohawk hairstyle, and as the popular legend goes: winning a national junior tournament final while wearing jeans and punk rocker-style make-up). But this dodgy history of Agassi's youth is largely dismissed in these articles as merely a phase he went through; an inconsequential part of Agassi's then current "teen dream" persona. Within these early texts, Agassi's docile "teen idol/rebellious youth" identity is also secured (at least partially) through an implied difference from other young white male youth of his age who are represented as cocky and headstrong.

Cultural acceptance of this "teen idol/rebellious youth" image is also enabled by frequent mentions of Agassi's huge potential to be a future American tennis great and his upwardly mobile career trajectory. These tidbits littered throughout these early stories about Agassi suggested to readers that his best days were ahead of him and that he was making progress toward becoming a champion. Indeed, Agassi's potentially problematic "rebellious" style and on-court antics were able to be defused and rendered irrelevant only insofar as his on-court performances were successful. Such athletic successes and achievements are constituted, and understood, in these articles as symbolic proof of his apparent investment in the values and norms constitutive of a productive and docile white masculinity (such as upward mobility, individualism, competition, and meritocracy).

Agassi is also cast as an "athletic throwback" in these early articles. This category of an "athletic throwback" is used to associate Agassi with previous categories of American athletes—predominantly coded and imagined as white males who played prior to the 1960s—who, in the early 1990s, are nostalgically imagined as representing a set of values, practices, and ideologies which are understood as being "traditionally" American (family oriented, hard working, humble, not-greedy, innocent, and respectful of tradition and authority (read: white patriarchal authority)). The quintessential contemporary athlete who is said to be a "throwback" to an earlier era is usually implicitly racially coded as white. He is also defined as the anti-thesis of the contemporary American professional athlete who is imagined as contemptibly greedy, hyper-individualistic, self-centered, naturally gifted, not invested in the team, and disrespectful of authority. This athlete is often racially coded as African American and male. Within these articles, Agassi is constituted as a relentless worker with an extraordinary level of sportsmanship which American men's

tennis had not seen in the era of Jimmy Connors and John McEnroe. Agassi's portrayal as an "athletic throwback" was, in part, produced through images which showed a sweaty but smiling Agassi hard at work training (jumping rope, lifting weights, and hitting volleys) (Amdur, 1989; Sullivan, 1987). These images provided readers of visual proof of Agassi's proper investment in hard work. But, Agassi's position as a (productive and docile) "athletic throwback" is also produced and secured through the definition of Connors and McEnroe as narcissistic, selfish, and unsportsmanlike whiners (read: abnormal and unproductive white males) whose disrespectful on-court antics which defy the authority and traditions of tennis (read: which challenge the norms, values, and institutions which reproduce white male authority and normativity) are emphasized in order to constitute them as unproductive and improper white masculine bodies. So then, within these early articles, Connors and McEnroe assume the identity of the contemporary professional athlete whose allegedly "improper" values and investments are said to be adversely affecting the values and investments of impressionable (white male) youths who envision them as role models. His status as the savior of American tennis was produced through his alleged difference from Connors and McEnroe, whose white masculinities (marked by excessive competitiveness and intensity) were imagined as excessive and problematic because they symbolically represented disrespect for authority and an excessive self-centeredness.

Finally, in these early articles which introduce Agassi to the American public, he is also constructed as a uniquely "American" body through rhetoric of his being the "savior" of American tennis. Agassi's articulation with "America" was enabled by, and predicated on, his construction as a hard-working (white male) youth with extraordinary athletic gifts, early athletic success, and the potential promise of one day being a tennis champion. Narratives which asserted that Agassi was motivated by an insatiable desire to one day achieve the status of the number one player in the world enabled Agassi's white masculinity to be constructed as an "American" body. His articulation as an "American savior" relies upon and requires his investment in American mythologies of individualism and meritocracy conveyed through visual and rhetorical displays of his apparent work ethic and unquenchable desire to be the best. The use of the term "American savior" signifies that at this time Agassi was imagined as the embodiment of a productive and docile young white male and as a professional athlete which included being invested in hard work, espousing "traditional" American values (individualism, meritocracy), and respecting authority and tradition.

What is perhaps most notable about this initial "teen dream/rebel" signification of Agassi's white masculinity is the conspicuous absence of the codes, meanings, and themes produced in and through the Generation X discourse. The absence of these codes is perhaps not that surprising since the Generation X discourse was not explicitly formed and present within the American popular imaginary until the early 1990, although its logics were surely already in circulation at this time (see Litwin, 1986; Okimoto & Stegall, 1987). The articles written about Agassi at this time were also significant for their superficiality, brevity, and focus on his on-court talents. Thus, I contend that these particular images of Agassi, which were constructed prior to his establishment as a legitimate top ten professional tennis player, are largely generic images of Agassi produced more from the standard codes and conventions used to produce the categories of a "teen idol/rebellious youth" and of a "rising athletic talent" than from any conjuncturally specific set of forces and conditions. Agassi's imaged identity would soon undergo a significant re-articulation as his athletic promise to become a "tennis champion" was called into question by losses in his first three Grand Slam finals even though he was heavily favored to win each of those finals. Additionally, reports of his aversion toward rigorous training and seemingly insatiable appetite for junk food coupled with inconsistent on-court performances, his mysterious decisions to skip Wimbledon and the Australian Open (two of the four prestigious Grand Slam tournaments) in the first couple of years of his career, and his rapid commodification without having achieved the status of a true champion (defined by winning a Grand Slam title) further contributed to the significant re-articulation of his imaged identity. But this conspicuous re-articulation of Agassi's identity, and the particular form and content in which it took, cannot be understood apart from the formation of the rather derogatory Generation X discourse implicitly centered upon producing alarming images of wayward, downwardly mobile, and unproductive young, white, middle and working class males. Between 1989 and 1994, Agassi's popular image would be radically re-defined through the codes, logics, and themes produced within the Generation X discourse so that he was implicitly produced as a real-life embodiment and sporting exemplar of a Generation X slacker.

Andre Agassi and Generation X

Although Andre Agassi's connection to Generation X has rarely ever been explicitly conveyed in the mainstream media's coverage of Agassi's career, the

inextricable link between Agassi and the contemporary attention given to Generation X is expressed in several more subtle, seemingly innocent, and inconsequential ways. For example, Agassi has been described by Nike as "the talent of his generation" (http://www.nike.com/athletes/Agass_1003 /1003 _bio). Additionally, in television adverts for Mountain Dew which aired during the mid-1990s Agassi was represented both as an extreme sport athlete, a figure that has been unquestionably created from the logics of the Generation X discourse, and as a favorite of two long-haired, flannel-shirted white male fans whose long, unkempt hair, flannel shirts, and apathy were obviously crafted through the codes derived from the Generation X slacker. Finally, Canon's advertisements for their "Rebel X" camera, which prominently draws upon the sign value of the "X," further reinforce this implied connection between Agassi and Generation X. That the most explicit links between Agassi and Generation X occur within commercials should not be too surprising, considering the prominent role which American marketers have had in creating and reproducing the "Generation X" discourse (see Ritchie, 1995; Walker Smith & Clurman, 1997).

But, in the following sections, I show how the connection between Agassi's varied representations and the creation of the Generation X discourse extends beyond these rather superficial connections. I make visible the themes which organize the popular press' articles on Andre Agassi beginning in the late 1980s and extending throughout the 1990s to demonstrate how Agassi's identity has been constituted by (and, in turn, is constitutive of) the meanings, themes, and logics which organize the Generation X discourse, even as the identity of Generation X was significantly re-articulated around 1997.

Again, it is important to reiterate that the meanings articulated with Andre Agassi's imaged identity have been notably dynamic, complex, unstable, and even contradictory. It is, in fact, the changes in the meanings articulated to Agassi's imaged identity at various historical moments from the late 1980s to the present which are interesting in relation to the discourse about Generation X and his white masculinity because these changes in the cultural discourses surrounding Generation X and white masculinity in the American imagination.

Agassi and the Generation X Slacker

From 1989 to 1993, Andre Agassi climbed to the elite ranks of men's professional tennis finishing each of these years in the top ten, an extraordinary feat for a man who had just celebrated his twentieth birthday in 1990. In 1989, Agassi set a record in men's tennis by surpassing $1 million in career earnings

after having played in only 43 tournaments. During this five-year span, Agassi reached four Grand Slam finals on three different playing surfaces (clay, hard courts, and grass), but won just one of these tournaments. Surprisingly, this sole victory in a Grand Slam final came at Wimbledon, a tournament which many tennis experts vociferously doubted whether Agassi's explosive backcourt game would ever be suited for success because the tournament is played on grass, where conventional tennis logic dictates that serve-and-volleyers hold a decided advantage over baseliners. Despite this apparent high level of success on the tennis court at an extraordinarily young age, the stories written about Agassi during this time period were largely mean-spirited and rather than emphasizing his successes frequently focused on such things as his poor training habits, his "tanking" sets (purposely losing sets), his lack of an education, his poor sportsmanship, his highly commodified celebrity-athlete status, his disrespect toward tennis' traditions, and his apparent disavowal of tacit responsibilities associated with being an American professional athlete (see Amdur, 1989; Hirshey, 1989; Jenkins, 1992; 1993; Kirkpatrick, 1989; Lupica, 1990a,b). So then, given Agassi's apparent success in reaching four Grand Slam finals at such a tender age, how do we make sense of the disparaging way in which Agassi's identity was rendered visible during this time period?

In order to make sense of the rather derogatory tone and characterizations of Agassi in the media at this point in his career, we must consider how the Generation X discourse was being formed in the American culture at the same time, the early 1990s. Amazingly, the codes used to construct Agassi's imaged identity in these articles parallels with a remarkable symmetry the identity of the white male Generation X slacker produced in the Generation X discourse about the new coming-of-age generation of Americans in the 1990s. It is in and through the codes and meanings constitutive of the Generation X slacker that Agassi's white masculinity was implicitly constituted and vilified during the early 1990s.

In 1988 and 1989, Agassi rapidly rose to the top ranks of men's tennis. His good looks, entertaining playing style, and his extraordinary tennis potential garnered the attention of companies like Nike, Donnay, and Canon who signed him to lucrative multi-million dollar endorsement deals. At this time, Agassi also became the biggest drawing card of men's tennis, which allowed him to collect six-figure appearance fees in smaller regional tournaments before he had even reached the tender age of twenty. But, when Agassi failed to reach the number one ranking and win a Grand Slam final (in his first three opportunities), suspicions about Agassi's work ethic and his apparent

contentment with being tennis' biggest name on the marquee, rather than a tennis champion, began to organize the stories written about Agassi in the popular press. The tone of the stories shifted from being largely positive toward Agassi (when he was represented as the supposed savior of American tennis) to increasingly negative articles which questioned his competitive desire and motivations. This change in the tone of the articles was even noted in the press: "At first it was confined to pressroom cynicism, but then little digs started showing up in articles: 'peroxide' instead of 'blonde,' 'smirk' instead of 'smile'" (Wetzsteon, 1989, p. 62).

Most significantly, Agassi's identity was re-constituted at the beginning of the 1990s from being a hard-working player (Leerhsen, 1988; Sullivan, 1987) to being soundly criticized for his lackadaisical or lackluster on-court efforts and for having very poor training habits. Feature articles about Agassi in *Sports Illustrated* and *Gentlemen's Quarterly* mentioned stories of his practicing for only 15 minutes before playing an important Davis Cup match (Hirshey, 1989; Kirkpatrick, 1989), or his taking red-eye flights to tournaments, practicing for 20 minutes, if at all, and then playing later that night (Jenkins, 1992). Or, much was made of Agassi's poor diet and his almost uncontrollable and seemingly insatiable appetite for fast food and candy bars (Jenkins, 1992). These comments about Agassi's alleged poor work ethic, his laziness, his excess, and his seemingly deficient will paralleled those characteristics used to describe the identity of the Generation X slacker. The Generation X slacker is predominantly coded as a white male who is distinguished by his extreme laziness, disdain for work of any sort, and alleged valorization of the "leitmotiv: [that] second place seems just fine" (Gross & Scott, 1990, p. 60). At this time, Agassi was popularly imagined as not having made the most of his athletic talents. Agassi's losses in his first three Grand Slam finals (the 1990 US Open and 1990 and 1991 French Opens), matches which he was favored to win, along with several public and private accusations (by players and reporters) that he frequently "tanked" sets and matches were frequently employed to call into question Agassi's work ethic and his commitment to being a tennis champion. Absent from these stories about Agassi's Grand Slam losses and his tanking sets was any sense of sympathy for Agassi or effort to emphasize Agassi's accomplishments (like having made it to the finals of these Slams at such a young age). This lack of sympathy toward Agassi, and the way in which these stories questioned Agassi's work ethic, must be understood, at least in part, as an effect of a broader cultural suspicion about the allegedly wayward values and practices of a new generation of American (read: young, white, and middle class

males) expressed in and through the Generation X discourse. The deficient will of the Generation X slacker is marked by his contentment with his downward economic mobility and with a desire not to have to be number one. Agassi's inability to win a Grand Slam in his first three opportunities, coupled with his apparent disdain for performing the requisite work ethic of a professional athlete enabled him to be implicitly coded and popularly understood as a "real-life" symbol and embodiment of the simulated Generation X slacker (Baudrillard, 1983).

Agassi was also represented at this time as naïve and poorly educated by sportswriters who seemed to take great enjoyment in poking fun at Agassi's ignorance of global geography and international politics, topics which were represented in these stories as rudimentary knowledge which everyone would and should know. For example, Agassi was defined as being poorly educated and ignorant through a story of his not knowing what the word "coup" meant or that Peru (where he was playing for the United States in a Davis Cup match) was in the midst of one (Kirkpatrick, 1989). In another, Agassi is chided for not knowing the historical significance of the Tower of London (Jenkins, 1992). Additionally, Agassi would be represented in ways which suggested that his sense of history extended as far back as the latest television commercial (Collins, 1991). This representation of Agassi as an ignorant young person with a short attention span was undoubtedly framed by a burgeoning broader cultural discourse of Generation X which asserted that the new coming-of-age generation of Americans were ignorant of basic ideas, values, and knowledges about the United States and the world (Hirsch Jr., 1988).

Within this time period, Agassi's public image was also rendered visible through the "Image Is Everything" promotional campaign of Canon cameras. The advert generated much popular fervor and resentment toward Agassi. I contend that the resentment generated toward Agassi's "Image Is Everything" identity can be read as a part of the cultural anxiety over Generation Xers' alleged affinity for media culture.[4] The Generation X slacker was popularly imagined as a disaffected youth, whose disaffection was a product of a dysfunctional home and his self-immersion in a pervasive media culture. The Generation X slacker's proclivity for the media, which is said to provide him with a sound-bite attention span and an ignorance of American history, was used to argue that he was disconnected from traditional American norms and values (Kellner, 1995). In these commercials for Canon, Agassi is dressed in vibrant and decidedly un-traditional neon colors, smacking tennis balls in various locations around the world. The final shots of these commercials show

a close-up of Agassi enthusiastically proclaiming that "Image Is Everything." This "Image Is Everything" phrase was popularly interpreted as being authentically created and espoused by Agassi himself. There was no consideration that Agassi was merely a mouthpiece for a camera company trying to sell its product. The "Image Is Everything" phrase seemed to reinforce the popular interpretation that Agassi's failures at his first three Grand Slams were the result of his desire to merely be a celebrity rather than a tennis champion. Within the context of the popular anxieties about Generation Xers' mesmerizing affinity for media culture, Agassi's "Image Is Everything" image became interpreted as further proof a young white male Generation Xer whose apparent affinity for having the right "image" and "style" exemplified his disconnection from traditional American values such as a sound "work ethic, repressive sublimation, and the ethos of rugged individualism" (Giroux, 1997b, p. 126).

The question: "who is the real Andre Agassi?" is also repeatedly asked in these early articles written about Agassi. The query conveys a remarkably similar concern and anxiety about the new generation's "hazy sense of their own identity" expressed in *Time*'s seminal 1990 article about Generation X (Gross & Scott, 1990, p. 57). The question of who is the "real" Andre Agassi stems, on one level, from the disparity between the early representations of Agassi (those prior to 1989) and those produced from 1989 to 1993.[5] But, the public query about Agassi's identity also indicates a political struggle to produce, secure, and contain the meanings of Agassi's white masculinity. The disdain for Agassi expressed in the articles written between 1989 and 1993 represents the confusion and anxiety raised by the failure or reluctance to perform the type of productive and docile young white masculinity expected not only of American male athletes, but of white men. Agassi's apparent unwillingness to demonstrate a professional work ethic and his inability to be number one at this time in his fledgling career were used to symbolize his disinvestment in the values, practices, relations, and ideologies expected of white men in the 1990s; most notably, his lack of professionalism signified his apparent disinvestment in liberalism and its logics (hard work, individualism, and meritocracy) (Flax, 1998). Such practices performed by American white males need to be marked as abnormal in order to implicitly establish and reproduce a normative, more productive, white masculinity. Consequently, the question of who is the "real" Agassi explains more about the cultural expectations of a normative (productive and docile) white masculinity in the 1990s in the United States than it does about Agassi. This recurring concern over who is the "real" Agassi indicates

how his appeal, both as an athletic endorser and as the key figure in popularizing tennis to a mass American sporting audience, is rooted in his apparent struggle to be a productive white guy who espouses and embodies those norms and values ideally expected of white men in America at the *fin de siècle*. Our cultural fascination with Agassi exemplifies America's cultural appetite—especially in the mid-to-late 1990s—for white guys who are struggling to be "better" men (invested in family, upwardly mobile, and sensitive, yet still ruggedly individualistic, and sufficiently strong and tough).[6] This rationale for the fascination with Agassi is further substantiated, as you will see (in the next chapter), by the way in which the press embraced "the new Andre Agassi" after winning his second and third Grand Slam titles (the US Open and Australian Open, respectively) in 1994 and 1995.

Agassi as Anti-Slacker Savior

The inflammatory and skeptical tone of the articles describing Agassi in his early years as a professional (prior to 1994) would disappear after he returned from career-threatening wrist surgery in the middle of 1993 to become the first un-seeded player to win the US Open in 1994. Agassi's second Grand Slam victory was described in the press as signaling the "redemption of Andre Agassi" (Price, 1994). Agassi followed up his amazing win at the 1994 US Open by notching his third Grand Slam title (and second in a row) just a few months later at the 1995 Australian Open. Together these victories marked a turning point in the way in which Agassi's identity would be constituted within the media during the next two years.

Following these victories, no less than four feature articles written on Agassi appeared, not only in sport magazines (*Sports Illustrated, Tennis, Tennis Match*), but also in mainstream magazines and newspapers as well (*Esquire, New York Times Magazine*, and *GQ*). The appearance of these stories of Agassi's "redemption" in these non-sport magazines and newspapers suggests that his personal "transformation" was one which transcended the American sports world and resonated with broader cultural concerns and anxieties about the investments and values of young white males within the mid-1990s.

Within these feature stories, America was introduced to "the new Andre Agassi" (Jenkins, 1995). For the first time, the articles about Agassi focused not simply on his tennis career, but significant attention was given to constructing an image of Agassi off the tennis court. These stories of Agassi's life beyond the tennis court were employed not only to legitimate the claim that he had truly developed a new, more positive attitude on the court, but they produced a

more holistic image of Agassi's white masculinity (on and off the court), one which, I contend, gives his imaged identity broader ideological value.

The narratives used to construct this "new Andre Agassi" are interesting particularly in their difference from the narratives that had been used to construct the identity of the Generation X slacker in the early 1990s. In these articles, any suggestion that Agassi was lazy, uneducated, instantly gratified by his wealth and sports celebrity status, satisfied with being less than number one, or that he had a deficient will—the characteristics used to define the Generation X slacker—were explained away as meaningless youthful indiscretions, rather than the essence of his true character. On one level, the significance of these articles is that the narratives which organized this re-articulation of Agassi's imaged identity distinctly marked him as the antithesis of the Generation X slacker. This "new Andre Agassi" was produced through stories of his blossoming romantic relationship with actress, Brooke Shields; stories of his new corporation, Agassi Enterprises, that he and his childhood friend, Perry Rogers formed to manage Agassi's image and his riches; and stories of his hard work and decision to personally commit to becoming a tennis champion. In addition to these main themes, Agassi was also represented as a thoughtful and vulnerable guy who was valorized for displaying a determination to be optimistic about people and his future (see deJonge, 1995; Higdon, 1994; Jenkins, 1995; Sherill, 1995). These themes—being invested in a marriage-oriented relationship, being upwardly mobile and entrepreneurial, being invested in friends and family, being committed to hard work, and being optimistic rather than cynical—were precisely the practices and attitudes which Generation X slackers lacked or were said to be not investing themselves in. Consequently, the form and content of this re-articulation of Agassi's identity at this time suggest that he was implicity being portrayed as a symbol of a white, male Generation X slacker who was able to elevate himself out of his (self-imposed) downwardly spiraling life to invest himself in the proper behaviors, values, and ideological investments expected of him not only as a professional athlete but (perhaps more importantly) as a productive white male in 1990s American society. It should also be noted that Agassi's redemption in these stories is predicated on (and is publicly celebrated because of) his ability to embody and represent the desired values, norms, and ideologies expected of white men in American society in the 1990s. In short, it could be said that within these celebratory stories about Agassi he was constructed as a slacker savior.

But, the re-articulation of Agassi, and specifically his differentiation from the Generation X slacker, was not by any means a simple process but was instead complex and seemingly contradictory. At the same time as this multitude of articles about the "new Andre Agassi" distanced him from the identity of the Generation X slacker, some media sites more closely associated him with conspicuously coded slacker figures. This observation begs the question: How can we make sense of this seemingly problematic incongruency between Agassi's new anti-slacker identity produced in the popular press and the manner in which some of his commercialized representations became more closely associated with the slacker? Let us take a closer look at a specific commercial featuring Agassi during this time period to understand the ideological process at work here.

In a Mountain Dew television advert that was broadcast on American television in 1994 and 1995, Agassi was initially displayed as a risk-taking extreme athlete sky-surfing off of a helicopter. In the next image, Agassi is shown playing an aggressive, all-out brand of tennis in a Wimbledon-like setting. Next, we see two inarticulate slacker-like white guys with long hair, goatees, and flannel shirts (the usual sartorial and bodily codings used to signify the slacker figure) sitting court-side enthusiastically applauding Agassi's every shot. The commercial ends with Agassi sprawled out on the ground smiling to the camera with a mouthful of dirt after having dove after one of the opponent's challenging returns.

In this case, Agassi's connection to the Generation X slacker is made more apparent through his articulation with these two obvious slacker figures. But, this articulation between Agassi and these slackers is made not to highlight the similarities between them but rather to emphasize their difference from one another. The choice of portraying Agassi in action shots (showing Agassi sky-surfing and diving after his opponent's shot) provides an entertaining comedic moment in the commercial, but they simultaneously enable Agassi's white masculinity to be articulated with the very anti-slacker qualities of being active, hard working, and displaying a desire to be his very best. Thus, Mountain Dew's commercial more closely articulates Agassi with the Generation X slacker, not to assert Agassi's similarity to the slacker but rather to constitute him as different from and superior to the Generation X slacker youths in attendance. Finally, by portraying the obviously coded slacker figures as enthusiastic fans of this hard-working, strong-willed Agassi also suggests that Agassi is being constituted as an exemplary form of white masculinity which these young slackers should emulate.

This re-constitution of Agassi's identity in 1994–1995 is also significant with respect to Generation X because his re-articulation pre-dates a remarkably similar re-articulation of the identity of Generation X as documented by *Time*'s cover story entitled, "Great Expectations" (Hornblower, 1997). In this article, *Time* asserts that the initial representation of Generation X as a bunch of slackers was entirely erroneous. This egregious error was proclaimed on the magazine's cover—"You called us slackers. You dismissed us as Generation X. Well, move over. We're not what you thought" (Hornblower, 1997, front cover). *Time*'s article declares that the image of Generation X as a bunch of whining, passive, nihilistic, downwardly mobile, latchkey kids who were fearful of commitment (regarding marriage) was produced too prematurely and is not at all an accurate representation of this generation. The article also exemplifies how, by 1997, the meaning of the slacker image of Generation X had shifted and was now popularly imagined as an inaccurate stereotype rather than an accurate reflection of the behaviors, values, and ideological investments of this twenty-something generation. In the place of the slacker image of Generation X, *Time* constructs an image of Generation X which virtually inverts the initial derogatory Generation X slacker image. Citing new and more extensive research (as opposed to the former news stories whose "extensive research" is now represented as inaccurate conjecture), *Time* contended that Generation Xers were ambitious "get-aheads" who were confident, savvy, dedicated to upward mobility, valued family, materialistic, and "crave(d) success American style" (Hornblower, 1997, p. 58). They were said to be "deeply competitive" and wholeheartedly believed that "competition encourages excellence," as well as, poignantly espousing a "do-it-yourself, no-one-is-going-to-look-out-for-me-but-me-spirit" (Hornblower, 1997, p. 62) which they purportedly developed from the Reagan and Bush I years. The role models of this optimistic and highly motivated image of Generation X were said to be risk-taking entrepreneurs like the technological wunderkid creators of Yahoo! Search engine: Jerry Yang, 28, and David Filo, 31 (Hornblower, 1997). Finally, Generation Xers were portrayed as the generation putting a stable family at the center of their portrait of the American dream (which included affluence, a two-parent family, and a comfortable suburban home).

Through these new representations of Generation X, the former anxiety about the values and ideological investments of the next generation which pervaded the earlier discourse about Generation X was not only defused but dismissed almost entirely. In place of the old image of Generation X, *Time* confidently proffered a new image of Generation Xers (read: white male

youths) as being invested in and committed to upward mobility, materialism, family, individualism, and hard work.

The *Time* article is important because it shows how this re-articulation of the identity of Generation X in 1997 parallels the significant re-constitution of Agassi's imaged identity just two years earlier. It seems as if the re-articulation of Agassi's imaged identity in 1994–1995 prefigured, in its form and content, the popular re-articulation of Generation X popularly expressed in the 1997 *Time* cover story. In identifying a relation between the re-articulation of Agassi's imaged identity and that of Generation X, I do not mean to suggest the reconfiguration of Generation X's identity in 1997. Instead, I merely want to show that although Agassi's re-articulated identity in 1994 was constituted in and through some anti-slacker-like codes—a change which could seemingly problematize my argument about the parallels between Agassi and Generation X—the subsequent broader re-articulation of the identity of Generation X in 1997 demonstrates how Agassi's identity was still inextricably linked with the identity of Generation X. In fact, the timing of the re-articulation of Agassi's identity illustrates the mutually constitutive relationship between the identities of Andre Agassi and Generation X.

In the next chapter, I examine the representational patterns and themes used to render visible Agassi's white masculinity from the mid-to-late 1990s and into the next century. As opposed to this chapter which focuses on the mutually constitutive relationship between Agassi's imaged identity and the cultural discourses surrounding Generation X, my analysis in the next chapter focuses more attention on reading various media representations of Agassi as often overlooked cultural sites involved in the political struggle over the meanings articulated with white masculinity in American culture.

╬ CHAPTER THREE

The New, *New* Andre Agassi: The Cultural Politics of White Male Redemption

Introduction

> *"At four, he was a prodigy, trading forehands with Jimmy Connors. By twenty-one, he was merely a class clown. So Andre Agassi started over—got a haircut, studied hard, and found a sweetheart"*
>
> *(Sherrill, 1995, p.89).*

> *"I make a lot of mistakes, and I'm going to continue to make them. I have, I do, and I will"*
>
> *(Andre Agassi cited from Higdon, 1994, p.40).*

> *"All of it looked familiar, but different too, for here, at the defining moment of his career, Andre Agassi was becoming a new man. Not everyone experiences a cleansing redemption, but on Sunday, June 6, at 6:28pm Paris time, Agassi did"*
>
> *(Price, 1999, p.34).*

> *"the redemptionist paradigm…is from an initial state of alienation, through trial and suffering, to reconnection to family and cosmos…the point (of this redemption for the white male protagonist) is not finally to give up power, but to emerge from a temporary, tonic power shortage as someone more deserving of its possession and more compassionate in its exercise"*
>
> *(Pfeil, 1995, p.38-9).*

Beginning with his dramatic re-articulation of Andre Agassi as an anti-slacker in the articles of late 1994 and 1995, and continuing in subsequent articles (especially after 1999), Agassi's white masculinity was portrayed in and through a dramatic new set of codes, narratives, and logics through the latter half of the 1990s and into the new millennium. Largely gone in the media coverage of Agassi during this time period are the codes and logics associated with the Generation X slacker. Instead, one encounters more stories of Agassi that extend beyond the tennis court and provide more in-depth information on his personal life. This "new, *new*" Andre Agassi offers, I think, a more complex,

contradictory, and complicated white masculinity than the Generation X-influenced versions of Agassi discussed in the previous chapter. It is during this time period that Agassi's white masculinity is best read as an allegory of a white masculinity which became hegemonic in American culture—one that is both strategically feminized (coded as innocent, child-like, sensitive, vulnerable, and caring) and masculinized (coded as tough, strong, determined, and successful); one that is ambivalent toward wealth (cognizant of his wealth but attempting to distance himself from it), internally conflicted, family oriented, and, in general, attempting to manage its relationship to social privilege.

As Savran (1998) and Pfeil (1995) have pointed out in their reviews of popular films of the 1990s like *City Slickers, Regarding Henry, Rambo,* and *Forrest Gump,* and as I have applied their ideas in a review of the film, *Jerry Maguire* (Kusz, 2001c), the redemption of individual white men was a recurring theme in American popular culture throughout the early and mid-1990s. These repetitive stories of individual white men redeeming themselves contribute albeit insidiously, via the often unacknowledged and allegedly apolitical realm of popular culture, to the production of images and performances of white masculinity as unprivileged, disadvantaged, sensitive, caring, vulnerable, and child-like. As I've argued throughout this book, such representations of white masculinity are used to deny, mask, and disavow the socially, culturally, and economically privileged position of being white and male in a contemporary American cultural context where such unearned privileges were increasingly being illuminated and criticized (Giroux, 1997b; McCarthy, 1998a; Yudice, 1995). Thus, I will use insights drawn from a number of contemporary analyses of the meanings articulated with white masculinity across American history (Bederman, 1995; Giroux, 1997a; Kennedy, 1996; Pfeil, 1995; Savran, 1998; Yudice, 1995), to read the complexities of Agassi's multifaceted white masculinity and how it has been most prominently portrayed after 1997 through narratives of personal and professional redemption.

On the Conjunctural Politics of White Male Redemption[1]
In a general sense, redemption usually involves a subject performing an action which allows them respite from a previous state of sinfulness and its consequences. The theme of redemption presumes a subject who has committed a wrong in the past but has subsequently reformed himself so that he can now be absolved of all guilt and/or responsibility for that previous wrong. This redemptive subject is often represented and imagined as a divided subject. His subjectivity is split between a former self who has committed some

sort of "sin" or wrongdoing, and a new, present self who is absolved of his previous transgressions because he has undergone a significant personal transformation. This personal transformation, which enables and is a necessary part of the subject's redemption, often requires "a passage through trials and suffering" (Pfeil, 1995, p. 45) through which the subject cleanses himself of his "old self" (leaves behind his old transgressive acts and/or changes them into "proper" ones) and is re-born as a new man innocent of his previous wrongdoings. In this narrative of redemption one moves from a moment of committing of sins, to alienation from one's self, to suffering, to reconnection to the world as a supposedly "changed man" (Pfeil, 1995). This redeemed subject, after having undergone his transformative suffering is also able to claim an ostensibly virtuous and innocent position because of the individual suffering and difficult trials he has undergone in order to redeem himself.

Following these observations, it should be of little surprise that during this time where some left-leaning critics brought to light and denounced the long history and continuing existence of white male privilege in US culture, while simultaneously often creating a caricatured image of all white men as evil, uncaring, and oppressive, a number of stories of seemingly unprivileged white men who had redeemed themselves from past transgressions and wrongs began to appear in mainstream American media culture and resonate with white audiences. Indeed, the redeemed white male figure was a prominent and implicitly politicized figure of the 1990s in the United States. This redemptive white male figure played a key role in popularizing an image of white masculinity as having undergone a transformative conversion from a white man who admittedly transgressed in the past and suffered for those transgressions, to one who has redeemed himself through his suffering to become virtuous in the present. By locating these "wrongs" in the past, this white male is able to be constituted as innocent of any wrongdoing in the present. More importantly, such an image of redeemed white masculinity, buttressed by the "common sense" notion today that America's racial inequities were solved by the civil rights movement and the federal legislation passed in its wake, is politically instrumental in masking and disavowing the structural privileges of being white and male in the United States in the 1990s.

Indeed, this redeemed white male is perhaps the perfect embodied figure within this era of public critiques of white male privilege where many conservative whites faced with the imperative to bear witness to white male privilege (and the continued racial inequalities in US society) attempt to locate the inequalities, violence, and abuses associated with racism, structural racial

inequalities, and white privilege in the distant past (implicitly suggesting that such privileges and inequalities have been eradicated in the present). The response of many whites to recent efforts to seek reparations for the United States' history of slavery is just one site where this cultural logic is at work. Such representations of white masculinity as redeemed and white male privilege as a past historical social structure, enable contemporary white men to conveniently disavow their role in the perpetuation of this system of racial advantage as such structures of privilege are imagined as a thing of the past nullified and eliminated by the civil rights legislation of the 1960s (including affirmative action programs) and the apparent purging of more overt forms of racism from American society since that time.[2]

Another key feature of the redemptive white male is that his alleged suffering allows him to attempt to occupy the position of a victim, thereby further allowing him to disavow his privileged social position by claiming that he too has suffered (just as African Americans, women, and gays and lesbians have over the past forty years). That is, the redemptive white male who has suffered provides a subject position which affords a "redeemed" white man the possibility of equivocating his experience of suffering with those of other minority subjects in order to say that he too knows what it is like to have suffered. He makes this claim by highlighting any and all isolated "moments of suffering"[3] that he has experienced in his life in order to attempt, to authenticate, and legitimize his claim of being disadvantaged, victimized, or simply not living a completely privileged life. Since he can then make a claim of having suffered in his past, he feels able to be positioned (and to position himself) as a figure who is an authentically unprivileged subject and innocent of any "wrongdoings" in the present (for, as this binary logic goes, an unprivileged victim cannot also be constituted as a privileged oppressor). Of course, a key problem with this logic is that it relies on equating white men's isolated and personal "moments of suffering" with the repeated and continued existence of racial and gender structures and ideologies which provide unearned privileges to white men (and unearned disadvantages to racial and ethnic minorities and women) in American society (Kincheloe & Steinberg, 1998).

With the conjunctural politics of the redemptionist paradigm now outlined, I will show how, after 1999, Agassi's white masculinity is articulated to this redemptionist paradigm through stories which focus on, and indeed celebrate, his personal and professional redemption.

Agassi and the Politics of White Male Redemption

In 1999, after many tennis experts and fans had ostensibly pronounced that Andre Agassi's once-promising career was effectively over following his precipitous drop to number 141 in the world tennis rankings back in 1997, Agassi surprised these detractors by making the finals of three Grand Slams (French Open, Wimbledon, and US Open), winning two of them, the French and US Opens. In an ironic twist of fate, both of Agassi's victories in these Grand Slam finals required him to come from behind to defeat his opponents in dramatic five-set wins. Agassi's comeback victory at the French Open, in particular, appeared to symbolically represent Agassi's recent professional/personal redemption.

The match seemingly allowed viewers to see Agassi's redemptive transformation take place right before their eyes. This victory was an especially exciting and amazing feat as Agassi was thoroughly outplayed in the first two sets (6-1 and 6-2) by his opponent, Andrei Medvedev. The intriguing subtext of these first two sets for informed tennis fans was that they seemed to repeat Agassi's previous performances early in his career in the final of the French Open when, although heavily favored, he lost to Andres Gomez and Jim Courier in successive years (1990–1991). But, unlike these previous matches, the "new, *new*" Andre Agassi did not cower in the face of adversity the way he was said to have in the past. Instead, he battled his way back into the match. Finally, he gained control of the match from Medvedev and won in the decisive fifth.

In winning the French Open, Agassi achieved an impressive milestone by becoming one of only five men to win all four of tennis' coveted Grand Slams during their career (Price, 1999).[4] Of this select company, Agassi was the only one to win his four Grand Slams on three different surfaces (grass, clay, and hard courts). Many tennis analysts proclaimed that this accomplishment would ensure him of a prominent place in the annals of men's tennis history, a position that many questioned Agassi would ever achieve due to the off-the-court notoriety and on-court disappointments which marked his early career.

Agassi's comeback, demonstrated on one level by his dramatic come-from-behind victory at the 1999 French Open, was described as "the latest and most significant turnaround in a career marked by flashes of brilliance and unfulfilled promise" and as "the stuff of fairy tales" (Finn, 1999, p. 46). Agassi's successes on the tennis court in 1999 were framed in the media through narratives which spoke of, and delighted in, his "redemption," his "resurrecting his career," and

his "becoming a new man" (Price, 1999, p. 34). In short, these stories reveled in the arrival of a "new," "redeemed" Andre Agassi.

The first key aspect of these narrations of this "new" Andre Agassi is that his post-1999 persona is implicitly contrasted with his former "Image Is Everything" and Generation X slacker selves, the dominant personas used to constitute Agassi's identity throughout much of his early career (as discussed in Chapter 2). These former incarnations of Agassi's white masculinity represented him as being more interested in making money and commercials than winning Grand Slam titles. This Agassi was also criticized for his disrespectful irreverence toward the traditions of tennis he seemed to display as a young pro when he decided not to participate at Wimbledon (perhaps the most prestigious of the four Grand Slam tourneys), or when he donned an intentionally non-traditional colorful sartorial style (bright, flashy neon colors and denim, as opposed to traditional tennis whites) while on the court. Finally, Agassi is castigated in these redemption articles for taking his athletic "gifts" for granted, and for choosing not to cultivate his athletic talents to their fullest extent early in his career so that he could become a tennis champion.

Through these stories of the transformation of Agassi from his old "bad" self to his new "good" self, Agassi's subjectivity is divided so that his "sins" as a professional athlete (and symbolically as a white male) are located in his former self. Dividing Agassi's white masculinity in this way enables the contemporary "redeemed" Agassi to be rendered visible as virtuous, beneficent, and extraordinary, just as he is simultaneously disavowed from the sins of his former self. Additionally, it allows Agassi's new white masculinity to be endorsed over and against his former one. And as I will discuss more fully below, one of the tacit pleasures of Agassi's new "redeemed" self resides in his transformation from being an arrogant, spoiled, and self-centered (read: over-privileged) white male who prospered from (and did not display a humble appreciation for) his athletic "gifts" and privileged position within tennis and American sports culture to a more humble, unprivileged white male who has not only "suffered" in his life but who has also achieved athletic success and displays an investment in the liberalist values of hard work, agency, and personal responsibility.

Along with contrasting this "new" Andre Agassi with his former "Image Is Everything"/Generation X slacker self, stories of his amazing redemption, like the white male redemption films mentioned above (Pfeil, 1995), focused much attention on a number of low points in his life which he had recently endured that caused him much pain, suffering, and psychological trauma. These low

points were identified as his failed marriage with Brooke Shields, his precipitous drop in the men's tennis rankings coupled with his decision to "humble" himself by playing in satellite tour events (what many tennis pundits referred to as tennis' "minor leagues"), and his undergoing psychotherapy to learn to deal with his turbulent relationship with his father (who pushed him extraordinarily hard from infancy to his teen years when he moved away to The Nick Bolletieri Tennis Academy in Bradenton, Florida). These are the main stories which are used to implicitly secure an image of Agassi as a white male who not only lacks any sort of social or economic privileges but who has also suffered in his life, with his suffering being the key element necessary for his redemption.

For example, in stories of Agassi's failed marriage with Brooke Shields, rather than deriding Agassi for this "failure" in his personal life or his disinvestment in "family values," his divorce was constituted as a difficult experience or obstacle which he endured and overcame. Through these stories, Agassi was implicitly constituted not only as an "unprivileged" or "disadvantaged" white male who has endured "tough times" in his lifetime, but as someone who, through the experience, became a better man. In particular, his broken marriage was represented as making him more humble and appreciative of the positive things in his life which he previously took for granted. In the 1990s, such conspicuous displays and proclamations of an awareness of, and thankfulness for, the positives of "privileges" of living a "blessed life" by a host of white athletes and celebrities should be read as a subtle form of disavowing the privileges of being white and male in contemporary American society (Yudice, 1995). It is as if merely displaying or declaring a self-awareness of, and appreciation for, one's privileged existence (in opposition to the caricatured socially unaware middle-aged white male who just doesn't want to admit or refuses to recognize the existence of structural racial and gender privileges) protects the supposedly self-aware white person who makes such statements from feelings of guilt or anxiety that they might experience from their "possessive investment in whiteness" or from charges of actually enjoying unearned privileges made by a host of historically marginalized "others" (Lipsitz, 1998). Thus, we can read these stories about the effects of Agassi's divorce on his identity as discursive mechanisms which work in a variety of ways to constitute Agassi as an unprivileged white male who has suffered in his life. In producing such an image of white masculinity as unprivileged, these representations of Agassi also tacitly operate to attempt to "deny what is most obvious: the privileged position of whiteness [or more specifically, white masculinity]" (Kincheloe & Steinberg, 1998, p. 15).

This image of Agassi's white masculinity as seemingly unprivileged is further reinforced in stories which focus on his marked descent in the tennis rankings and virtual disappearance from the men's tennis circuit following his marriage to Brooke Shields in 1997 (Bodo, 1999; Price, 1999; Shuster & Felsen, 2000). Following his subsequent divorce from Shields, Agassi is said to have rededicated himself to the game of tennis. Part of this re-dedication involved Agassi deciding to play in the "lowly" satellite tour where most of the players are either journeymen or young players who will, only on rare occasion, ever be good enough to play in regular ATP tour events let alone win an opening round match in one of them. Many tennis analysts like Mary Carillo repeatedly lauded Agassi's decision to "swallow his pride" and play in tournaments on the satellite tour in order to accumulate much-needed points to improve his tour ranking enough so that he could *earn* invitations (due to his ranking) into the "main draw" (regular ATP tour events) (*Real Sports*, 2000).

In these tales, Agassi is applauded for his humility and lack of a sense of entitlement, or, in other words, he is praised for not using his privileged position as a former Grand Slam champion and popular athlete-celebrity to obtain unearned privileges, and for choosing to work his way back into the "main draw" by playing in the satellite tour. Agassi is celebrated for not feeling as though he is "too good" for the satellite tour. He is also lauded for his willingness to earn a position in the main draw by accumulating points that would increase his world ranking by playing in these small, substandard satellite tourneys, rather than accepting "wild cards" to play in the "main draw" tournaments (a structural privilege often given by tournament directors to specific big-name professional tennis players who may, for a variety of reasons, not have qualified for their tournament).

The implicit pleasure in celebrating Agassi's decision to play on the lowly satellite tour and to earn his way back to the main tour, is that it allows the production of an image of white masculinity as not only unprivileged but also as not wanting to reap the benefits of any unearned privileges and willing to work for everything he gets in life. Again, through the representation of Agassi's white masculinity as seemingly lacking privileges of any sort or of possessing an over-inflated sense of entitlement, he occupies a white male subjectivity that appears to be completely antithetical to the much-maligned white male figure who came to prominence in 1990s American culture and just didn't seem to "get it" about the critiques being made about the institutionalization of white privilege and many white men's problematic inflated sense of entitlement.

These narratives about Agassi's redemption also involve constituting Agassi as an "everyman" who professes an uncomfortableness with material excesses and the unearned social advantages/privileges that go along with being an athlete-celebrity, while he, paradoxically lives a lifestyle marked by an almost incomprehensible wealth for an actual "everyman."

One story which corroborates this incarnation of Agassi represents him explaining how he has not become comfortable with the privileges that go along with being a star athlete-celebrity like flying first-class. In an interview with tennis analyst, Peter Bodo, Agassi states, "No matter how often I fly first-class I never get comfortable with the way with the way they hold everyone else back, watching, while we get off first" (Bodo, 1999, p. 36). Repeated accounts appear in the popular press of how the "new, *new*" Agassi no longer collects expensive sports cars (an often-repeated tale in early stories on Agassi which were used to highlight and demonize him for his excessive, undisciplined materialist urges). These stories also suggest a distancing of this "new, *new*" Agassi's white masculinity from the material privileges which seemed so important and integral to his previous self (Bodo, 1999; Granger, 1996; Lieber, 1996). Again, we must remember how these discursive maneuvers in portraying Agassi's imaged identity come about during a historical moment when white men (conceived as a monolithic group) were increasingly being defined publicly by the critics of whiteness and white privilege as society's most materially privileged subjects. Although such apologetics and discomforts with wealth are asserted in these stories of Agassi, it is important to note that such representations of Agassi do not in any way alter or threaten his (or any other white man's) very real, privileged social and economic positions. As I think it is fairly easy to see, Agassi could, for example, rather easily relieve his sense of guilt about, or discomfort with, the privileges of flying first-class by simply flying coach, but he does not make such a choice. So then, Agassi's remark reveals how such statements are little more than a pose or posture taken up by him. Agassi does not really want to give up his privileged lifestyle, he only wants to display an uncomfortableness with such privileges because such a stance can seemingly protect him from criticisms of being an over-privileged, uncaring, arrogant, white male.

Many stories written about Agassi after 1995 also give much attention to his foundation for underprivileged children—aptly named: The Andre Agassi Foundation—which he established with his best friend and manager, Perry Rogers. Agassi's Foundation is an arm of his corporation, Agassi Enterprises, which he and Rogers created in order to manage his athletic career and

promotional activities. Through Agassi Enterprises, Agassi has raised money to construct the Andre Agassi Boys & Girls Club for underprivileged kids in Las Vegas (Lieber, 1996; *Real Sports*, 2000). In 1996, while playing in a tournament in Atlanta he donated "Agassi's Court for Kids," an inner-city tennis court made from recycled athletic shoes in conjunction with Nike (Lieber, 1996). His annual "Grand Slam for Children" raises an average of $2.5 million each year for at-risk youth in Las Vegas (Lieber, 1996). Through such stories of Agassi's generosity and his willingness to give back to those who are less fortunate, his white masculinity is encoded as caring, generous, philanthropic, and civically responsible (Lieber, 1996). Through these stories he is cast as a white male who, although occupying an overwhelmingly privileged position, demonstrates a seemingly genuine concern for, and apparent identification with, less economically and socially privileged people within society. Most often, the "at-risk" youth he is seen helping through the work of his foundation are African American kids. Thus, through this articulation of Agassi with African American youth, one could say that Agassi's efforts to give back to his community also further distance him (whether intended or not) from reading him as a privileged white male. Although such charitable efforts are laudable (and not to be easily dismissed or criticized), his connection to these less privileged populations also has the ancillary benefit of working to code him as caring and compassionate for the less privileged, sensitive, and understanding of their hard lives. One might even consider how it allows him to align himself with these unprivileged groups of society and in so doing, the penchant for celebrating Agassi for "giving back" to less economically privileged groups displayed in these articles can be read as just another part of a cultural effort to disarticulate white masculinity from the connotation of being always already materially and socially privileged, uncaring, and oppressive.

Additionally, this "new, *new*" Agassi is both subtly and dramatically constituted as a vulnerable, fragile, innocent, and child-like white male who has experienced much suffering in his life (see Bodo, 1999; deJonge, 1995; Higdon, 1995; Price, 1999; Sherill, 1995; Shuster & Felsen, 2000). Along with the alleged "suffering" that Agassi endured through his divorce with Shields and his time spent on the satellite tour, this particular image of Agassi, as one who knows suffering, is achieved via stories of his turbulent relationship with his overly ambitious father whose desire to produce a tennis champion fostered a relationship with his son that almost bordered on exploitation and left many psychological scars with Andre, which gain more prominence in press coverage of him at this time.

To provide a bit of background, as the story goes, Andre's father, Mike Agassi, is an Iranian immigrant who immigrated to the United States in the late 1940s and worked long hours in order to make a better life for his kids. More specifically, he worked and saved his earnings to accumulate enough money to build a private tennis court and purchase several ball machines which his children used to practice their tennis games before and after school (whether they wanted to or not). Mike is frequently portrayed in the press as a strict disciplinarian who forced his kids to practice tennis for several hours every day. His goal was to create a tennis champion. Many articles which reported his fanaticism revealed how Mike hung a tennis ball over Andre's crib while he was still an infant and even taped a ping-pong paddle into the palm of his hand so that he could develop hand–eye coordination at an early age (Hirshey, 1989; Kirkpatrick, 1989). While Andre was still a small child, Mike is said to have told anyone who would listen that Andre was his "little champion" (Kirkpatrick, 1989). So at an early age, Agassi was literally developed by his father to become a tennis champion; nothing more and nothing less. In another recurring story about the dysfunctional relationship between Andre and his father, Jim Courier, an American tennis player who spent his teenage years playing against Agassi at the prestigious Bolletieri Tennis Academy, recalls a story which showcases the extreme pressure that Mike Agassi placed on Andre not just to be good, but to be a champion, even as a youth. Courier remembers witnessing the elder Agassi disposing of Andre's third place trophy in a dumpster after a youth tournament because he had not won the championship (Leand, 1996).

This portrayal of Agassi as a person who has suffered in his life is also corroborated via his willingness to publicly discuss his voracious appetite for self-help literature from gurus like Tony Robbins and Marianne Williamson which is another often-repeated topic discussed in magazine stories about him during this time (Bodo, 1999; deJonge, 1995; Higdon, 1994). Popular press accounts also mention how Agassi has sought out and undergone a significant amount of psychotherapy and counseling to try to heal the deep wounds he has incurred through his tumultuous relationship with his father. Through such stories, Agassi is constituted as fragile, vulnerable, and as having unfairly suffered from his father's overzealous ambitions. These stories of Agassi having suffered through his relationship with his father (and with tennis), are a mechanism which not only constitute his white masculinity as wounded, but this "victimized" representation of Agassi implicitly works to deny and attempt to distance him from the privileges associated with being white and male in

American society by highlighting how he has endured events in his life that have caused him to suffer.

These stories of Agassi's divorce with Shields, his decline in the men's tennis rankings, and his relationship with his father together represent Agassi's moment of hitting the metaphoric "rock bottom," a position where he is allegedly devoid of privileges of any kind. Additionally, through these stories of his efforts to undergo psychotherapy and to seek out the aid of self-help gurus (and their literature), he is constituted as a vulnerable, sensitive, and emotional white man who is not only dedicated to develop a greater awareness of himself (especially his emotions), but who is trying to foster better, more positive, caring relationships with the significant people in his life.

Yet, the stories of Agassi's personal trials and tribulations do not only portray an image of white masculinity as victimized, disadvantaged, or unprivileged. In fact, representations of Agassi's white masculinity as disadvantaged, wounded, and suffering—virtually a victimized status—are only possible because they are coupled with corresponding tales of his subsequent re-dedication to, and success within, tennis through which his extraordinary will is implicitly forwarded as the factor which enabled his personal and professional redemption.

For example, articles frequently inform readers about Agassi's outrageously difficult workout regime (Bodo, 1999; Lieber, 1996; Price, 1999; Shuster & Felsen, 2000). One aspect of this regime includes what he calls, "Death Row," a 45-minute, high-intensity aerobic workout that involves jumping on and off a series of exercise machines (Lieber, 1996). Another part of this grueling workout involves a series of about 50 sprints ranging in distance from 40 to 300 yards up a "hellacious hill" (Lieber, 1996, p. 3C). In these stories of his "vomit-inducing workouts" (Wertheim, 2001, p. 64), Agassi's white masculinity is constituted as strong, tough, superior, and as possessing an extraordinary will; and in gender terms, as a thoroughly masculinized man. Stated differently, these stories about Agassi which, in part, figure his white masculinity as wounded, suffering, and victim-like, are only able to be produced because of his on-court successes and new dedication to a professional work ethic which work together to valorize this new redeemed Andre Agassi. Likewise, this representation of Agassi's white masculinity as superior, tough, and possessing an extraordinary will inextricably relies on Agassi's suffering and allegedly disadvantaged, wounded position.

These stories of Agassi's personal and professional descent and suffering also focus on his re-dedication to his tennis—training properly, returning to the

top ten, and once again becoming a champion (defined as winning Grand Slam titles). Within these stories, Agassi's white masculinity is simultaneously coded as superior, successful, hard working, self-sufficient, and opposed to accepting unearned privileges. In fact, the phenomenal resurrection of his tennis career, which is explained through stories of Agassi's choice to dedicate himself to the game in order to really discern for himself the limits of his capabilities (to see what he could possibly achieve if he worked hard at his craft), enables him to be constituted as a white male who possesses a virtually limitless will that allows him to achieve anything to which he sets his mind. In Flax's (1998) terms, this particular rendering of Agassi's white masculinity constitutes him as the apparent embodied "truth" of the ideal liberal human American subject, a position only fully available to white males in American society, who is not constrained by social conditions or cultural ideologies but is a sovereign, self-determining, unconstrained individual who has the agency to achieve whatever he desires in life. Through these stories, a traditional image of white masculinity as superior, sovereign, in control, and unconstrained by the social is stabilized. Such an image of white masculinity is needed to reproduce and re-secure a normative cultural position for white masculinity in American culture.

Yet, within the socio-cultural context of these culturally pervasive critiques of the structural privileges afforded to white men during the 1990s, such an image of a superior white masculinity with an extraordinary will cannot be unproblematically, nor straightforwardly, produced and publicly valorized. In the era of identity politics where moral and political currency goes to those individuals and groups who can make an authentic claim to being systemically disadvantaged by American society (McCarthy, 1998b), popular forms of white masculinity in 1990s America (even up to the present really) must be encoded as unprivileged and/or disadvantaged as part of its attempt to gain political currency in order to reproduce and re-secure its normative cultural and social position. As Kincheloe and Steinberg argue, such representations of whites as victims are "a form of vampirism … [that] suck the blood of moral indignation from Blacks, Latinos, and Native Americans and use it to reposition themselves in the new racial order" (1998, p. 14).

Thus, when read together, one of the tacit pleasures of these various depictions of Agassi is that they enable him to be authentically represented as a white man who has supposedly endured strife and hard times in his life which have led him to virtually "lose it all" (thus, he is seemingly legitimately coded as lacking advantages or privileges of any kind). But, at the same time, despite its depiction as unprivileged (a potentially destabilizing and anxiety-producing

representation of white masculinity), through stories of Agassi's redemption his white masculinity is also implicitly invested in notions of personal responsibility, sovereignty, self-determination, and the disavowal of structural privileges of any kind. Through these portrayals, Agassi's white masculinity is represented both as not having privileges of any kind and as possessing an extraordinary will that is solely responsible for any "privileges" that Agassi enjoys. In other words, the ecstasy of Agassi for white America is that he has suffered, he has supposedly been transformed into a better person because of his suffering, and his response to his episode of suffering enabled the reaffirmation of the fantasy of extraordinary will and limitless agency of white men.

The Strong, Yet Sensitive Agassi

In popular press articles during the late 1990s, Agassi's white masculinity is also both feminized through depictions of him as a sensitive "new man" and hyper-masculinized via a number of stories. Such seemingly contradictory representations of Agassi's work, in this case, to constitute his white masculinity as both amenable to the new ideals for post-feminist men, while still encoding his white masculinity as sufficiently masculine and unthreatening to the historical structural privileges of being white and male in American society. In other words, Agassi's new sensitive guy persona (that is still sufficiently masculinized) is not one which threatens to invert the power relations between men and women, instead, as Pfeil (1995) comments, such representations of white masculinity are "clever episode[s] in a concerted effort to simultaneously renovate, modulate, and extend male dominance" (p. 60).

To highlight this point one can look at the attention given in the stories written about Agassi which focused on his courtship with Brooke Shields (deJonge, 1995; Higdon, 1994; Sherill, 1995). Articles discussed how the pair trepidatiously traded transcontinental emails for months, hesitantly and cautiously getting to know one another, before ever meeting one another face-to-face. They were said to have bonded over their shared need to be vulnerable and to be completely emotionally honest with one another. Also, during this time period, Shields underwent surgery on both of her feet. One *Sports Illustrated* article featured pictures of Agassi nursing Shields back to health following her surgery (Jenkins, 1994). Other stories reveal that Agassi spent many nights waiting backstage for Shields as she performed on Broadway in the play, *Grease*. In these stories Agassi is quoted as thoroughly enjoying the supportive role that he was performing in his relationship with Shields. In each of these stories,

Agassi is constituted as a sensitive, supportive, and caring (read: feminized) male who desires a loving relationship predicated on openness, honesty, vulnerability, an absence of cynicism, and mutual support of one another.

Similar depictions of Agassi are constructed in more recent stories about Agassi's relationship with his new wife, Steffi Graf. In an interview with Agassi on HBO's *Real Sports*, Mary Carillo comments that it is Agassi's "sensitivity" (Shuster & Felsen, 2000) that makes him so endearing to her. More recently, Agassi has been lauded for choosing to skip tournaments that he had been scheduled to play in order to be by the side of his mother and sister both of whom were stricken with breast cancer. In these stories, Agassi is celebrated for putting his career aside to lend emotional support to these important women in his life during this trying time. One story even noted that Agassi decided to shave his head bald as a sign of solidarity with his mother and sister when they lost their hair through chemotherapy (Tresniowski, Benet, & Trischitta, 2000; Wertheim, 2001). More recent articles on Agassi even position him, unlike many of his male tennis-playing brethren, as a proponent of women's tennis (Wertheim, 2001).

On one level, these feminized images of Agassi's white masculinity are symptomatic of the changes in the social organization of gender relations since the Women's Liberation movement of the 1960s. At the same time, it is important to recognize how Agassi's "new man," sensitive guy persona is also a white male subjectivity which may at first glance seem to resist and challenge traditional gender relations but which very often simply reproduces such relations. As Pfeil (1995) notes in his observations of some of "sensitive guy" films of the early 1990s, the sensitive white guys of these films are often portrayed in ways which simultaneously feminize and re-empower them via their "pro-women" stances. So, although this more emotional, supportive, and caring white male appears at first glance to be a refreshing new form of white masculinity that challenges traditional gender relations, this feminized "new man" sensitive white guy does not finally have to "give up power," rather he emerges "from a temporary, tonic power shortage as someone more deserving of its possession and more compassionate in its exercise" (Pfeil, 1995, p. 49). Consequently, just as Agassi's portrayal as an unprivileged white male who has suffered and consequently redeemed himself works to render invisible and disavow the continued existence of racial and gender privileges in the contemporary American social formation, Agassi's depiction as a feminized sensitive guy similarly works by making it appear as if this white male occupies a subordinate or co-equal position in his relations with women (a model of

gender relations that subverts or modifies a traditional model), yet this sensitive guy never really relinquishes his empowered subject position.

Perhaps the best example of this point is revealed in a humorous exchange between Agassi, the supposedly super-sensitive and supportive defender of women's tennis, and Carillo on the June 12, 2000 episode of *Real Sports* (Shuster & Felsen, 2000). In this interview, Carillo asks Agassi how many of her twenty-two Grand Slam trophies his new fiancée, Steffi Graf, is allowed to bring to his home in Las Vegas (they were at the time living there together). Agassi replies that she is only allowed to bring seven trophies, the number of Grand Slam titles that he has won (at that time in his career). In this humorous and seemingly benign exchange, Agassi's mutually supportive, "new man" persona is exposed as not quite what it seems, as nothing more than a posture that is unable to contain his masculinist desire to remain in a dominant position, at least athletically, in his relationship with his then fiancée.

Juxtaposed with these feminized images of Agassi's white masculinity are a set of hyper-masculinized representations of Agassi. The often-repeated stories of Agassi's incredibly strenuous workout regimes, as mentioned above, are just one of the narratives used to distinctly masculinize Agassi after 1997. He is frequently represented as not only being in the best physical shape of his career, but as being the fittest player on the men's tennis circuit. The descriptions of Agassi's on-court style of play also undergo a significant change at this time in his career. At times his play is described as a "grind it out" style (one where he is willing to wear down his opponent with long, grueling points) and as "workman-like." In a story from HBO's sport program, *Real Sports*, youths playing at Agassi's Boys & Girls Club in Las Vegas are shown marveling at Agassi's calloused hands which he pridefully describes as "working hands" (Shuster & Felsen, 2000). Such descriptions of Agassi's play were almost unimaginable early in his career (during his Generation X "slacker" days, 1990–1994). One can even discern an appreciable change in the tone of television announcers' calling of Agassi's matches after 1999. Frequently, they cannot seem to contain their pleasure in Agassi's new willingness to outwork his opponent in each match, to attempt to run down every single of his opponent's shot, and to do whatever it takes to win a point and the match. It is this newfound, full-time dedication to hard work and rigorous training off of the court which is identified as the cause of his later Grand Slam victories. Not only do these stories reinforce Agassi's extraordinary will, as discussed previously, but they also code him as a thoroughly masculinized figure that is strong, tough, and able and willing to endure the pain of this excessive training

in order to be successful on the court, which is defined as winning Grand Slam titles. Such stories articulate Agassi's white masculinity with extraordinary strength, toughness, stamina, and an iron will.

Agassi's white masculinity is also masculinized through a number of other facts and stories—he is said to drive a Humvee (popularly identified as the "muscle car of the 1990s"), he takes pride in demonstrating his athletic superiority, he finds pleasure in enduring the pain of strenuous workouts, and he even exudes enough masculine sexual appeal that he garners sexual invitations from a porn star (though he goes to great lengths to avoid meeting her despite her best efforts) (Granger, 1996). Through this peculiar story of a porn star's relentless pursuit of Agassi at a hotel where they both were staying that could be found in *Gentleman's Quarterly* magazine (Granger, 1996), Agassi's white masculinity is coded as sufficiently virile and attractive enough (read: sufficiently masculinized) to warrant the attention of an adult film actress with a healthy sexual appetite. Yet, interestingly the story also details Agassi's all-out efforts to avoid meeting this woman. Through this aspect of the story, we can discern the complex and contradictory gender dynamics at work in how Agassi's white masculinity is made public—on one hand, Agassi is figured as an appreciably masculinized, virile, and sexually attractive male, while, Agassi's fearful reluctance to even meet the woman casts him as an innocent, shy, and modest man who presumably has strong moral values, rather than one with an uncontrollable, animal-like sexual appetite who is eager to capitalize on an offer of casual "no-strings-attached" sex (read: a self-centered stereotypical, hyper-masculine white male figure). In fact, through the particular representation of this near-encounter between Agassi and this porn star, the complex and contradictory gender coding of Agassi's white masculinity, both feminized and masculinized (but always in strategic ways which preserve a positive and politically useful image of white masculinity), that takes place in media stories about him in the late 1990s gets revealed.

Through these various depictions, Agassi is rendered visible in ways which attempt to secure an image of a "sensitive guy" white male who seems to lack privileges of any sort, but who is also thoroughly masculine, dedicated to hard work and winning, and who possesses an extraordinary will—thus his white masculinity is valuable and useful for a conservative representational politics interested in producing and popularizing stories of seemingly unprivileged, innocent, sensitive, and caring white guys in order to contest the public image of white males as uncaring, guilt-ridden, oppressive, and insensitive to the fates of "others" and to systemic inequalities (Gates, 1993). This image of white

masculinity also serves to reproduce and re-secure the cultural and social normativity and dominance of white masculinity in American culture by displaying a white masculinity that reinforces and is thoroughly invested in American liberalist values. Thus, Agassi's white masculinity is made to appear to challenge and modify "traditional" white masculine norms and values, but, in this case, "image is not everything." Such an image of white masculinity is offered to attempt to make it immune to conjunctural criticisms of the abusive practices and systemic privileges of white men historically and in the 1990s. Thus, in final analysis, Agassi's "unprivileged" white masculinity that has suffered and is sensitive and almost proto-feminist, is also one which does not disrupt gender or racial ideologies, nor does it challenge the structural conditions which reproduce white male privilege in American society.

New Millennium Agassi

In September of 2005, Agassi once again surprised many within the tennis world by becoming the oldest player to reach the finals of the US Open since 1974 (when Ken Rosewall made the final at the tender age of thirty-nine). He made it to the final in dramatic fashion by winning each of the three matches leading to the finale in five sets, the best arguably being his quarterfinal match with American, James Blake, which many tennis commentators instantly billed as one of the classic matches in the history of the US Open.

The fact that Agassi was soundly outplayed by legend-in-the-making Roger Federer in the final mattered little to most American tennis commentators and fans. What did seem to matter was that Agassi, at the age of thirty-five and only able to play because he endured a cortisone shot for his ailing back in the weeks leading up to the Open, was still out there putting in the graft and competing with opponents, some of whom are nearly half of his age. In the press conference following the final, Agassi vowed to the world that he was not ready to call it quits on his tennis career quite yet. In many ways, the events of the 2005 US Open epitomize the way Andre Agassi is imagined in new millennium America.

Like his late 1990s version and early new millennium version discussed above, the theme of Agassi's personal and professional redemption still largely guides how the public is compelled to envision him. From the turn of the century to his recent retirement following the 2006 US Open, tennis commentators like Patrick McEnroe and others seem to have delighted in nicknaming this Agassi as "the grinder," the one who was more than willing to outwork and wear down his opponents with savvy, on-court shot selection and

a certain readiness to "suffer" enough during training so that he could run down the majority of his opponents shots. Agassi himself, at the twilight of his career, revealed through interviews that the challenge of playing tennis for him today was to find pleasure and pride in pushing himself to overcome his battered and beat up body to get the most out of his extraordinary talents. Absent was the undisciplined Agassi of the early 1990s who bragged about his fast-food diet and seemed almost allergic to hard work and professionalism. This wiser, elder statesman-like Agassi spoke of his keen awareness and understanding of the responsibilities to his athletic gifts, to his chosen profession, and to the sport of tennis (even as he occasionally—and with much controversy—mysteriously backed out of tournaments at the last minute, or tanked opening round matches in minor tournaments). Yet, such transgressions that received so much negative press early in his career hardly seemed to matter in the final couple of years of his career. His redemption both as professional athlete and white man enabled the discourse of his imaged identity to change dramatically so that in his final days he could be portrayed as the heroic and selfless warrior who challenges himself to live up to his personal and professional responsibilities and to provide (through his foundation) money and opportunities for those at-risk youths in Las Vegas not lucky enough to have been privileged like him to possess such athletic gifts. In fact, in 2005, Agassi allegedly ended his long-standing relationship with Nike to sign with rival, Adidas, because the latter promised to contribute money to Agassi's Foundation (which benefits his Las Vegas charter school for at-risk youth) while Nike balked at making such a contribution.

Hardly socially or economically unprivileged at this point in his life, we are still urged to like and admire this economically secure Agassi because he is a white male aware of his privileged social position who is willing to give back to those less privileged than himself. With wife and mother, Steffi, and his two kids, increasingly finding their place in media stories and several recent television commercials that have aired over the final years of his playing career, Andre has arguably become sporting America's foremost father figure and family man. No longer mainly cast as the sexy, yet rebellious tennis star who invented rock 'n' roll tennis, this Agassi is comfortably domesticated, even as his conventional white masculinity is stabilized and demonstrated by his rigorous training and ability to still win his share of tournaments even though his best playing days were years behind him.

So, through these new millennium media incarnations of Agassi we can see how even up to the final days of his playing career his imaged identity was

being employed to tell politically useful stories about white men in contmporary America. Through the totality of his athletic accomplishments (having won eight Grand Slam singles titles), his public portrayal as a good father and husband, his upward economic mobility and accumulated wealth, new millennium Agassi reaffirmed conventional ideas about white men as superior and dominant, as good providers and family men, and as economically successful. At the same time, Agassi "the grinder" who finds pleasure in the suffering of training to be the best he can be on the court and who is supposedly selflessly still playing professional tennis to give back to at-risk black youth less privileged than himself reveals the extent in which cultural efforts are still being made in the mid-2000s to manage (mask and disavow) notions of white male privilege, while providing justification for why a white male like Agassi is worthy of all the social and economic privileges he "earns" and enjoys.

In the next chapter, I turn my attention toward understanding the emergence and popularity of extreme sports in mid-to-late 1990s America. More specifically, I interrogate the conditions which have enabled these new "alternative sports" to become so popular. Additionally, I focus my attention on the images and performances of white masculinity that are produced in and through the various discursive spaces of these new alternative sports. Like my examination of Andre Agassi's white masculinity, I am interested in critically examining the cultural politics of these sports and the white masculinities promoted within particular media discourses about the extreme sports.

╬ CHAPTER FOUR

Extreme America: Interrogating the Racial and Gender Politics of Media Narratives about Extreme Sports

Introduction

> *The early 1990s seemed like the epicenter of 'toxic masculinity'… a categorical shift had occurred and it threatened bedrock concepts of American manhood.*
>
> > *Faludi (1999, pp. 42–43).*

> *So where can men go to feel like men?*
>
> > *Kimmel (1996, p. 309).*

> *Extreme athletes … with their unwavering cool in the face of extraordinary circumstances, resemble the romantic heroes of spaghetti Westerns or Indiana Jones-style adventures and thus pique the imaginations of those secretly wishing to put that Man With No Name swagger in their step—if not full time, at least for a few brief moments on Saturday or Sunday.*
>
> > *Koerner (1997, p. 59).*

The June 30, 1997 *U.S. News & World Report* cover story about Extreme sports modified the conservative pundit George Will's famous adage about baseball to proclaim, "If you want to understand America, you must know extreme sports" (quoted from Koerner, 1997, p. 56). Throughout the article, Extreme sports are introduced through dramatic images and narratives of white everymen performing supra-normal athletic feats in high-risk sporting activities like BASE jumping[1] and sky surfing. Extreme sports are also portrayed as sporting activities which have revived a set of traditional American masculine values and pursuits: rugged individualism, conquering new frontiers, and achieving individual progress. Two years later, *Time* magazine offered a remarkably similar cover story about Extreme sports (Greenfeld, 1999). Like the *U.S. News & World Report*'s story, *Time* depicted Extreme sports as activities which were resurrecting traditional American ideals, such as pushing boundaries, taking risks, always progressing, and being innovative. Both articles even went so far

as to connect the white male participants in these sports to a peculiar fraternity of American icons (both real and fictional) like William James, the American frontiersman, Indiana Jones, and the *Old Spice* sea captain.

For those who have followed Extreme sports[2] since their formation in 1995, this favorable and distinctly patriotic Americanized portrayal of these sporting activities might be more than a bit surprising. Upon their initial creation, Extreme sports were primarily imagined in American media culture as a radical new collection of non-traditional sporting activities like skateboarding, BMX bike riding, street luge, and in-line skating which were associated with a (sub-)urban street culture and performed mainly by "alternative" young white male athletes (in their teens and twenties). Extreme sports were popularly represented as the preferred sporting activities of that so-called lost, apathetic, and nihilistic younger generation of slackers popularly known as Generation X (Rinehart, 1995). In the early 1990s, this allegedly notorious X-generation, as they have sometimes been called, was demonized across American media culture as living proof of all that was said to be wrong in the United States in the early 1990s.[3] But by 1995, corporate America discovered that Generation Xers, despite pronouncements of their bleak economic present–futures, actually controlled $700 billion in individual and familial spending power per year (Greenfeld, 1998). ESPN, armed with this knowledge, created Extreme sports primarily as a means of tapping into this much-coveted young demographic and attracting them to its then fledgling station: ESPN2 (*The Economist*, 1994).

Due to these dynamics, many American sports fans and pundits initially dismissed Extreme sports as made-for-television pseudo-sports created solely to peddle products to the much-coveted teen male demographic. Additionally, these sporting activities were publicly derided as the sporting outgrowth of the short-attention spans, nihilistic desires, and aberrant world views of wayward Generation Xers (*Sports Illustrated*, 1999). Thus, the American general public's dismay of Generation X was projected onto these new and different sporting activities upon their creation. But only a few short years later, an astonishingly new image of Extreme sports was constituted in cover stories by *Time* and *U.S. News & World Report*; gone was the image of Extreme sports as suburban street activities performed by a misguided younger generation of slackers. It was replaced by a depiction of Extreme sports as adventurous activities involving substantial risks that were increasingly enjoyed by uniquely different, but "average" middle-aged white men (ranging in age from 20 to 40 years) in pristine and majestic pastoral settings. Notably, within these two mainstream magazine cover stories, Extreme sports were largely distanced from their

"Generation X" roots and dramatically re-constituted as symbols of all that was right in *fin de siècle* United States.[4]

So then, my interest in this chapter lies not in examining the lived experiences of the participants of any of the activities that have been articulated together under the term: "Extreme sports," but rather in interrogating the representational politics of this dramatic re-articulation of the American mainstream image of Extreme sports in the late 1990s as it can be evidenced through the *U.S. News & World Report* and *Time* magazines cover stories referenced above. The questions that broadly frame my inquiry are: How do we make sense of this radical re-articulation of the identities of Extreme sports and its participants on the pages of these mainstream magazines in late 1990s America? How are these "different," non-traditional sporting activities which had previously existed on the margins of American sporting culture and were largely ridiculed by the American mainstream suddenly embraced by the American mainstream and re-articulated as symbols of a contemporary reaffirmation of American ideals in the late 1990s? And finally, what sense are we to make of the concomitant "Americanization" and masculinization of these Extreme sports activities as they are mainstreamed?

In order to provide provisional answers to these questions, these representations of Extreme sports must be situated within the socio-historical context of their production. More specifically, I argue that this particular re-codification of the identity of Extreme sports and its participants must be read within a post-1960s United States context of a perceived crisis of white masculinity, where the meanings articulated with white masculinity are struggled over within various sites of American popular culture. I will also make visible the cultural politics of the white masculinity being constructed and valorized in these celebratory stories about Extreme sports, showing how these stories about Extreme sports participate in this cultural struggle over the meanings articulated to white masculinity in the late 1990s America. Stated a bit differently, I show how this masculinized and patriotic representation of Extreme sports can be read as a symptom and imagined solution to this post-1960s perceived crisis of white masculinity.

Post-1960s Crisis of White Masculinity

Many cultural observers have identified post-1960s America as a time of a crisis of white masculinity (Cole & Andrews, 2001; Davies, 1995; Faludi, 1999; Kimmel, 1996; Pfeil, 1995; Savran, 1998; Weis et al., 1997). This post-civil rights American crisis of white masculinity was produced by a historically

specific constellation of social, cultural, political, and economic forces and conditions which Savran (1998) describes as:

> the re-emergence of the feminist movement; the limited success of the civil rights movement in redressing gross historical inequities through affirmative action legislation; the rise of the lesbian and gay rights movements; the failure of America's most disastrous imperialistic adventure, the Vietnam War; and, perhaps most important, the end of the post-World War II economic boom and the resultant and steady decline in the income of white working- and lower-middle-class men (p. 5).

One of the key effects of these conjunctural forces and conditions was that they publicly illuminated the largely invisible social, cultural, psychic, and economic privileges which white men enjoy in American society. In *Stiffed: The Betrayal of the American Man*, Faludi (1999), echoes Savran's description of post-1960s America above, asserting that the social institutions which formerly revered and nurtured men and reproduced their socially privileged positions have deteriorated during this period. This perceived loss of social supports that valorize men, according to Faludi, also coincides with the rise of an increasingly ornamental culture that further feminizes men by valuing a manhood displayed (one based on a look and appearance) rather than a manhood demonstrated (based on one's achievements and civic responsibilities).

This crisis of white masculinity was also exacerbated by some destabilizing economic changes which took place in the United States from the 1970s to the 1990s. Due to the related forces of deindustrialization and globalization, the American economy underwent significant restructuring during this time period (Messner, 1997). From 1973 to 1992 white men experienced a steady decrease in their median income from $34,231 to $31,012 (Wellman, 1997).[5] According to Mishel, Bernstein, and Schmitt (1996) these poor economic trends seem to be continuing into the mid-to-late 1990s:

> despite growth in both gross domestic product and employment between 1989 and 1994, median family income in 1994 was still $2,168 lower than it was in 1989 ... [So] the 1980s trends toward greater income inequality and a tighter squeeze on the middle class show clear signs of continuing in the 1990s (cited from Fine & Weis, 1998, p. 17).

Further, these economic restructurings and poor economic climate created tremendous anxiety in many middle and working class white men during the 1990s whether they actually experienced real declines in their economic position or merely feared that they might (Faludi, 1999; Fine & Weis, 1998; Messner, 1997).

The economic fears and anxieties of many white men were expressed and magnified within a number of "paranoic" (Scott, 1995, p. 112) discourses about such things as the changing racial demographics of the United States (where it is predicted that whites will soon become the numerical racial minority) (Maharidge, 1996); affirmative action policies (popularly imagined by whites as unfairly discriminating against whites) (Wellman, 1997); or the new cultural logics of multiculturalism and cultural diversity (especially present in advertising discourse and thought to marginalize whites) (McCarthy, 1998a).[6] Such discourses were popularly read as signs of the "downward spiral of the living white male" (*Newsweek*, 1993, cited from Kellner, 1995, p. 145).

At the same time, the anxieties of many white men were further heightened by related calls to improve minority rights and to re-write American history from the bottom up not only to recognize the contributions of marginalized groups to American history but to also bear witness to the racial and gender violences, exclusions, and oppressions which were perpetrated in the process of building the United States (Giroux, 1997b). Such calls to re-write American history challenged many taken-for-granted, mainstream popular narratives, and historiographies of US history which reductively articulated whiteness with America, constituted white males as the sole or central determining agents of American history, and effectively erased the contributions of historically marginalized groups.

It was also during the 1990s that whiteness as a racialized identity became increasingly visible and "came under scrutiny by various social groups as an oppressive, invisible center against which all else is measured" (Giroux, 1997a, p. 286). Evidence of such public criticism of whiteness can be seen in *Newsweek*'s 1993 cover story titled, "White Male Paranoia." The public critique of white privilege was often directed at white males who were constituted as its embodiments (Gates, 1993).[7] Such criticisms of white male privilege left many white men feeling guilty, angry, or resentful.[8] The comments of American comedian, David Spade, excerpted from a *George* magazine article tellingly titled, "White Man's Blues" reveal not only the anxieties of many white males at this time, but also how their anxieties were too easily converted into tales of white male victimization, "I'm talking about the disadvantages of being a white guy in America. I'm sick of minorities hogging the good complaints. Whitey's been silent for too long … Whitey's been getting a constant pounding. I've been taking so many lefts, I'm begging for rights" (1998, p. 52).

**"I Want to be the Minority": Contemporary Responses
to this Crisis of White Masculinity**

During the 1980s and 1990s, symptoms of this crisis of white masculinity
ranged from the popularity of Robert Bly's *Iron John* books and his all-male,
"tribal" weekend retreats to the rise of the Promise Keepers; from the
popularization of "hard-bodied" male celluloid figures like Rambo and the
Terminator (Jeffords, 1994), to the appearance of "white males-in-crisis" films
like *Falling Down, The Fan,* and *Disclosure*; from the mid-1990s school shootings
in Arkansas, Colorado, Kentucky, Oregon, Mississippi, and Pennsylvania to
Timothy McVeigh's bombing of a federal building in Oklahoma City (Savran,
1998). These socio-cultural phenomena showcase one frequent response to this
crisis of white masculinity—testosterone-dripping displays of male masochism
coupled with rage directed at others (Savran, 1998).

During this time period a reactionary "recovery rhetoric" also formed
across a variety of sites within American media culture. This recovery rhetoric
did not assume a monolithic form but involved a variety of representational
strategies and discursive logics mobilized in complex ways. The implicit
purpose of this recovery rhetoric (whatever its form) was to protect and re-
secure the central and normative socio-cultural position of white masculinity in
the United States (Kincheloe & Steinberg, 1998). As exemplified in the
comments from David Spade above, one key strategy mobilized within this
recovery rhetoric was white males' use of the logic of identity politics[9] to
constitute themselves as the latest social victims of American society (whether
of affirmative action, of feminist and multicultural initiatives, of an increasingly
feminized American culture, etc.) (McCarthy, 1998b; Kincheloe & Steinberg,
1998).

Another reactionary strategy, as Wray and Newitz (1997) observe through
the popularity of television shows like *Roseanne, My So-Called Life, Married with
Children,* and *Grace Under Fire* and music like grunge rock during the 1990s, was
the American mainstream's seemingly insatiable appetite for images of whites
who were apparently authentically disadvantaged, unprivileged, or otherwise
"trashed" (1997). For Wray and Newitz, these representations of "trashed"
whites functioned as a popular means of disavowing the privileges of whiteness.

Similarly, Yudice (1995) observed that many whites (from all class
backgrounds) made various "claims of marginality" at this time (p. 256). By a
white "claim of marginality," Yudice means the practice of a white-skinned
person attempting to construct his/her identity in and through various codes
which signify cultural difference or a lack of economic or social privileges in
order to gain entry into the emergent multicultural system of (market and socio-

cultural) value. Yudice's observation highlights how, in the midst of the spread of cultural diversity in 1990s America—where whites were often not imagined as having a seemingly authentic place—this increase in the display of stories of authentically disadvantaged, unprivileged, and "different" whites within the mainstream media can be read as a part of a reactionary white recuperation effort to defuse the counter-hegemonic force of multicultural initiatives by constituting whiteness in codes of marginality, difference, and a lack of privilege (which are the moral and political foundation of many of these minority initiatives).

Yet, another strategy employed within backlash efforts to re-secure the privileged position of white masculinity during the 1990s was the use of populist rhetoric about returning to the traditional American values (like individualism, self-reliance, meritocracy) that the nation was founded upon and protecting American families (Giroux, 1997a). This populist rhetoric—which does not explicitly mention race, gender, or class—was often employed in the 1990s to ratify, protect, and reproduce the values, institutional structures, and social relations which reproduced the central and normative socio-cultural position of white masculinity. This populist rhetoric often portrays multiculturalist and feminist forces as threats to American families, traditional values, and the nation, all of which are coded as white (see Bennett, 1992; Sacks & Thiel, 1995 for examples of how this rhetoric operates).

Together, these representational strategies which organized images of whites all across American media culture (magazines, newspapers, popular films, radio, and television shows) implicate these texts as key instruments and effects of this white male backlash politics which attempt to deny the existence of racialized privileges of whites while masking (and thus ensuring the reproduction of) asymmetrical racial relations of power in the present. Additionally, these strategies were constituted by, and constitutive of, the cultural backlash which attempted to arrest the minimal gains made by historically marginalized groups since the 1960s (Giroux, 1997a; Kincheloe & Steinberg, 2000; McCarthy, 1998a; Savran, 1998).

It is within this politico-cultural context which this mainstreaming of Extreme sports—which involves its Americanization, masculinization, and implicit racialization—took place. Thus, in the rest of this chapter, I show how this recent re-articulation of Extreme sports as a distinctly "American" cultural activity in these *U.S. News & World Report* and *Time* magazine cover stories is not only predicated on the racial and gender dynamics of this perceived crisis of white masculinity but also reproduces the representational strategies of the

backlash politics discussed above while simultaneously offering Extreme sports and its participants as imaginary solutions to this crisis of white masculinity.

Extreme America: The Racial and Nationalistic Politics of Extreme Sports

Rodriguez (1998), drawing on the work of Nakayama and Krizek (1995), has argued that, at the level of everyday discourse, one of the ways in which whiteness obtains its largely invisible position as the un-raced social norm in the United States is through the conflation of whiteness with American-ness. Rodriguez submits that equating America with whiteness is, whether intentional or not, a policing of national identity that constructs an essentialist and stagnant view of the nation, one which contests other representations of national identity which would highlight the inevitable "messiness of overlap" in racializing America's national identity (1998, pp. 45–46). Conflating whiteness with American-ness relegates "all individuals and groups in the United States that fall outside of the white equals American paradigm to a marginal role in national life" (Rodriguez, 1998, p. 46). Even further, this strategy of representing whiteness as American-ness "downplay[s] and even remove[s] from history, and thus from memory, the way contributions by people of various races and ethnicities as well as by women and by people of varying sexual orientations have all contributed to the character of what constitutes American-ness" (Rodriguez, 1998, p. 46).

Within the *U.S. News and World Report* and *Time* cover stories about Extreme sports, whiteness (more specifically—white masculinity) and "American-ness" are conflated by articulating the predominantly white male Extreme sport participant to America via associating him with a fraternity of American masculine icons and the American mythology of the frontier. The American mythology of the frontier is invoked to produce a nationalistic narrative whereby Extreme sport participants are represented as the metaphoric offspring of the rugged white male individualists frequently imagined as founding the United States. Photos of individual white Extreme sportsmen located in natural surroundings pushing themselves to their limits are included to visually reinforce this point. The frontier which challenges, yet is ultimately conquered by, white American men is a foundational national trope which reproduces not only dominant ways of how America imagines itself, but also how American manhood is imagined. It is invoked here to articulate Extreme sports not only as a contemporary extension of this mythology but also as a contemporary site where the masculinizing practices and values of this mythology are reproduced. Both of these white male figures—the Extreme

sportsman and American frontiersman—are valorized as ideal American citizens because they are invested in a set of distinctly American values—rugged individualism, self-reliance, personal responsibility and individual/social progress. Further, the white male Extreme sport practitioner's representation as an ideal American citizen is authenticated by contending that he, like the American frontiersman, is constituted by an insatiable appetite for risk, a thirst for adventure, and a desire to be the embodiment of strength, coolness, and confidence (Koerner, 1997). In this way, the narrative constructs an unmistakable whitened, male-centered national genealogy which begins with our country's founding fathers and extends to the Extreme sport practitioner.

By articulating the Extreme sport participant with the mythic American frontiersman and forwarding them as embodiments of "traditional" American ideals, a specific image and story of America which privileges the contributions of white men (over and against the contributions of, and structural violences and marginalizations against, Native Americans, African slaves, and women) is produced. This essentialist view of America positions white males as the central and most important agents of American history (in the past and in the present). These heroic white men are the ones who have risked their lives and pushed themselves to their limits for the collective good of American society. The articulation of the white masculine Extreme sports figure with America's national identity comes at a time when changing racial demographics and multicultural initiatives have challenged the often taken for granted connection between whiteness (white masculinity) and America (Kincheloe & Steinberg, 1998; Maharidge, 1996). Cole and Andrews' (2001) discussion of Tiger Woods' portrayal as an unifying symbol of the United States' multicultural present– future, where his success (both on and off the field) is represented as a measure of contemporary America's (read: white America's) colorblindness and tolerance for cultural diversity, reveals how sport is a key terrain where the struggle over the racial identity and consciousness of the nation is currently taking place. In contrast to these portrayals of Tiger Woods as a symbol of multicultural America, we can read this celebratory discourse about Extreme sports, which casts its exclusively white male participants as the embodiments of a revival of "traditional" American values, represents a cleverly disguised version of the contemporary reactionary populist rhetoric about traditional values and the nation which re-secures and privileges the articulation of white masculinity with America within what McCarthy (1998) calls, "the Age of Difference, the Multicultural Era" (p. 339).

Constituting America's ethos as being founded upon a proclivity for risk and adventure in and through this Extreme sports discourse may seem

innocent and apolitical at first glance, but when one looks more closely, this whitening of American national identity resonates with other contemporary reactionary efforts like the rhetoric of Rush Limbaugh (Giroux, 1997), the White Patriot movement, and the rise in the White Supremacist movements (McCarthy, 1998). In each of these sites, attempts are made to reclaim a whitened image of America by representing white males as America's authentic and most important subjects over and against these other emergent multicultural and non-white representations of American national identity being produced in late 1990s America (see Berlant, 1996; Cole & Andrews, 2001).

The Return of "The Man": Extreme Sports Participant as White Masculine Ideal

Within this alleged crisis of white masculinity, Extreme sports are constituted in these cover stories as a masculinizing practice where white male participants can experience a set of affective and bodily pleasures which allow them to reclaim a masculinity which they feel has been lost. The crisis of white masculinity is implicitly signified in these stories by depicting American culture as a feminized "scaredy-cat culture ... that seems hell-bent on expunging risk from every aspect of life," and by constituting men (at least those who do not participate in Extreme sports) as feminized subjects experiencing excessive worries about waistlines and corporate bottom lines due to pervasive cultural and economic conditions (Koerner, 1997, p. 56). Set within this context, Extreme sports are tacitly celebrated as an imaginary solution—a masculinizing corrective—to the apparent cultural feminization occurring with American white men in the 1990s. Extreme sports are said to appeal to those white men who "secretly wish to put that Man With No Name swagger in their step—if not full time, then at least for a few brief moments on Saturday or Sunday" (Koerner, 1997, p. 59). Extreme sports are also implicitly figured (through the absence of women[10] and people of color) as a racially and gender exclusive place, what Kimmel (1996, p. 309) calls a "homosocial preserve," where (white) men can un-apologetically perform an ideal masculinity which they covet by taking death-defying risks, enduring the pain of participation, and displaying an unwavering confidence and coolness in the face of apparent danger. Additionally, through the valorization of the unusual and extraordinary athletic feats which they perform, these white males are portrayed as extraordinary and exceptional individuals who are, different from, and superior to, anyone not willing to attempt such potentially dangerous athletic exploits.

In subtle contrast to the familiar sensitive, apprehensive, and appearance-oriented (read: feminized) "new man" (Kimmel, 1996), the Extreme sportsman

is forwarded as an exemplary white masculinity deserving of mass cultural admiration because he is represented as in control, confident, unconstrained, superior, and sovereign over himself (Flax, 1998). For example, through performing athletic feats (like BASE jumping, extreme skiing,[11] and mountaineering[12]) where he risks his health and safety by staring death right in the eye, he is displayed as possessing an extraordinary (imagined) sense of control over himself and his environment. It is this sense of control which American cultural definitions of white masculinity (oriented by liberal-humanist discourses) have taught white males that they are entitled to in their everyday lives. Perhaps then, the attraction of Extreme sports for many white men in this era of their perceptions of "falling down" (economically) and being unfairly constrained by women, people of color, and gays and lesbians via the edicts political correctness is that they provide an opportunity for these men to satisfy an inarticulable desire (yet one which I contend many white men "feel") to experience a sense of control over themselves and their surroundings during a historical moment when this sense of control has been compromised by changing socio-historical conditions. Since the Extreme sport participant is one of only a few who are willing to participate in such dangerous athletic endeavors, his participation produces a sense of superiority or extraordinariness about himself in relation to others not willing to take such risks.

These sentiments are best represented in *Time*'s description of the feelings of a BASE jumper just prior to his jump and immediately after successfully touching down on the ground:

> He [the Extreme sports participant] prays that his parachute will open facing away from the dam, that his canopy won't collapse, that his toggles will be handy and that no ill wind will slam him back into the cold concrete … When he lands … he hurriedly packs his chute and then … lets out a war whoop that rises past those mortals still perched on the dam … It's a cry of defiance, thanks and victory; he has survived another B.A.S.E. jump (Greenfeld, 1999, p. 29).

Clearly, the experience of BASE jumping is represented as an opportunity for a person to test one's fate against the gods. But once the risky athletic endeavor is completed successfully, the participant is able to claim a "god-like status" for himself and sense of superiority over others (remember, he is immortal in relation to "those mortals still perched on the dam") (Greenfeld, 1999, p. 29). Thus, the article's description suggests that participation in such dangerous and "Extreme" sports, provides men with a practice where they can satiate a desire to demonstrate an ideal masculinity within an era where it is imagined that there are fewer opportunities to do so.

The appearance of this particular story about Extreme sports in mainstream non-sporting magazines participates in a broader-based cultural valorization (one that transcends the boundaries of sport) of an ideal American white masculinity constituted through this depiction of the Extreme sportsman—a white masculinity that is strong, brave, sovereign, demonstrably superior, and in control of himself—within this era of a perceived crisis of white masculinity. This transcendent cultural valorization of this white masculinity is further reinforced through the peculiar inclusion of subsections within the *Time* article which feature individuals (all of whom, except one, are white males) who are not necessarily Extreme sportsmen (firemen, neurosurgeon, options trader, etc.), but who are said to embody the masculine characteristics and values being lauded through this cover story about Extreme sports. In one subsection, the story of a New York City fire fighter is mobilized to articulate Extreme sports with a heroic white masculinity that sacrifices "for the greater good [of society]":

> I was in the Marines in Vietnam, and fire fighting is like war. If a life is in there, you go in, you get 'em out—even when it's black and smoky, your body's burning up and you're fighting the natural urge to run. The F.D.N.Y. [Fire Department of New York] trains you to be aggressive and hypervigilant, not to take stupid risks. We don't do this for sport or for thrills or money. You're risking your life to save somebody. That's what makes this job special. We take risks for the greater good (Greenfeld, 1999, p. 34).

In another, the first disabled person to climb Yosemite's El Capitan (he was paralyzed in a previous climb) is valorized for his optimism, his determined unwillingness to be limited by his disability, and his exceptionality for continuing to climb despite his disability. Finally, another subsection in *Time* on an Extreme skier who was caught in an avalanche while filming an extreme skiing video celebrates his extraordinary agency and his ability to keep control of himself which enabled him to survive seemingly certain peril (Greenfeld, 1999, p. 34). Each of these stories highlights the agency, bravery, strength, unwillingness to be constrained, willpower, sacrifice, and exceptional abilities of these white male individuals, while they also assert the value of these individuals to the optimal functioning of society. Together, the stories are seemingly included to develop a sense of awe and reverence of these conspicuously white and male "extreme" individuals while they simultaneously constitute the Extreme sport participant as a supra-normal individual who is not only a hip, unique, and "different" individual (the dominant way in which Extreme sports figures are imagined), but is, more importantly, *exceptionally* different from and superior to the average American subject.

The Invisible Man: Public Criticisms of Whiteness, White Desire(s), and the Mass-Mediated Extreme Sports' White Masculinity

We must also situate this mainstream valorization of the white male Extreme sportsman within the context of a 1990s America where whiteness as a racial identity and its structural privileges were increasingly being made visible and undergoing criticism, even in the world of sport (see Price, 1997).[13] Situated within this context, an implicit appeal of Extreme sports is that they offer a cultural space that is overwhelmingly white, yet is rarely ever imagined as a racially exclusive space. In crude terms, Extreme sports is constituted largely as a white sporting fraternal order where membership is predicated on one's investment in recovering an ideal *white* masculinity (one that is absent of any obvious, visible signs of material privilege). In this way, Extreme sports, as they are portrayed in these articles, implicitly serve the interests of a reactionary white male backlash politics by providing a space/practice where white men can not only strengthen their relations with one another, but where, as argued above, they can re-imagine themselves as superior and extraordinary subjects. In fact, in their de facto racial exclusivity, Extreme sports seem to share a bit in common with other reactionary men's groups of the 1990s like the Promise Keepers and Robert Bly's "Iron John" contingent, as well as, the White Patriot and White Supremacist movements mentioned above.

But, as mentioned earlier, Extreme sports are also portrayed in these articles as activities which satiate a male desire to put that "Man With No Name swagger" back in their step (Koerner, 1997, p. 59). In racial terms we might read this desire as a defiant reaction by white men (though one which they probably would not—or could not—articulate) to the increasing visibility of whiteness during the 1990s and the subsequent constraints that having their whiteness made visible and particularized (as opposed to being understood as the "universal human subject") places on them as racialized subjects. This desire to evade the constraints imposed by the increased public marking of whiteness is also evidenced in the representation of Extreme sports as an activity which provides "an outlet for the kind of creativity and individual expression often squashed in a homogenising culture of chain stores and minimalls" (Koerner, 1997, p. 58). Of course, this desire to evade racial categorization (where white masculinity is increasingly publicly imagined as always already privileged, oppressive, uncaring, and dominant) cannot be abstracted from the multicultural age of difference from which it emerged (McCarthy, 1998), nor from a cultural context where a pervasive essentialist public equivocation of whiteness with economic and social privilege was prevalent. The desire for individual expression and creativity associated with

Extreme sports can be read as an aspiration to evade the homogenizing effect (experienced by whites as a new social constraint) and derogatory characterizations which the increased visibility of this notion of whiteness places on these white men.

At the same time as this desire to be a "Man With No Name" expressed in one of the cover stories about Extreme sports can be read as a symptom of, and reaction to, the pervasive public criticisms of white masculinity going on during the 1990s. Extreme sports, through the overwhelmingly whiteness of its participants (as well as, its norms and values), simultaneously provides a space/practice where whiteness operates as the unspoken norm (thus, is rendered largely invisible) so that the white male participants are not constrained by its categorical logics. Perhaps then, this popular mainstream celebration of Extreme sports is at least partially grounded in the way that Extreme sports provide a seemingly authentic white cultural space and practice for white men where they can also temporarily escape an American social context rife with public criticisms of white male privilege and a concomitant need to be cognizant of, and sensitive to, issues of cultural difference.

Ironically, the overwhelmingly white and male cultural space/practice of Extreme sports also offers its participants a cultural space/practice where its largely white male participants can simultaneously cultivate (and be read as) a seemingly different, marginalized, and unprivileged white masculinity. This depiction of the white masculinity of the Extreme sports athlete as different and unprivileged is made possible by the often-repeated notion of Extreme sports as activities existing on the margins of the professional American sporting landscape (defined in relation to basketball and football which are implicitly represented as the central and prominent sports of 1990s American culture, as well as, sports dominated by African Americans to the imagined exclusion of whites[14]). Additionally, the values, norms, and ideologies of these "alternative" sports are constituted as new, unique, and different from mainstream sports like football, basketball, and baseball which are linked with a set of values described as boring and traditional.[15] Consequently, the apparent cultural difference and lack of privilege of the white male Extreme sportsman is achieved and authenticated by Extreme sports' marginal position within the professional American sports formation. Additionally, the frequent articulation of many of the sports which make up Extreme sports with the anti-establishment ethos of the 1960s, further solidifies the alternative and seemingly unprivileged character of the Extreme sportsman's white masculinity. Once we recognize how the Extreme sportsman's white masculinity is also coded through signs of difference and an apparent lack of any sort of socio-

cultural or economic privilege we can read this white masculinity as an effort to distance and differentiate it from the image of white masculinity as always already privileged, oppressive, and dominating that organized many popular modes of imagining white men during the 1990s. Following Wray and Newitz (1997) these images of seemingly different, alternative, and unprivileged white guys within Extreme sports implicitly function, like other images of other "trashed" whites, as seemingly authentic "evidence" of white non-privilege which is used to disavow and deny the existence of structural white privileges. Thus, this mainstream representation of white male Extreme sports participants as unique and "different" individuals, and Extreme sports as an alternative, non-traditional, marginalized sporting practice, can be understood, in Yudice's (1997) terms, as an example of a cleverly disguised white masculine "claim of marginality."

Conclusion

Through this chapter I have offered a provisional attempt to make sense of the American mainstream's embracing of Extreme sports in the late 1990s as it was registered in the *U.S. News & World Report* and *Time* cover stories (Greenfeld, 1999; Koerner, 1997). I have rendered visible the complex and overdetermined constellation of social, cultural, and political forces that are responsible for this popular valorization of Extreme sports. My analysis has pointed out the identities, values, and desires being endorsed through the mainstream press' praise of Extreme sports as the symbol of a new American zeitgeist (understood as the revival of traditional American values like individualism, self-reliance, risk-taking, and progress) at the end of the 1990s. Namely, I have argued that Extreme sports are celebrated in these cover stories because they enable the apparent return of strong, confident, superior white men who are seemingly in control (of themselves and their environs) and no longer paralyzed by feelings of anxiety, uncertainty, resentment, and paranoia. The white masculinity of the Extreme sports performer is, paradoxically, positioned both as different, marginalized, and unprivileged and as a supra-normal white masculinity. This complex and contradictory depiction of the identity of the Extreme sportsman enables the disavowal of white privilege, while it simultaneously allows the resurrection and mainstream celebration of a superior and privileged white masculinity. Additionally, within this era marked by increasing multicultural images of America, this discourse about the overwhelmingly white Extreme sports re-articulates and attempts to naturalize the link between whiteness and America. In each of these ways, this specific mainstream discourse about Extreme sports implicates these sporting activities

as an important cultural site that is produced by, and productive of, the perceived crisis of white masculinity and the representational strategies and cultural logics of the recovery rhetoric of white male backlash politics.

'I Want to Be the Minority': The Politics of Youthful White Masculinities in Sport and Popular Culture in 1990s America

Introduction

> I'm talking about the disadvantages of being a white guy in America. I'm sick of minorities hogging the good complaints. Whitey's been silent for too long ... Whitey's been getting a constant pounding. I've been talking so many lefts, I'm begging for rights.
>
> *Spade (1998, p. 52).*

> It is also the era of the multicultural. And the challenge of this multicultural era is the challenge of living in a world of difference. It requires generating a mythology of social interaction that goes beyond the model of resentment that seems so securely in place at these times...Indeed, as the purveyors of "white reign" assert themselves, they simply underscore their own vulnerabilities and fragilities.
>
> *McCarthy (1998a, p. 339).*

As I search the radio for background music to facilitate my writing process, I tune into Green Day's latest release, "Minority." For the uninitiated, Green Day is a West Coast punk band whose music was surprisingly embraced by the pop music mainstream in 1995. Characteristic of punk music, Green Day's music, is fast, hard, and defiant. Yet, many of its songs, particularly those that have received airplay on mainstream radio stations and MTV, are also distinguished by great melodies and infectious choruses. "Minority," Green Day's first song on their new CD, features a catchy tune that invites listeners to bob their heads and sing along with the chorus: "I want to be the minority." Since its release, the song has regularly appeared on MTV's show, *Total Request Live,*[1] an unofficial measuring stick of what's popular with America's teens.

As I listen to Green Day's song, I contemplate the seemingly peculiar particularity of a punk song performed by three young, white guys proudly proclaiming a desire to be "the minority."[2] In all honesty, I am not that

surprised that such a song would find its way into mainstream pop music radio stations and MTV in 2000. "Minority" was preceded in the 1990s by the popularization of "alternative" music (grunge rock, indie rock, and 1990s punk, to name a few). Perhaps the most notable and unifying elements of alternative music are its performance and consumption by whites, particularly white males, and its appropriation of language and imagery associated with "working class and underclass white cultures" (Newitz, 1997, p. 146).[3] Green Day's anthem can be located within this 1990s popular music context in which we hear a number of songs by white male artists who express a desire for alterity and make claims of being disadvantaged and victimized. But, as the alternative music trend lost some of its momentum in the late 1990s, the popularity of Green Day's "Minority" demonstrates that in the new millennium, there is still a market and demand for songs by white male bands expressing sentiments of being victimized and ill treated.

Alternative music represents just one of the several sites of contemporary American popular culture in which one encounters images and narratives of victimized young white males. In this chapter, I examine such images and narratives of disadvantaged young white males as they are produced in a number of best-selling books that address the social–psychological development of adolescent boys written in the wake of the rash of school-shootings perpetrated by young white boys in 1997–1998 (Garbarino, 1999; Gurian, 1997; 1998; Pollack, 1998), and a 1997 *Sport Illustrated* cover story titled, "Whatever Happened to the White Athlete?" which offers a panic-driven tale about the declining position of white male athletes in American professional and high school sports (Price, 1997). My aim is to offer a contextualized cultural analysis of these discourses that explains how their representations of "youthful" victimized white males are not only constituted by, constitutive of, the representational strategies of 1990's white male backlash politics but signal a new inflection of these representational strategies. My project draws on David Savran's (1998) observation that the 1990s marked "the ascendancy of a new and powerful figure in US culture: the white male as the victim" (p. 4). But unlike Savran's work, which ignored the context of American sports and focused on older white masculinities that largely conform to the biographical dimensions of the baby boom generation, my study examines more white masculinities produced both within and outside of the context of American sports. Building on Sarvan's work, I contend that these representations of disadvantaged and victimized youthful white masculinities signify a new representational strategy of white male backlash politics—the youthification of the "white males as victim" trope. I highlight the youthful character of these

white masculinities for a couple of reasons. First, I use the term *youthful* because the ages of the representations of white masculinities that orient this study range from adolescent boys to twenty-something professional athletes. Second, within the discourse I examine, there is frequent slippage back and forth between the use of terms like *boys* and *young males* and *males* or *white males*, suggesting that these images and narratives about young white boys/males signify something more than that just innocent stories about disadvantaged (white) boys (namely, they serve to deny and disavow the privileges of being white and male not only in *fin de siècle* America but also in the future as we move into the new millennium). Finally, I use the term *youthful* to signify how these texts use the term *boys* and *youth* in ways that are meant to invoke connotations of innocence, lack of constrains, and hope for the future. Such innocent images of young white boys become political when they are produced within a post-Columbine context in which the violent practices of at least a few young white boys complicate such an articulation between innocence and youthful white masculinity.[4]

At first glance, these seemingly unrelated sites of American popular culture, the discourse on the development of adolescent boys and a *Sports Illustrated* report about the disappearance of a white majority within American professional sports, would not seem to share very much in common. But, through my analysis, I articulate these sites together as localities of the national-popular involved in the production of images and narratives of victimized and disadvantaged young white males that both reflect, and reproduce, the discursive logics of the contemporary white male backlash. By making connections between these popular sites, one that exists outside of sport and the other within sport, I highlight the pervasiveness of this strategy of representing young white males as vulnerable, victimized, or otherwise disadvantaged subjects. I am interested in these seemingly banal sites of popular culture (what Berlant (1997) called the "waste material of everyday communication," (p. 12) because they are the places where conservative backlash ideologies that seek to re-conceal, protect, and re-secure the representational and material privileges of white masculinity are being translated into a "non-ideological" and "common-sense" viewpoints, and where they are learned and mobilized by real social actors to make sense of their everyday lives (Kellner, 1995).

On Whiteness

whiteness is ... intimately involved with issues of power... [and] profoundly influenced by demographic changes, political realignments, and economic cycles. Situationally

specific whiteness is always shifting, always reinscribing itself around changing meanings of race in the larger society.

<div align="right">Kincheloe and Steinberg (1998, p. 4).</div>

To illuminate the politics of these "victimized" youthful white masculinities, my analysis is theoretically informed by the recent critical scholarship on whiteness that has been produced across a wide range of disciplines including literary studies, sociology, history, speech communication, and cultural studies (Frankenburg, 1997). This contemporary interest in examining whiteness is, following Dyer (1988), a response to the fact that critical studies of race have tended to focus on historically marginalized racial and ethnic groups, thereby overlooking whiteness "as if it is the natural, inevitable, ordinary way of being human" (p. 6). In an effort to denaturalize the idea of whiteness as the "privileged place of racial normativity," these critical studies of whiteness have viewed it as a social construction rather than as a "natural" biological category (Wray & Newitz, 1997, p. 3). Such a social constructionist view of whiteness emphasizes that its meanings are produced by "socially and historically contingent processes of racialization, constituted through and embodied in a wide variety of discourses and practices" (Wray & Newitz, 1997, p. 3). In addition, the meanings of whiteness are understood as always being intimately constituted by and constitutive of relations of power (Kincheloe & Steinberg, 1998).

Critical readers of whiteness also have pointed out that the discursive and social power of whiteness resides, at least partially, in its ability to be both everything and nothing (Dyer, 1988; Nakayama & Krizek, 1995). Nakayama and Krizek (1995) suggested that "whiteness makes itself visible and invisible, eluding analysis yet exerting influence over everyday life" (p. 293). Keeping with the tendency of whiteness to be invisible, Aanerud (1997) argued that it is important to read whiteness into texts that are not explicitly about race if one is to disrupt whiteness as the unchallenged racial norm. Shome (1996) reinforced this point by arguing that the goal of critical whiteness research is to expose and illuminate "the everyday, invisible, subtle, cultural and social practices, ideas, and codes that discursively secure the power and privilege of white people, but that strategically remain unmarked, unnamed, and unmapped in contemporary society" (p. 503). This recent research on whiteness also illuminates that whiteness is not a monolithic, unchanging, and fixed category that always already embodies a certain set of meanings within any and all cultural spaces (Kincheloe & Steinberg, 1998). The exemplary historical studies on whiteness done by Roediger (1994; 1999), Allen (1990), Nelson (1998), and others have

illuminated the historical contingency of the meanings of whiteness. Also, Hartigan's (1997a) ethnographic work on the meaning of whiteness for poor whites in Detroit in the 1990s—a space where whiteness is not equated with economic or social privilege called attention to the fact that within a specific historical moment in the United States, multiple forms of whiteness always exist. Thus, whiteness cannot be understood in an essentialist or overly reductive manner that obfuscates the polysemic, contingent, and dynamic characteristics of whiteness—how whiteness is inscribed with different meanings within various cultural spaces and historical moments. Critics of whiteness must be aware of how whiteness always already interacts with such things as gender, class, nation, generation, age, and sexuality, thereby inflecting the meaning of whiteness in subtle ways (Kincheloe & Steinberg, 1998).

Given its multiplicity, the meaning of whiteness within a specific historical era can even be conflicting and contradictory. Critics of whiteness have keenly pointed out that these conflicting and contradictory meanings of whiteness facilitate the hegemonic force of whiteness. As Davy (1997) argued, whiteness has the capacity for "a number of sometimes conflicting ideologies used differently and differentially depending on the historical needs of white control. Whiteness is not totalizing force, but one which changes and shifts in response to historical conditions" (p. 213). Davy's point here highlighted the need to recognize that the internal contradictions and conflicts of representations of whiteness often mask the insidious and not so obvious ways in which the normative position of whiteness in American culture is reproduced. Thus, one must be particularly attentive to the ways in which constructions of whiteness as unprivileged, victimized, or otherwise disadvantaged—images that seem to contradict the ideology of whiteness as privileged—can work in a particular context as a mechanism to re-secure the privileged normativity of whiteness in American culture. Taken together, this recent research on whiteness highlights the need for critical studies of whiteness that are conjuncturalist in their approach and that seek to make visible the discourses, practices, and material conditions that produce discourses of whiteness (and that very often render it invisible and hide its dominating effects). With these points in mind, I turn my attention towards outlining the specific historical and cultural conditions of post-1960s' Americans that implicitly figured the victimized youthful white masculinities that were constructed in a number of books about the development of boys and *Sports Illustrated*'s "crisis" narrative about the position of the white athlete in American professional sports.

Representational Politics of White Masculinity in 1990s America

> You cannot understand an intellectual or artistic project without also
> understanding its formation: that the relation between a project and a formation
> is always decisive; and that the emphasis of Cultural Studies is precisely that it
> engages with both, rather that specializing itself to one or the other
>
> Williams (1997, p. 168).

Post-1960s America has been marked by a conservative backlash politics that, on one front, sought out to arrest the scant gains that historically marginalized groups (women, people of color, gays, and lesbians) have made since the 1960s (Giroux, 1997a; Savran, 1998). Savran identified a number of forces of this time period that have produced this conservative backlash:

> The reemergence of the feminist movement; the limited success of the civil rights
> movement in redressing gross historical inequities through affirmative action legislation:
> the rise of the lesbian and gay rights movements: the failure of America's most
> disastrous imperialistic adventure, the Vietnam War: and, perhaps most important, the
> end of the post-World War II economic boom and the resultant and steady decline in
> the income of white working- and lower-middle-class men (1998, p. 5).

As these changing historical made visible the structural privileges of white masculinity in the United States, they simultaneously engendered a crisis of identity for a number of American white males (Weis et al., 1997; Wellman, 1997). Popular symptoms of this crisis are the appearance of television shows like *Men Behaving Badly* and *Becker*,[5] the popularity of Robert Bly's "Iron John" stories and the Promise Keepers, the rise of white militias epitomized by Timothy McVeigh bombing of the Oklahoma City federal building, and the resurgence of white supremacist groups like the Ku Klux Klan (Faludi, 1999; Kimmel, 1996; Savran, 1998). Amidst this growing anxiety among a number of white men, a conservative backlash politics developed that used a number of strategies to re-secure the structural privileges of white masculinity just as it simultaneously disavowed the existence of these privileges.

This conservative backlash politics was underpinned and motivated by specific race- and gender-based interests. For example, the main mouthpieces and figureheads of backlash discourses are white men like radio personalities Rush Limbaugh and Bob Grant, or columnist Mickey Kaus (Giroux, 1997a), or even fictional figures like D-Fens, from the immensely popular early 1990s film, *Falling Down* (1993). Consequently, I re-name conservative backlash politics as "white male backlash politics." By white male backlash politics, I mean those images, representations, and discourses that are currently being deployed in

American culture in a symbolic (and material) struggle over the meanings articulated with white masculinity in the United States (McCarthy, 1998b).

Backlash politics particularly intensified during the 1980s with mean-spirited discourses about welfare, drugs, and crime, which demonized African Americans (particularly young males, single moms, and welfare recipients) and represented their social problems as individual shortcomings and deficiencies. Such discourses blame already vulnerable minority populations for their economic and social difficulties and disadvantages while obscuring the devastating effects of the economic policies of Reaganism and deindustrialization on these groups (Cole, 1996; McCarthy, 1998b; Reeves & Campbell, 1994). In the early 1990s, widely reported struggles over the academic canon, affirmative action, multiculturalism, illegal immigration, and English-language-only legislation became the key sites of this white male backlash (Kincheloe & Steinberg, 1998, p. 11).[6] Within each of these struggles, the combatants were largely divided along racial lines between whites and people of color. At stake in these debates were whether to extend or contain the rights given to these marginalized social groups (Giroux, 1994, pp. 29–30), and whether white males would bear witness to (and rectify) the racial and gender-based injustices that occurred in the United States in the past and those that persist in the present. Historically marginalized groups—namely, people of color—used a strategy of identity politics[7] in an effort to demand their inclusion as full American citizens economically, culturally, and politically. Within the logic of identity politics, minority subjects (women, people of color, and gay and lesbians) took the offensive by arguing that their oppressed and marginalized positions were a direct result of the privileged position of the dominant groups of the United States (whites, males, heterosexuals).

One notable change within these backlash offensives of the 1990s was that whiteness—or more often white masculinity—was increasingly marked publicly as the "oppressive, invisible center" of the American social formation (Giroux, 1997a, p. 286). This public scrutiny of white masculinity as always ready dominating, oppressive, insensitive, and uncaring is exemplified in a 1993 *Newsweek* cover story titled, "White Male Paranoia," which announced that "feminists, multiculturalists, P.C. policepersons, affirmative action employers, rap artists, Native Americans, Japanese tycoons, Islamic fundamentalists, and Third World dictators, [are] all ... saying the same thing [about white males]: *You've been a bad boy*" (Gates, 1993, p. 48).

In response to these critiques of white masculinity, a conservative backlash formed that took issue with this construction of white masculinity as oppressive, dominant and dominating, uncaring, and socially and economically

privileged. American media culture (television shows, mainstream Hollywood films,[8] popular music, and talk radio[9]) became an important terrain that never simply reflected such backlash narratives but was instrumental in producing and disseminating the logics and key figures constitutive of white male backlash discourses. Figures like Rush Limbaugh and D-Fens became frequently cited popular embodiments of a new simulated figure, the "angry white male" (Gates, 1993). The cultural function of the simulated angry white male was that it enabled the rage and resentment of white males embittered by the public criticisms of white masculinity to be conveyed publicly. Yet, this repressed rage and resentment, expressed in simulated angry white males[10] like D-Fens, simultaneously allowed such derogatory sentiments to be disavowed by "real" white males as an exaggerated representation of their feelings.[11]

But the angry white male was not the only representational strategy employed by the white male backlash. In fact, this conservative backlash reconfigured white masculinity in a number of ways to contest the emergent view of white masculinity in the 1990s as always already dominant, privileged, and oppressive. One very prominent strategy constituted white men as the besieged victims of the 1990s American social formation. This strategy of constructing white men as victims exemplified how whites could also engage in identity politics (McCarthy, 1998b). This strategy also involved a measure of fantasy. For example, affirmative action programs were imagined as having unfairly slanted the economic playing field against white males despite plenty of sound information that clearly proved the economic advantages that white men still enjoyed in the 1990s (better pay, more opportunities, and lower rates of unemployment) (Wellman, 1997). This strategy of constructing white males as victims is deeply problematic because it requires a "socio-historical amnesia" that refuses to bear witness to the histories of racial and gender inequalities in the United States, as well as the cultural, economic, and political privileges that white men still enjoy in the present (Kincheloe & Steinberg, 1998, p. 13).

Another representational strategy used by white male backlash politics of the 1990s is the use of a populist rhetoric that, without explicitly mentioning race or gender or class, implicitly reproduces and protects the practices, institutional arrangements, and social relations that enable the central and normative position of white masculinity to be produced. The racial and gender politics of this project are very often expressed through rhetoric about protecting families, the nation, "traditional" American values, and individualism (Giroux, 1997c). This populist rhetoric is often employed to portray multiculturalist and feminist forces and discourses as threats to the values,

practices, and social relations on which American families, traditional values, and the nation are said to have been founded.

It should also be noted that the white male backlash was particularly effective in interpellating many white men to its ideologies because of the economic anxieties that many middle- and working-class white men were experiencing in the 1980s and into the early 1990s (Fine & Weis, 1998). These anxieties were produced by the globalization of many American corporations; the flight of high-pay manufacturing jobs with good benefits overseas, replaced by low-pay service industry work with little or no benefits; as well as the development of new computer technologies that eliminated (or threatened to eliminate) many white-collar, middle-management positions. From 1973 to 1992, the median income of white males decreased steadily (from $34,231 to $31,012) (Wellman, 1997, p. 315). Unable to make sense of their loss of work or declining or stagnating wages, the rhetoric of the white male backlash offered a variety of narratives that blamed the economic woes of "hard-working Americans" (read: white males) on a host of racially and gender-coded scapegoats. Again, affirmative action programs were offered as a scapegoat. These programs, created to remedy the long history of structural inequalities and institutionalized discriminatory practices against women and people of color, were strategically (mis-)represented as the sources of white men's declining or stagnating economic circumstances. Such (mis-)representations also masked how post-Fordist processes of deindustrialization or the laissez-faire US economic policies of the 1980s had significantly contributed to the declining (or stagnating) economic fortunes of American white men. Even further, these conservative backlash narratives concealed how the decline in white mens' median incomes did not mean any deterioration (by any measure) of their economic advantage over non-whites and women (Wellman, 1997). In fact, Wellman provides evidence that, since 1973, women and non-whites have experienced relatively similar declines as white men in their median incomes. Consequently, the main effect of these strategic (mis-)representations offered by the white male backlash is that they turned white men's economic fears and anxieties (whether real or perceived) into a rage directed at women and people of color. In this case, racism and sexism became the conduits through which many middle- and working-class white men's feelings of rage and resentment were (re-)directed away from perhaps a more appropriate source for their anxieties—corporate America and their global, late capitalist policies (McCarthy, 1998a). Xenophobic desires were produced and legitimated to stave off any white-on-white, class-based conflict between white "haves" and "have-nots."

The creation and repetitive presence of these backlash representational strategies are part of a broader trend in which mainstream American popular culture developed a seemingly insatiable appetite for representations of non-normative, de-privileged whites (whether in racial or economic terms) and even "trashy" white figures (many of whom are male) (Hartigan, 1997b; Newitz, 1997; Newitz & Wray, 1997). Hartigan (1997b) argued that the generation of these "bad images of whiteness" are symptoms of the way in which the meanings ascribed to racial categories have changed due, at least in part, to the criticisms of whiteness ushered in by the identity movements of the late 1960s (p. 325). Meanwhile, Newitz and Wray (1997) offered two primary reasons for the appearance of stories about white trash in American popular culture during this time period. On one hand, they contend that white trash can function as a politically conservative protest against so-called multiculturalist agendas such as affirmative action, revisionist education, and social welfare programs (p. 173). Alternatively, the proliferation of representations of white trash might signify "the first wave of assimilation to multiculturalist identity … [by] articulating racial dis-empowerment and whiteness together" (p. 173). Although I would optimistically like to believe the latter view, I think Newitz and Wray's former point more accurately captures the political/cultural function of these images of white trash—or, more generally, of whites who are coded as unprivileged, disadvantaged, victimized, or somehow "trashed" victims—they serve as a means of denying and disavowing the structural privileges of whiteness that have come under attack in the past decade.

Building on Hartigan's (1997b) and Newitz and Wray's (1997) findings about 1990s American culture, I have observed a number of popular films of the mid- to late-1990s that feature disadvantaged or otherwise unprivileged youthful white male figures that have been constituted by, and constitutive of, the discursive logics of the white male backlash politics. Mid-to-late 1990s films like *Good Will Hunting, Gattaca, Great Expectations*, and even *Titanic* offered narratives that featured young white males whose lack of social, cultural, economic, or genetic privilege (in the case of the futuristic film *Gattaca*, in which genetics determined the class structure of that society) is a central and featured aspect of their identity. Unlike an angry white male figure like D-Fens, American film audiences were asked to like and identify with these youthful, and seemingly unprivileged, white male protagonists. The narratives of these films could be aptly described as contemporary versions of an Horatio Alger-like upward mobility tale. In each of these films, the white male protagonist is represented as coming from unprivileged origins but is able to transcend these origins because of his superior innate capabilities and extraordinary will.

Another key aspect of these films is that they highlight class (or genetic) differences within whiteness in ways that allow the protagonist's social advantages of being white and male to be effectively overlooked by many viewers of the film. By focusing on class differences, and by offering representations of likable, lower class (and otherwise unprivileged), young white male protagonists, these films signal a trend in which white viewers are interpellated to identify with unprivileged youthful white male subjects. At the same time, the protagonist's explicit lack of social and economic privilege opens a space where white viewers could use the film as evidence to disavow the social and economic privileges of whiteness and masculinity.

I take time to briefly discuss these films because their representations of disadvantaged young white masculinities are resoundingly similar to the constructions of young white masculinities in the discourse about the development of adolescent boys and *Sports Illustrated*'s special report on the contemporary plight of the white (male) athlete. Again, I identify these representations of disadvantaged, "victimized," or otherwise unprivileged youthful, white masculinities across the landscape of late 1990s American popular culture to further demonstrate how they represent a reconfiguration of white male backlash politics—the youthification of the white male as victim figure. Now, I turn my attention to the late 1990s popular discourse of boys development.

"Lost Boys": Young White Males as "Social Victims"

> [There's] something very wrong with the adolescence our boys live today … adolescent boys are now, arguably, our most under-nurtured population … social structures that over the ages have honored boys are getting dismantled, and there is no increase in the number of equally strong structural elements for teaching duty, meaning, and purpose
>
> Gurian (1998, p. 3).

In the late 1990s, a popular discourse about a youthful white masculinity was constituted through a number of books explicitly concerned with the development of adolescent boys into "exceptional men" (Gurian, 1998, cover). Some of these books, like Michael Gurian's *The Wonder of Boys* (1997), *A Fine Young Man* (1998), and *The Good Son* (1999) and William Pollack's *Real Boys* (1998), garnered national acclaim and national best-seller status. The appearance of others, like Eli Newberger's *The Men They Will Become: The Nature and Nurture of Male Character* (1999), Daniel Kindlon's (with Teresa Barker and Michael Thompson) *Raising Cain: Protecting the Emotional Life of Boys* (1999), and James Garbarino's *Lost Boys: Why Our Sons Turn Violent and How We Can Save Them*

(1999) speaks to the proliferation of interest and concern with the development of "our nation's boys." This widespread cultural concern with the development of adolescent boys intensified after the highly publicized school-shootings committed by (white) suburban adolescent boys during 1997–1998 in Paducah, Kentucky; Pearl, Mississippi; Jonesboro, Arkansas; Springfield, Oregon; and Littleton, Colorado. What I find most interesting about this discourse about boys is its construction of young (white) boys as victimized and disadvantaged subjects. It is this repetitive construction of young boys as disadvantaged subjects that implicates these books as a site involved in the reconfiguration of white male backlash politics.

Rather than examining these books individually (noting their points of convergence and divergence), I will limit my discussion to the remarkable similarity of how the category of boys is constructed throughout these books. In each book, boys are rendered visible as suffering, confused, afraid, and vulnerable subjects who, beneath their hard exterior, have an innocent and good essence. Yet, the whiteness of these boys is not explicitly mentioned in most of the books. In Gurian's (1998) best-selling book, *A Fine Young Man*, boys are represented in essentialist terms, as fragile and emotionally disadvantaged subjects. Throughout much of the book, Gurian describes boys through a rhetoric of suffering, victimization, and disadvantage. In various chapters, he wrote, "our adolescent males are suffering privation we have not fully understood" (p. 11); they are the "primary victims of school violence," as well as the innocent victims of girls' emotional manipulation (p. 41). According to Gurian, the fragility and emotional disadvantage of boys are biologically determined by such things as the "inherent intellectual fragility in the male brain system" (p. 17), or their "biological hardwiring" (p. 30). Through this biological determinist argument, young adolescent males are figured as disadvantaged victims of their own biology. In contradiction to this biological determinist argument, he also contends that boys are additionally disadvantaged by the development of an allegedly "female culture" that has "collapsed" the social structures set in place to "honor" males and nurture them into their proper roles as men (Gurian, 1998). So, not only does Gurian find it important to note how boys are figured as innocent victims of biological processes beyond their control, but his victimized representation of these white-unmarked boys is coupled with the strategy of shifting the blame for boys' abuses to an allegedly feminized American culture that failed to properly nurture them. These representational strategies set the stage for Gurian to offer his solution to the boys' improper behaviors, our society need to re-erect those structures that will honor boys and return them to their proper roles as society's leaders.

Although it does not subscribe to Gurian's (1998) biological determinist view of the behaviors of boys, in *Real Boys*, William Pollack (1998) similarly discussed boys as being "in serious trouble" (p. xxvi). For him, boys' trouble (their confusion and alienation) is the result of conflicting messages about masculinity in post-1960s America that require boys to be both "New Age men" (sensitive, unselfish, and caring) and "cool dudes" (strong, stoic, non-emotive, and in control). Meanwhile, Garbarino (1999) noted in his discussion of lost boys that boys might exhibit hard exteriors, but these displays are merely superficial facades that mask a "vulnerable inner self" (p. 22) and a "wounded soul" (p. 35). These authors even instructed the reader that although the vulnerability, disadvantage, woundedness, or innocence may not be easily seen because of the hard, cool, and confident masks that boys often present to the world, we should learn to read such masks as further symptoms of the silent suffering and vulnerability of these boys, harboring no doubts about the essential innocence and goodness of boys. Masterfully, the discourse on boys produced in these books is able to rearticulate the dominating and prohibitive behaviors that boys/men often enact on others as further proof of their own vulnerability, suffering, and need for compassion for our culture. In a language of compassion and care for our nation's sons, these books offer a solution to the contemporary problems of boys that, when examined critically, must be read as endorsing a project of re-masculinizing men.

Within these books, readers are urged to discard gender stereotypes of males that do not allow them to see boys as they "truly" are—innocent, fragile, vulnerable, scared, and essentially good. They contend that these gender stereotypes of men as uncaring, selfish, non-emotive, and insensitive not only act as a "gender straitjacket" for boys (Pollack, 1998, p. xxiv) but also unfairly constrain the actions of boys and lead our culture to neglect the alleged "real" needs of boys, which are defined as being the center of attention, living without constraints on one's actions, and being placed into positions of control. In this case, where the normative and invisible character of masculinity has been expressed by feminist critiques and led others to categorize men in stereotypical ways, this discourse on boys, through its calls to stop using "unfair" gender stereotypes of men, seeks to re-secure the invisibility of masculinity. It also calls for the shoring of social structures for the purpose of developing young boys into "fine young men" (to paraphrase Gurian). At the same time, the discourse on boys has the effect of working to re-secure masculine norms and values and institutional supports that men, within the logic of the backlash imaginary, fear have been unfairly eroded.

Although gender is the social force most explicit within this discourse about boys, race also plays a constitutive role as well. It is significant that this concerned discourse about our nation's boys is produced, not following stories of violence in urban schools in the 1990s (which are racially coded as black or non-white in the popular imagination) or following the alarming tales of everyday violence in urban communities in early 1990s films like *Boyz in the Hood, Juice,* or *Menace II Society.*[12] Instead, this discourse about boys is produced only in the midst of the multiple school-shootings involving white suburban boys. Only in Garbarino's (1999) book is the racial dimension of this discourse on boys openly acknowledged. Taken as a whole, whiteness is largely represented as normal or neutral within this discourse on the development of boys (Aanerud, 1997). Although whiteness is largely rendered invisible through this "normal" and "neutral" discourse about boys, its presence can also be viewed in small traces, usually through imagery. For example, most of the book covers display images of frail-looking, innocent, blonde- and brown-haired, white-skinned boys. Or, the whiteness of this discourse is revealed by making explicit how the discourse uses coded language to evoke race in the reader's mind without having to discuss it explicitly. The use of racial codes within this discourse on boys is evident in Gurian's (1998) book, in which he begins the first chapter with this description of the type of troubled boy his book seeks to help:

> He was a hard shell of a boy already at twelve. Though he and I lived in a middle-sized American city in the Pacific Northwest, he reminded me of urban youth who feel they have nothing going for them at all, trapped in inner cities, dangerous schools, and more dangerous streets. Jason dressed in the hip-hop style, and he had a buzz cut, his baseball cap on backwards, baggy jeans, and a flapping belt. He liked to talk about music, rap music, of course. He liked to show off (p. 9).

Here, the comparison of Jason, a boy from a middle-sized American city in the Pacific Northwest who has an affinity for rap music, to an urban youth dressed in hip-hop style invokes a series of racial signifiers (both white and black) that implicitly connotes his white identity and implies that part of his trouble is his "inappropriate" identifications with styles and music popularly imagined as authentically belonging to African Americans.

The power of whiteness in this discourse about boys is also evident in its marked difference from the highly racialized contemporary discourses of urban crime and punishment of the 1980s and 1990s in which young black males are demonized as "menaces to society" who are prone to violence, unsuitable for rehabilitation, and must be incarcerated. Instead, in this discourse about boys,

which is implicitly centered on white boys, these boys are constituted as our nation's sons and are not demonized. In fact, they are instead rendered visible as innocent, suffering, and unfairly disadvantaged subjects in need of our nation's compassion and support. Furthermore, rather than blaming (white) boys for their poor behaviors and expressions of rage, blame is shifted onto American culture. The usual suspects repeatedly held responsible for the waywardness of youth are identified—breakdown of the family or absentee parents, violence in the media and video games, and "that crazy rock music that kids listen to today." In this case, American culture writ large is also indicted for becoming a feminized culture that has allowed the collapse of "traditional" social structures that once nurtured boys into proper men. Here, the power of whiteness (and masculinity acting together) resides in the production of a discourse about white boys that does not blame them for their transgressions but instead blames American culture for failing boys, while calling for reforms of American society and culture that serve to protect and re-secure the hegemonic position (socially and culturally) of white masculinity.

Through its representations of victimized and disadvantaged white boys, this discourse about the proper development of boys can be read as being produced by, and productive of, the representational strategies and discursive logics of the white male backlash. In fact, this discourse's images of victimized and disadvantaged white boys are remarkably similar to the images of victimized and disadvantaged adult white males in other backlash texts like Robert Bly's Iron John books; films like *Falling Down, Forrest Gump*, and *The Fan*; or Rush Limbaugh's conservative rhetoric about the embattled white guy (see Gates, 1993; Giroux, 1997a; Savran, 1998; or Spade, 1998). Like these other backlash texts, this discourse on boys offers interventions that have the effect of attempting to re-secure the patriarchal institutional structures and masculine cultural norms and values in the name of facilitating the proper development of adolescent boys who are represented as being naturally (biologically) and culturally victimized and disadvantaged.

When subjected to close analysis, what also becomes notably apparent within this discourse about boys and what further signals its link to the conservative backlash is how the terms *boy, young male*, and *male* are often used interchangeably. At times, the books' discussions of the forces that negatively affect the development of boys or young males become discussions of the forces affecting adult males or males without any mention of age. This slippage is readily apparent in Gurian's (1998) text through his frequent use of his own and other middle-aged men's recollections of their adolescent years as his empirical "data," or through statements like, "Testosterone then, is a major

factor in naturally cutting *males* [rather than *boys* or *adolescent males*] off from emotional development" (p. 36). In this rather easy substitution of males and adult males for boys and adolescent males, one begins to see how the alleged "truths" about the needs of boys produce a series of effects that, whether intended or not, effectively seek to reconstruct a social formation (values, norms, and institutional structures) that re-centers white masculinity within American social, cultural, and familiar life. Even further, the link between this discourse on boys and the discursive logic of backlash politics is revealed through Gurian's (1998) identification of notorious male backlash proponent Warren Farrell's book, *The Myth of Male Power* (1994), as a "must-read" for anyone who wants to understand what "men and boys" (notice the slippage) suffer in all human health indicators (p. 280).

Finally, this innocent, vulnerable, and victimized depiction of the racially unmarked category of boys serves as a brilliantly effective means of promoting (whether intended or not) the interests of the white male backlash. When the goal of the politics of the white male backlash is to, in Savran's words, "recoup the losses they [white males] have allegedly suffered at the hands of women and people of color" (p. 4), such things as bolstering social structures that honor males and promoting social practices that avoid putting constraints on boys (because constraints of any kind are represented as being unhealthy to boys' proper development) implicate the discourse on boys' development as an armature of the conservative backlash politics of the era. The category of boys is, perhaps, even more effective in generating support for the ideas of backlash politics because the connotation of the term boys with "innocence" and with "the future" helps to allow the discourse to appear to be non-ideological—just an innocent, non-politicized discourse interested in promoting the health and well-being of boys who represent the nation's future. But it is also because of the supposed innocence and good intentions of this discourse about boys that the backlash politics constitutive of it largely goes unnoticed. That is, because the discourse is presented through noble rhetoric about making "adolescent boys into exceptional men" (Gurain, 1998, front cover), one might miss how it inconspicuously promotes a set of values and social arrangements that seeks to ensure the reproduction of the hegemonic social and cultural position of white masculinity. Not only does the use of the term boys, where race is erased and "boy" stands as a sign of a youthful white masculinity, allow the racial and gender politics of the discourse to be masked (or easily denied even if they are made visible), but also the youthfulness of "boys" urges the reinvestment in social structures that honor (white) males not just in the present but, perhaps

even more important, promotes the reproduction of these structures (and masculinist norms and values) in the future.

Sports Illustrated's Crisis of the Young White (Male) Athlete: American Sports as a Site of the White Male Backlash

> The white athlete—and here we speak of the young men in team sports who ruled the American athletic scene for much of the century—doesn't want to play anymore ... the playing field [American professional sports arena] had become the nation's common ground, the one highly visible stage on which black and whites acted out the process of learning to live, play and fight together as peers. Today fewer whites stand on that common ground (Price, 1997, pp. 32–33).

Sports Illustrated's December 6, 1997 issue offered readers a special report titled, "Whatever Happened to the White Athlete?" (Price, 1997). The article is represented as a 6-month long inquiry into the subject of race and sports that included "dozens of interviews with coaches, athletes, executives, and academics and a nationwide poll of 1,835 middle school and high school kids" (p. 33). Despite its best efforts to give this article the gloss of an objective and soundly researched scientific report, the end product of *Sports Illustrated*'s work is a panic-driven news story focused on the increasing absence of the white athlete in contemporary American professional sports. In my analysis, I implicate this article about the declining position of white (males) in sport as another site of 1990s America in which the representational strategies and discursive logics of the white male backlash politics are deployed and disseminated for public consumption. Then, I make visible how *Sports Illustrated*'s report uses representations of youthful white males, configured by the logics and strategies of the white male backlash, as opposed to adult white males. These young white masculinities first get figured as suffering and victimized minority subjects and then get contradictorily refigured, by the article's end, as having an extraordinary will and self-determining agency as well as a restored confidence. In addition, through critically interrogating the functions and contradictions of the article's depictions of youthful white masculinities, we gain insight into how the article's conflicting and seemingly incongruous representations of white masculinity work to reproduce the hegemonic power of whiteness.

The first evidence of how *Sports Illustrated*'s report on race and sports is produced by, and reproduces, white male backlash ideologies is the magazine's conspicuous choice for the cover photo that accompanied the report. The cover displayed a nostalgia-laden, black-and-white image of four high school-

aged, clean-cut, affable white male basketball players whose uniforms and hairstyles unmistakably code them as pre-1960s figures. Each player is shown kneeling with one hand extended forward touching a single basketball resting in the center between them. This positioning of the athletes, each with a hand on the basketball, signifies them as a team that presumably works together toward a shared goal rather than as a group of individuals. Their smiling faces, oozing with optimism and innocence, and their unifying pose invite white male readers to nostalgically identify with them and a set of traditional values that they project—teamwork, competition, camaraderie, winning, hard work, and playing for the love of the game. Of course, these are the values that many sports pundits and fans resentfully decry as having been lost in today's professional athletes and sports. So then, this 1950s team-oriented, sacrificial white male athlete constructed in *Sports Illustrated*'s article is implicitly defined over and against the African American NBA or NFL player who is said to be more concerned with making money and achieving celebrity status than with winning championships and being a solid role model.

Sports Illustrated's decision to use a picture of pre-1960s white male youths rather than an image of contemporary youths is quite noteworthy for a number of reasons. Like other texts framed by the white male backlash ideologies, *Sports Illustrated*'s decision to use this image evokes a pervasive nostalgia (invested in by many white male adults) for a historical moment imagined as a less complicated and innocent time, particularly for white males. A moment absent from such things as the "annoying" sensitivities of political correctness and affirmative action, the increased public marking of whiteness, and directives to emphasize and celebrate multiculturalism and cultural diversity. This recollection of 1950s America, embodied in these smiling and wholesome young white males, invokes a longing for imagined good ole days—prior to the "disrupting" events of the 1960s—when the centrality and preeminence of the white male was taken for granted, when the position of white males was rarely publicly challenged.

This nostalgic longing for a pre-1960s America expressed in this *Sports Illustrated* cover photo is a variation of the backlash strategy discussed earlier in which populist rhetoric that does not explicitly mention race, gender, or class is deployed to reproduce social practices, institutional arrangements, and ideologies that center and normalize the position of white masculinity. In this case, by invoking these backlash ideologies through this photo without actually expressing them in words, this nostalgia (with its racial and gender implications) can be conveyed in a seemingly innocent and inconspicuous manner.

Sports Illustrated's cover image also begs the question: What audience would be interpellated by this image and special report on the plight of the professional white male athlete? *Sports Illustrated*'s nostalgic black-and-white choice rather than a contemporary color photo of white youth may signal an effort to appeal to middle-aged white men who recognize themselves in the image. But, *Sports Illustrated*'s repeated framing of the crisis of the white athlete as a contemporary crisis of *young* white male athletes suggests that the intended audience is a young white male who is allegedly turning away from sport. Rather than arguing that the article is intended to appeal to either older white males or younger white males, I contend that the article's framing—its choice for the cover image, use of statistics collected from a national survey of current high school athletes, and stories of contemporary young white males across different generations. On one level, the article's focus on young white (male) athletes signals how representations of unfairly disadvantaged youthful white masculinities, in this case within sport, are increasingly being employed as symbols to serve the ideological ends of white male backlash politics— generating anxiety, resentment, and a sense of crisis about the supposed declining position of white males within American society and culture. On another level, the interweaving of these images and stories about both former young white (male) athletes and current white (male) athletes suggests an effort to construct a narrative that interpellates younger white males to invest in the white male backlash imaginary.

Henry Giroux (1997a) has noted that during the 1990s, "whiteness" was increasingly made visible at times when whites were constituted as victims. *Sports Illustrated*'s special report exemplifies Giroux's observation. In bold white letters that stand out in relation to the black-and-white photo, the question, "Whatever happened to the White Athlete?" is posed. The word "White" appears in a much larger font; its prominence demonstrates how, in the late 1990s, whiteness is often made visible and marked in popular culture at those times when the practices of a white-skinned person or group do not conform to, or fit within, the dominant meanings associated with whiteness. Stated a bit differently, whiteness is often made visible in the national-popular when particular performances of white-skinned subjects or historical events (such as the changing racial configuration of athletes within certain professional sports in the United States) potentially challenge, and threaten to disrupt, our "naturalized" ideas about the cultural meanings of whiteness (its invisibility and/or normativity) or its centered social positioning. Even further, whiteness is not only made visible in the article to signify the disruption of its naturalized meanings or the social position of whiteness in society, but it is paradoxically

made visible to restore the invisibility of whiteness and, thus, to re-secure its normative and central socio-cultural position.

Moving to the text of *Sports Illustrated*'s special report, the article begins and ends with a story about a 29-year-old white male American sprinter named, Kevin Little. We are first introduced to Little recalling a recurring incident in his life in which, to his dismay, he has to explain to disbelieving others (whites and blacks) that he is a professional sprinter. Little laments about how he commonly receives a look of surprise, a slight chuckle, and the words, "But you're white?" when he identifies himself as a sprinter (Price, 1997, p. 32). We are told that Little is tired of the disbelief and skepticism he encounters when he tells others that he is a sprinter. Next, we learn that in March of 1997, Little not only tied the American indoor record in the 200 meters at the world championships in Paris, but he was the first white American since 1956 to win a major international sprint title (Price, 1997).

This story about Little is not mobilized simply to highlight his remarkable on-track performances (although his athletic success is an important facet to his story). Rather, Little's story gains its currency because it figures him as a young white male athlete who is "suffering" from self-doubts brought about by fans, friends, and (black) competitors stereotyping him as an inferior athlete because he is white. In the typical manner of a backlash text, Little is constituted as a victim of the negative stereotypes about white athleticism. Here, the increased public marking of whiteness by others is represented as having unfairly caused Little much suffering and unfairly constrained him by erecting social and psychic forces (people's unsupportive comments and his own self-doubts) that constrain his efforts to fulfill his aspiration of being the best sprinter he can be. In contradistinction to the arguments white conservatives often proffer that race does not affect a person's life of outcomes (usually applied in cases in which people of color speak of disadvantages that are the result of their racial identity), Little's story asserts that the recent public marking of whiteness— particularly, the limiting stereotypes of white athleticism—produces significant debilitating effects that unfairly restrict his actions and aspirations. Thus, within *Sports Illustrated*'s report, race is deemed important in those moments when the public marking of whiteness negatively affects the life possibilities of white males. Furthermore, through its exposition of the way in which making whiteness visible has had derogatory effects on Kevin Little, *Sports Illustrated*'s story implicitly endorses a desire to make whiteness once again invisible.

It should be no surprise that *Sports Illustrated* begins its report by featuring an athlete like Kevin Little. As a white person participating in a sport commonly understood as being dominated by black athletes (200-meter run),

he is the perfect figure to play the role of the unprivileged, minority white male subject within contemporary American sports. By making Little's story the lead, *Sports Illustrated* presents him as "Exhibit A" in its crisis narrative about the ground that the white (male) athlete has unfairly lost. Through its survey of middle school and high school youth's attitudes about sport participation, *Sports Illustrated* attempts to show that Little is not alone; that he is just one of many young white (male) athletes who have either turned away from sports or whose confidence in their athletic abilities has waned due to the disappearance of white (male) athletes on the national athletic stage. Young white males are represented as dropping out of the "big three" American sports (football, basketball, and baseball) at a rapid rate or as being unfairly deterred from participating in these sports by parents, coaches, and the media, all of whom see African American males as a dominating athletic presence that impedes white male athletes chances to compete at either the youth or professional levels. These young, white male athletes are figured as being unfairly subjugated (having their agency constrained), not only because of the debilitating effects of negative stereotypes about white athleticism but because of the overwhelming success of black males in American professional sport. Within this story line, black male athletes are depicted as a dominant, discriminating, and exclusionary force whose success unfairly constrains the life possibilities of white male youths by forcing them to abandon their dreams of being a professional athlete. This narrative of black dominance and white male disadvantage in sport enables the US racial hierarchy to be turned on its head, so that white males can be positioned as a seemingly legitimate unprivileged subject. But by inverting the social order, this story of white male disadvantage represents an attempt to forget or render inconsequential the long histories of racial inequalities, institutional racism, and white privilege that have existed in the past and that still persist in the present, both within and without sport (Rodriguez, 1998).

Sports Illustrated's special report then, alleges that perhaps the most alarming effect of the disappearance of the white male professional athlete is that it has caused "a spreading white inferiority complex" for young white males (Hoberman, cited in Price, 1997, p. 44). Although *Sports Illustrated* makes this claim, it does not support this allegation with evidence. In fact, it actually provides evidence that contradicts such a claim. The article provides the pie charts with shocking titles like, "White Flight" and "Feeling Inferior" that catch readers' eyes and reinforce its thesis of white (male) athletes being in crisis. But closer inspection of these graphs and charts reveals that only 34% of the white male youth surveyed agreed with the statement, "African-American players have become so dominant in sports such as football and basketball that many

whites feel they can't compete at the same level as blacks," whereas 45% of the white male youths surveyed disagreed with the statement (Price, 1997, p. 34). Although short on evidence, these graphs and statistics, with their veneer of scientific objectivity and their prominent titles, create the impression that *Sports Illustrated* has sufficiently supported its hyperbolic claims of white male victimization within sport.

The articulation of this white inferiority complex is also important because it shows how youthful white males, as opposed to middle-aged white men like a Promise Keeper, or Rush Limbaugh listener, or the celluloid figure D-Fens, are being mobilized within this backlash politics. The relative youthification of the white male backlash figure within this narrative is significant because it is his youth—a traditionally subordinate subject position—that, in part, facilitates the production of his victimized identity. In *Sports Illustrated*'s narrative, constructing American professional sport as a site of African American dominance and white inferiority requires that one selectively forget two things. First, the commercialized and mediated American sports formation also includes sports like tennis, golf, extreme sports, professional wrestling, and soccer, which are (numerically) dominated by whites. Second, professional sports are almost exclusively administered (coached, owned and operated) by white males. But, by focusing on relatively young white athletes (whether at the professional or youth levels of sport) within its narrative of white athletic crisis, such irrefutable evidence can be conveniently forgotten or overlooked.

In addition, as in the discourse of boys development, the connotation of "the future," which is often articulated with the category of youth, implies that the "spreading inferiority complex" being felt by these white males is not merely a problem of today but could escalate into a potential problem of the future. The unspoken anxiety that underwrites this claim of a spreading white inferiority complex translates into feelings of inferiority in other spaces and practices unrelated to sport. Suddenly, what is at stake is not simply the cultural position of white males in sport but the cultural and social position of white masculinity in American culture as a whole.

Similarly, the category of youth is also frequently articulated with notions of "hope" and "limitless opportunities." Consequently, the alleged African American dominance in sport becomes a force that unfairly limits the life possibilities of white male youths afflicted by this supposed inferiority complex. It supposedly does so by influencing young white male athletes to give up their optimistic dreams of athletic stardom and effectively end their athletic development. The notion that taking away a young person's dreams is equivalent to arresting their development is subtly at play within this

articulation of this white male crisis to youthful white males, especially as sport is understood as providing youths with valuable lessons about the merits of hard work, perseverance, meritocracy, and optimism that transcend their sporting experiences. Thus, the youthfulness of the victimized white male athlete intensifies what is at stake in the African American dominance of American professional sport. Not only is the alleged growing white inferiority complex with young white males implicitly cast as a symptom of the eroding position of white masculinity within American culture in the present, but its articulation with youthful white males further suggests that it may have deleterious effects on them in the future.

Meanwhile, the article also produces another important image of white masculinity through a story about the athletic success of white NBA player, Brent Barry. Although Barry garners much attention as the son of NBA legend Rick Barry, his story is important for *Sports Illustrated*'s narrative because he defied conventional racial logic when he won the 1996 NBA Slam Dunk Championship. Thus, Barry is introduced into the article's narrative because he represents a young white male who has achieved a relatively high level of athletic success in a sport dominated by black athletes in the 1990s (basketball). He is valorized for his strong will to succeed and his ability to be a self-determining agent who is not constrained by forces outside of himself (i.e., black dominance in basketball, derogatory stereotypes of white athleticism). This representation of a youthful white masculinity as an unconstrained, self-determining agent is needed within *Sports Illustrated*'s special report to counter its initial image of white masculinity as a suffering, disadvantaged, minority subject within American sports. In addition, this counter-image of white masculinity functions to re-secure the normative way in which white masculinity is imagined within American culture (as a sovereign, individualistic, and self-determining agent), thus providing an imaginary solution to any possible anxieties created (in white male readers) by its initial construction of white masculinity as a suffering, constrained victim within contemporary American sports.

The construction of Barry as possessing an extraordinary will relies on the stereotype of whites' athletic inferiority to blacks and is enabled by the depiction of suburban culture (implicitly coded as white) as a social barrier for white (male) athletic success because it is overwrought with comforts and distractions like video games and abundant opportunities outside of sport. In addition, the supposed lack of community-wide support of white athletes is used to constitute suburban culture as a social constraint on white (male) athletes. Quite ironically, suburban comfort is cast in *Sports Illustrated*'s narrative

as a gigantic social barrier that young white male athletes have to overcome to become professional athletes. This peculiar representation of "suburban comfort as constraint" is necessary to constitute youthful white male athletes, like Barry, as possessing an extraordinary will. Coupled with its reliance on the stereotypical notion of white athletic inferiority, this depiction of suburbia allows young, white male athletes to be represented as having to work harder than the inner-city black athlete. A testimonial from Barry is used within the article to legitimate this representation of suburban culture:

> "It almost takes more effort to get out of a situation where you could sit back and be comfortable," he says. "If you're struggling you could say, 'I don't need to do this anymore. My parents have great jobs, I could go to any college I want.' It's a much different set of social barriers; the pressure on you to perform isn't so great. If you're the white kid and you've got glee club after school, the ski trip on the holidays and Stratomatic baseball in the spring, well, that's what you're going to do. I pride myself on the fact that I had to have a lot of desire and will and competitiveness to get out of white suburban America and make it in a game dominated by great black athletes" (quoted in Price, 1997, p. 50).

Through his comment, Barry offers an amazing inversion of the customary sporting upward-mobility tale usually associated with basketball and African American, inner-city males in the 1990s. Within Barry's statement, the dire economic and social conditions (deindustrialization, drugs, rampant crime, institutionalized racism) that often leave economically disadvantaged, inner-city black males few viable avenues for success other than sport are trivialized and rendered less problematic than the alleged social barriers facing the suburban white male athlete. In fact, these bleak social and economic conditions are constituted as advantages for the black athlete because they produce pressure to succeed in athletics in the black community. Incredibly, *Sports Illustrated* does not merely equate the social conditions of the suburban white male athlete and the inner-city black male athlete; rather, it constitutes the plight of the white male suburban subject who has to overcome the "distractions" of suburban comfort and a white community that does not fully support his athletic investments as being more difficult than the condition of his black male counterpart. The economic and social privileges of being white, male, and from the suburbs are reconstituted to become social barriers hampering white males' athletic success. *Sports Illustrated*'s contradictory narrative of white male disadvantage (a variation of the construction of the "white male as victim" trope) represents an unique and troubling attempt to disavow white male privilege. Yet, its framing of Barry's story also enables white masculinity within the *Sports Illustrated* article to be rendered visible not just as a social victim but

also to be figured as a self-determining agent whose strong will and determination propelled him to overcome the social and psychological barriers necessary to achieve athletic success.

The configuration of Barry as a white male with an extraordinary will is reinforced by a final story about the lone white sprinter, Kevin Little. In the closing two paragraphs, Little reenters the narrative and is much different than the Kevin Little the reader met in the opening of the article. He is constituted as no longer being afflicted by feelings of self-doubt and defensiveness brought about by the negative stereotypes of white athleticism. Instead, Little is represented as using his newly visible whiteness to gain an advantage on his black competitors:

> No one [African American] wants to lose to him. "Then the edge goes to me," he says. "I can look into their eyes and their faces, and if they have a little fear of losing to a white sprinter, I've won right there. *I'm holding the cards"* (Little, quoted in Price, 1997, p. 51, emphasis added).

Little's quote is employed to both reaffirm the need to make whiteness once again invisible while also serving to reassure the (white male) reader through this fabrication of white men as self-determining subjects who are not and will not be constrained by social conditions (like stereotypes, black dominance, and lack of social support for their athletic endeavors). Little reemerges at the end of the article as a pedagogical figure for white males, an example of an unfairly disadvantaged white male who not only proves the superior will of white males but has even learned to use "black dominance as his weapon" (Price, 1997, p. 51). Thus, by the article's end, white masculinity is reconfigured not as a suffering and constrained social victim but, as many white American men would like to imagine themselves, as self-determining subjects of history (rather than its objects) who author their own life outcomes and who are not constrained by social forces beyond their control.

Conclusion

> Forms of media culture induce individuals to identify with dominant social and political ideologies, positions, and representations. In general, it is not a system of rigid ideological indoctrination that induces consent to existing capitalist societies, but the pleasures of the media and consumer culture…[that] seduce[s] audiences into identifying with certain views, attitudes, feelings, and positions (Kellner, 1995, p. 3).

Several other cultural critics, influenced by the critical work being done on whiteness, have illuminated how a number of popular cultural sites, like

Hollywood films (Clover, 1993; Giroux, 1997b; Kennedy, 1996; McCarthy, 1998a; Savran, 1998); AM radio (Giroux, 1997a), television (Newitz & Wray, 1997), and grunge music (Newitz, 1997), have been instrumental in not only disseminating but also generating the representational strategies and logics of this white male backlash politics. Surprisingly, little work has examined how contemporary discourses involving sport, as a site of popular culture, have been influential in the production and dispersal of the logics of this white male backlash politics, whose implicit goal is to re-secure the central and dominant cultural position of white masculinity in the late 1990s. My interrogation of *Sports Illustrated*'s special report is an initial effort in this direction. Such critical attention of contemporary discourses and developments in sport can illuminate how sport has become an important site of the white male backlash because the overrepresentation of African American males in some sports enables the fabrication of a crisis narrative about the precarious and vulnerable cultural position of white males that can be seemingly defended through a quick glance at the "empirical" evidence of the contemporary racial make-up of American professional athletes.

Furthermore, my analysis provides evidence of how images of more youthful white masculinities are increasingly being employed within white male backlash texts. The youthification of the white male backlash figure suggests that an effort is being made to interpellate younger white males to the white male backlash ideologies. Such an effort might produce a cross-generational investment by white men of various ages in these ideologies that would facilitate the continuation of the white male backlash's political goals in the future. Or, the youthification of the white male backlash figure might also be symbolically useful as it enables the popular acceptance of backlash ideologies that seek to re-secure the hegemonic position of white masculinity within American culture in the name of such things as improving the lives of boys or in the name of enabling young white males an opportunity to pursue their interests in traditional sports, like basketball or football or track. Nonetheless, what can be said with some reasonable certainty is that the production of these representations of disadvantaged and victimized young white males within popular music, popular literature, and popular sport operates, as Kellner (1995) stated, as sources of cultural pedagogy that attempt to seduce (white male) audiences to "deny what is most obvious: the privileged position of whiteness" (Kincheloe & Steinberg, 1998, p. 15).

⌗ CHAPTER SIX

White Boyz in the Hood: Examining the Cultural Politics of *Dogtown and Z-Boys*

Introduction

According to the promotional rhetoric on the back cover of its video sleeve, *Dogtown and Z-Boys* is a documentary which tells the story of "a gang of discarded kids who virtually revolutionized skateboarding with an aggressive style, awe-inspiring moves and street smarts, and, in the process, transformed youth culture forever" (back cover of video). The description continues:

> Featuring historic old-school footage, exclusive interviews and a blistering rock soundtrack, DOGTOWN AND Z-BOYS captures the meteoric rise of the Zephyr skateboarding team from Venice's Dogtown, a tough 'locals only' beach with a legacy of outlaw surfing. Armed with a guerilla code, the notorious Z-Boys sharpened their skills in the concrete jungle of '70s L.A. and then took it to the next level. Getting vertical in abandoned suburban swimming pools, they ignited an underground phenomenon that shaped the attitude and culture of modern-day extreme sports. With rare appearances by skateboarding icons TONY ALVA, JAY ADAMS, and TONY HAWK, DOGTOWN AND Z-BOYS is a thrilling all-access tour of the birth of a pop culture phenomenon.

Directed and co-written by Stacy Peralta, a former Z-Boy and skateboarding world champion himself, on the face of things, the film offers viewers "the" history of skateboarding; one that not only presents the Z-Boys as the radical pioneers of their sport but represents their extraordinary athletic exploits in the 1970s as the originating spark for the extraordinary popularity of skateboarding and extreme sports as a whole during the 1990s.

In 2001, the film received much popular and critical acclaim when it won the Best Documentary Award at the Independent Spirit Awards and took home

the Audience Awards at both the Sundance and SFI film festivals. Peralta also garnered the Best Director honor at the Sundance Film Festival.

In addition to garnering these independent film awards, *Dogtown and Z-Boys* was also overwhelmingly well-received by film critics from all across the United States.[1] Ann Hornaday of *The Washington Post* described the film as a "gorgeous, poetic, [and] exhilarating film … a thing of beauty in itself." While Margaret McGurk of *The Cincinnati Enquirer* called *Dogtown and Z-Boys* an "exhilarating film memoir" that "makes even viewers who have never touched a skateboard feel a part of the action." Some reviewers like Michael Wilmington even went so far as to say that *Dogtown* is "one of the most entertaining sports documentaries [produced] in years." Wilmington's ringing endorsement of *Dogtown and Z-Boys* was echoed by Del Harvey (2002) who proclaimed that this "documentary of how skateboarding became an extreme sport rivals the earlier genius of [the 1966 surfing film] *Endless Summer.*"

"It Feels Good": Media Responses to *Dogtown and Z-Boys*

Judging from the above reviews, a key aspect of the popularity of *Dogtown and Z-Boys* rests in its apparent ability to reach audience members on an affective level. Countless comments from reviewers suggest that the film was able to foster strong affective connections with audiences by offering footage and a musical score that invited the "audience to feel jolt after visceral jolt" (Hornaday, 2002). Weiskind (2002) describes the film as a "visceral and kinetic artifact of cultural history." Since skateboarding is an activity practiced by relatively few Americans (despite skateboarding ascendant popularity during the 1990s), forging such an affective connection between audiences who know little about skateboarding or the Z-Boys' story is absolutely necessary to the documentary's mainstream appeal and its aspirations to turn a profit. Yet, it is the film's apparent ability to reach and connect with mainstream viewers on an affective level that is peculiar to me considering the fact that most viewers will not have had an intimate connection or experience with skateboarding. So, obviously the film must appeal to American mainstream audiences for reasons other than skateboarding.

We should keep in mind that many films with extraordinary imagery and musical scores fail to make few, if any, affective connections with their audiences. So, the supposedly "great" soundtrack and skateboarding footage offered in *Dogtown and Z-Boys* cannot, in and of themselves, be cited to explain the popularity of the film (as these critics seem to suggest). Instead, the pleasures of watching any film, which are often difficult to put into words (and often not fully, consciously known to both the casual viewer, professional critic,

or academic for that matter), must be more fully explained in some other manner. Here is where the work of media analyst and cultural critic, Douglas Kellner, can help our discussion. Kellner writes:

> the forms of media culture [including films] induce individuals to identify with dominant social and political ideologies, positions, and representations ... not [through] a system of rigid indoctrination ... but [through] the pleasures of the media. Media entertainment is often highly pleasurable and uses sight, sound, and spectacle to seduce audiences into identifying with certain views, attitudes, feelings, and positions (1995, p. 3).

Here, Kellner illuminates the links between pleasure, the media, and cultural politics; that is, how media texts—particularly popular films—can "seduce" viewers into identifying with particular political ideologies through the creation of pleasurable cultural narratives whose perspectives and verisimilitude resonate with broader cultural discourses and people's own pleasurable experiences or ideological interests. Clearly, Kellner advises media consumers to critically interrogate how particular media texts (i.e., films or even media stories about particular athlete-celebrities) attempt to compel us through pleasurable stories to accept, if not endorse, particular political ideologies. His work also highlights how it is naïve to think that the pleasures produced through the media are somehow innocent, apolitical, and disconnected from the broader social realm. Instead, we should see how the pleasures of film are intimately tied up with how people construct their personal identities (racial, gender, social class, sexual, etc.) as well as expressing, in a coded manner, discourses which serve the specific political interests of dominant groups at that particular historical moment. Although the pleasures enjoyed through the consumption of particular films are often commonly imagined and discussed by most people as universal ("everyone enjoyed the film X," or "how could you *not* like film X?"), we must recognize that such pleasures are instead unavoidably particular; intimately connected to one's cultural identities (race, class, gender, sexuality, generation, nationality, etc.), political inclinations, and life experiences.

Taking Kellner's points about the politicization of media culture even further, Grossberg (1992) has argued that the new conservative hegemony of the late 1980s and early 1990s (which I would contend has extended into the new millennium, yet in different and slightly varied ways) "works at the intersection of politics, everyday life, and popular culture" (p. 255) by attempting to garner the consent of the populace to particular ideologies not through rational and reasoned arguments but rather by seizing their hearts, desires, and bodies by appealing to affective energies generated with/in popular

cultural texts which, in the end, often work to align people on a non-conscious level with particular reactionary politics. For Grossberg, "the [key political] question [within this era of the new conservative hegemony] is how people's affect—their attention, volition, mood, passion—is organized, disciplined, mobilized, and ultimately put into the service of specific political agendas" (p. 255).

Considering the apparent overwhelming affective appeal of *Dogtown and Z-Boys* (judging by the comments of the reviewers), I am concerned with how the film's affective connection with audiences is simultaneously disciplined, mobilized, and ultimately "put into the service of" a conservative cultural politics that approves of, and identifies with, a tight-knit "us against the world" band of marginalized, tough, and supposedly unprivileged white man-boys who, at first glance, appear to be "different" non-conformists who challenge mainstream social norms and values, but whose identities, upon closer inspection, are hardly oppositional or progressive at all. Additionally, the Z-Boys' story authorizes and popularizes, in a remarkably clever and disguised way, a particular masculinity that appears as disadvantaged and unprivileged both economically and socially, yet is definitively white, although able to occupy a subject position associated with a young, black, hip-hop masculinity that has once again become very popular with young white males. And it is through the affective appeal of the Z-Boys that the reactionary racial, gender, and class politics produced through their collective identity are overlooked and avoid critique.

With these thoughts in mind, the questions which organize this chapter are: How do we make sense of the film's unabashed celebration of these rebellious, "in your face," white male "cultural revolutionaries"? How are white audiences of various ages, many of whom have never even fallen off of a skateboard let alone dared to carve a line in a dried-out swimming pool, able to identify with, and find pleasure in, the story of the Z-Boys? Upon closer inspection, what are the particular aspects of the story of *Dogtown and Z-Boys* which transcend the culture of skateboarding and resonate with white audiences (themselves stratified by social class, gender, and generation) on an affective level?

Coming to terms with these questions will enable me to explain how the film is able to forge affective connections between white audiences and the seemingly aberrant Z-Boys who, at times in the film, revel with great delight in recounting such seemingly unbecoming anti-social, rebellious stories, such as: threatening "outsiders" who dared to surf at the Pacific Ocean Pier (POP); draining and vandalizing other people's pools in order to skate them; scaring

"old ladies" on public transportation; and throwing rocks at buses that would not pick them up because of their past poor behaviors on public transit.

In short, I am astounded as to how these white man-boys are not read by these film critics (and other viewers) as menaces to society. Instead, I wonder how their anti-social antics are read as seemingly innocent youthful transgressions, which they pridefully recount at various times in the film with unquestioned humor or lack of shame. I am miffed at how their unsociable acts seem to avoid criticism from mainstream audiences and critical interrogation from cultural observers in the new millennium. Perhaps, these anti-social acts of the Z-Boys are seemingly excused and overlooked because they are interpreted through the logics of "teen rebellion" and "boys will be boys" or because they took place nearly thirty years ago. Yet, the total absence of any critical commentary on the above actions of these boys is deeply problematic in my view. In short, the absence of criticism toward the Z-Boys is a symptom and effect of the social and cultural privileges of being white and male. The apparent whiteness of the Z-Boys urges viewers to read their rebellious actions as ultimately "innocent fun," more the product of age and gender than a sign or manifestation of their race.

But, I think the absence of criticism of some of the more derogatory aspects of the Z-Boys cultural practices and values is not simply a product of the normative power of whiteness to obscure the negative actions of specific "white" actors. Instead, I also read this absence of criticism as a sign of the times. The reluctance in white audiences to read these behaviors of the Z-Boys as alarming and problematic is related to the way in which the Z-Boys' white identity represents a particular form of whiteness which is strategically useful to white Americans in late-1990s and new millennium America. That is, in this historical moment, where whites attempt to disaffiliate themselves from what Wiegman (1999) calls, "dominant whiteness," a form of whiteness as economically privileged and explicitly interested in asserting and maintaining its socio-cultural superiority, the Z-Boys white masculinity appears as the exact opposite of this dominant whiteness. It appears to authentically come from the social margins and to be economically unprivileged and socially non-normative. And yet, this portrayal of white masculinity, in actuality, is paradoxically being employed to ultimately re-secure dominant whiteness, as well as provide ideological legitimation for the logics of neoliberalist economics in new millennium America.

The few criticisms that were made of *Dogtown and Z-Boys* by reviewers focused mainly on how the film's narrative too often dovetailed into a self-reverential celebration of the Z-Boys as the originators of the contemporary

popularization of extreme sports. Such criticism is to be expected considering the film was produced by one of the former Z-Boys, Stacy Peralta.

Other criticisms of the film highlighted the contradiction which exists in the film between the Z-Boys self-proclaimed investment in anti-mainstream/anti-commercialism values and the film's explicit celebration of the commercial success of Z-Boys, Tony Alva and Stacy Peralta, both of whom garnered great wealth through their skating. This contradiction is also glaringly apparent if one considers the film's inherent commercial motives and corporate-backed financing and distribution. But even though such criticisms begin to illuminate the contradictions of social class which the film unsuccessfully attempts to contain through the Z-Boys' "alternative/Dogtown/anti-commercialism" identity, a full substantive critique of these class contradictions never fully materialized. Even further, and of interest for the purpose of this chapter and book, the gender and racial aspects of their collective and individual identities are never even mentioned in the twenty or so reviews of the film I have read. In short, the reviewers of *Dogtown and Z-Boys* did not find it necessary to question why white Americans would take an interest in, and enthusiastically feel a connection with, a film about white man-boys which "spits in your face [and] makes you give a shit about people who don't give a shit about you" (Sanger, 2001).

So then, in the rest of this chapter, I explain how the documentary, *Dogtown and Z-Boys*, is constitutive of, and constituted by, the representational strategies, logics, and cultural narratives of a new variant of contemporary cultural racism at the turn of the 21st century in America. Perhaps most significant about this new form of cultural racism is the fact that not only is race rarely, if ever, mentioned, but it is expressed through stories of whites and a virtually white-exclusive social world. As a consequence, this form of cultural racism does not seem to be making a political statement about race at all. Yet, it is precisely because these narratives do not appear to be about race that they work so effectively as instruments and effects of a new cultural racism whose goal is not necessarily to perpetuate racial inequalities by demeaning people of color through objectification and/or caricature via stereotyping, rather it seeks to particularize white identities and to put a spotlight on whites who can make an authentic claim to being unprivileged in order to contest the essentialist idea that all whites are privileged which gained prominence in the mid-1990s. At the same time, this new cultural racism implicitly re-secures a centered and normative position for whites in American culture and society.

Another significant characteristic of this new cultural racism is that it often features "real-life stories" of actual white people who are either authentically

economically unprivileged, come from or exist within the margins of society, or have been a racial minority at a particular time. In these narratives, the white subject's authentic lack of privilege (whether racial, social, or economic) is usually foregrounded and highlighted early on in the story as the central feature of their cultural or personal identity. These un-conventional depictions of whites as unprivileged are then necessarily coupled with more conventional representations of whiteness as dominant, unmarked, and securely centered as the American normative by the end of the story. Together, these two, seemingly paradoxical, images of whiteness—as initially and authentically economically unprivileged and socially marginalized and, in the final instance, as unmarked, centered, and dominant—effectively enable whiteness, and the systemic social, economic, political, and psychological privileges it confers upon those considered to be "white," to be subtly disavowed just as they are strategically reproduced through the film's narrative. Such stories not only serve to mask and deny the existence of systemic white privilege, but they simultaneously reproduce racial hierarchies and commit symbolic violence on people of color in order to re-secure whiteness as the invisible and taken for granted normative center of American culture and society.

Finally, I want to show the various dimensions of this form of cultural racism as it shapes and is expressed through the skateboarding documentary, *Dogtown and Z-Boys*. One thing in particular that I want to emphasize within this chapter is the way in which this form of cultural racism is being made popular with white audiences by disseminating its logics and discourses through affectively appealing stories about sports where racial politics appear to be "somewhere between beneath notice and out of bounds" (Pfeil, 2002, p. 128). It is precisely because of the common way in which the socio-political aspects of sports are frequently overlooked or go unnoticed, that narratives about sports appear in recent times to be used increasingly to promote, popularize, and extend ideas and models of behavior and social relations amenable to the interests of the white power bloc.

Critical Studies of Whiteness and *Dogtown and Z-Boys*

As mentioned above, the main thing which stood out to me after reading a number of reviews of the documentary *Dogtown and Z-Boys* is the complete absence of any commentary about the racial aspects of the film. At this time when a growing number of academics are writing an obituary for whiteness studies and discussing the politics of pronouncements of a "post-white" (Hill, 2004, p. 11) or "race is over" (Roediger, 2002, p. 7) historical moment, the complete absence of any critical analysis of how whiteness invisibly

overdetermines the film's narrative or of the specific racial politics constitutive of the white identities offered throughout this documentary is alarming and should signal to scholars that the work of whiteness studies—although some of it may be flawed and problematic—is still necessary, relevant, and important.

Before interrogating the specific aspects of the racial politics of *Dogtown and Z-Boys*, however, I want to position my analysis of the film within the field of whiteness studies to show how it is informed by many of its key assumptions and insights. My analysis follows three of the basic tenets of the work of whiteness studies: (1) interrogating whiteness from a social constructionist view of race; (2) a critical awareness of how whiteness as a social system is constitutive of, and constituted by, discourses and individual and institutional practices which produce and reproduce racial violence (both material and symbolic) and asymmetries of power between those considered "white" and "people of color"; and finally, (3) an impulse to contest monolithic and essentialist views of whiteness as always already privileged and occupying the position of "the normal" or "the universal" in order to better understand the complexity of white identities and their relation to white privilege (see Dyer, 1997; Frankenburg, 1997; Kincheloe & Steinberg, 1998; Pfeil, 1995; Wray & Newitz, 1997). More specifically, my chapter follows the work of scholars like Wiegman (1999), Davy (1997), Giroux (1997a), Savran (1998), Robinson (2000), and King and Springwood (2001), who take as their analytic starting point the resiliency and elasticity of whiteness as a social system which confers a host of privileges to those considered to be "white" (and disadvantages to people of color) in a given historical moment by highlighting how whiteness has the capacity for "a number of sometimes conflicting ideologies used differently and differentially depending upon the historical needs of white control. [Thus,] whiteness is not a totalizing force, but one which changes and shifts in response to historical conditions" (Davy, 1997, p. 213). Davy's point clearly emphasizes how those involved in the project of reproducing the normativity and supremacy of whiteness in the United States will appropriate virtually any representational strategies that, within various specific historical and social contexts, can work to reproduce asymmetrical relations of power for those considered "white." As a consequence, Davy stresses the need for critical analyses of whiteness to interrogate various white identities and white racial projects in their specific historical and local contexts, always remaining vigilantly critical of the complicated, contradictory, and not so easily apparent or straightforward ways in which various representations of whites or white racial projects—even those which appear to criticize, challenge, expose, or be disaffiliated from white privilege or white supremacy on the face—can still

facilitate the reproduction of white control, privilege, and normativity. Employing such a critical analytic optic toward whiteness means recognizing that the power of whiteness is not only reproduced, maintained, and extended by the ability of whiteness to go unmarked or to occupy the position of "the universal" in various cultural texts. Rather, the power of whiteness is also complexly reproduced by marking, making visible, "othering," and particularizing differences within those considered to be "white" when doing so serves the interests of perpetuating the socio-cultural normativity and dominance of whiteness (Wiegman, 1999). So then, using these theoretical optics on whiteness, I want to briefly discuss the historically specific racial context in which the documentary, *Dogtown and Z-Boys*, was produced and released in order to read it not only as a symptom of this era, but also as an instrument and effect of this new cultural racism.

Dogtown and Z-Boys, New Millennium America, and the New Cultural Racism

On one hand, new millennium America has been described as a time where many whites attempted to "disaffiliate" from whiteness (Wiegman, 1999) as it became increasingly visible as a racial identity and criticized as a social system which affords a "knapsack" (McIntosh, 1997) of unearned privileges to "whites" (see Gates, 1993; Giroux, 1997a; Winant, 2004). This public critique of white privilege and the invisible and normative position of whiteness in American culture and society was fostered by a specific constellation of political, cultural, social, and economic forces and conditions such as the pervasiveness of identity politics; the increasing institutionalization of multicultural and cultural diversity programs in the United States during the past fifteen years (Kincheloe & Steinberg, 1998; McCarthy, 1998b); the increased visibility of people of color in American public culture since the 1980s (Kincheloe & Steinberg, 1998); the rise of discourses projecting that by the middle of the 21st century white people would no longer represent the racial majority in the United States (Maharidge, 1996); and the impact of globalization. Together, these forces created a crisis of legitimizing white privilege and an invisible position of normalcy for whiteness in American culture and society. This crisis of legitimizing white privilege and normativity led to various cultural responses to bring about "the recovery of white supremacy" (Kincheloe & Steinberg, 2000, p. 191). It is these cultural narratives whose implicit effect is to recuperate a central, normative, and dominant position for whiteness that I want to identify as a new form of cultural racism.

Unlike more unsophisticated ideas of biological inferiority which accompanied earlier popular forms of scientific or biological racism, this new cultural racism is usually cleverly expressed subtextually through racially coded rhetoric that "can produce a racist effect while denying that this effect is the result of racism" (Soloman & Black, 1996, p. 27, cited in Carrington, 1998, p. 101). This form of cultural racism is shaped by the conjuncturally pervasive logic of colorblindness, and the idea that race consciousness is no longer preferred or needed because racial inequalities and hierarchies are imagined as being dismantled as a consequence of the activism and legislation produced out of the civil rights movement of the 1960s. The desired effect of this new cultural racism is "to rearticulate and re-legitimize white supremacy" (Winant, 2004, p. 57) but to do so in such a way so that such a goal is difficult to discern and/or easily disavowed. As a racial project that seeks "to resist the challenge to white supremacy posed by movements of the 60s and their contemporary inheritors" (Winant, 2004, p. 66), this new cultural racism, ironically, often appropriates the logics and representational strategies of identity politics as first popularized by the social movements of the 1960s to make its challenge (Robinson, 2000; Savran, 1998). Another important feature of this cultural racism is that it is characterized by cultural narratives where not only are people of color usually not represented as central figures, but they often do not appear at all in these texts. In this way, this variant on cultural racism is unique, more complex, and insidious because, unlike other racisms that are centered upon people of color, this form, at first glance, does not seem to be what Winant (2004) would call a "racial project" or commentary on race at all (especially from the vantage point of whites). More specifically, this new form of cultural racism involves the production and dissemination of a number of affectively appealing stories of white people who authentically come from, and/or exist within, the social margins; or whites portrayed as victims (of affirmative action, black athletic superiority, etc.); or white groups or individuals who appear to be disaffiliated from white privilege. These particular cultural narratives of whites (particularly white men), who appear as socially and/or economically unprivileged and distanced from white privilege work on an affective level for whites to deny the contemporary existence of systemic racial privileges of any sort. These stories operate on a simplistic logic that if any authentically economically unprivileged or socially marginalized white people can be found and their stories told, then their very existence negates the notion of systemic white privilege. This logic itself is predicated on, and a response to, the overly simplistic and essentialized notions of whiteness as always already evil,

oppressive, dominating, and privileged which emerged from the public critiques of whiteness from the 1970s to the late 1990s (see Gates, 1993).

Although the cultural vectors productive of this new cultural racism, the crisis of legitimizing white privilege and the reassertion of white supremacy might seem at first to be contradictory and at odds with one another, several cultural critics have shown how white claims toward victimization, marginality, minoritization, and disaffiliation from the privileges of whiteness in the 1990s are not disconnected from efforts to re-secure white normativity and supremacy during the 1990s, especially in the late 1990s, but in fact often strategically work hand in hand with such efforts (see Giroux, 1997; Robinson, 2000; Savran, 1998; Weigman, 1999; Yudice, 1995). The desire of some whites to recover white supremacy took blatant and extreme forms like the marked rise in both the membership and number of white supremacist groups during the era (Ferber, 1998). But such desires to recover or re-secure white centrality, dominance, and normativity were not merely held by "extremist" whites and deeply invested in white supremacist ideas and living on the margins of American society. Such desires were also being expressed by many whites who were thoroughly invested, and represented, in the American mainstream. In fact, some cultural observers like Ferber (1998) have argued that the increased media visibility given to "extremist" white supremacist groups by the mainstream media during the 1990s functioned politically and discursively to make it difficult to recognize how alarmingly similar the rhetoric was between mainstream discourses on race and those of white nationalist groups during this time period.

Several scholars have shown the prominent role which popular culture (particularly films like *Falling Down, Forrest Gump, Dangerous Minds, Jerry Maguire,* and *Fight Club*) has played in disseminating and naturalizing this desire to recover the centrality, normativity, and dominance of whiteness in American culture and social life (Giroux, 1997a; Kincheloe & Steinberg, 1998; Kusz, 2001c; Rodriguez & Villaverde, 2000; Savran, 1998; Wiegman, 1999). But, few have noted the extent to which media discourses about sport as well as sport-related films have shaped, and been shaped by, the discourses, representational strategies, and logics of this new cultural racism which seeks to re-secure white normativity by featuring tales of white victimization (see Cole & Andrews, 2001; King & Springwood, 2001, and Carrington, 1998 [in the context of Great Britain], as exceptions in this trend). So then, let me provide two noteworthy recent examples of tales of white victimization, marginalization, and minoritization that have recently appeared in the American sporting press.

First, is the December 6, 1997 *Sports Illustrated* cover story titled, "Whatever Happened to the White Athlete?" (Price, 1997) which represents perhaps the clearest expression in the sporting press of Ferber's (1998) insight about the alarming similarities between the racial logics and desires constitutive of mainstream discourses (as long as these similarities are subtly disguised or can be effectively denied) and those of white supremacist groups in the 1990s. *Sports Illustrated*'s cover story produced a panic-driven narrative, yet one considered by many who identify as "white" to be completely reasonable and justified, which lamented the decline in the number of whites (read: white men) on the most popular and visible stages of American professional sports (i.e., baseball, basketball, and football), even going as far as stating that whites have become "second-class citizens in contemporary sports" (Price, 1997, p. 34). Although the author explicitly attempted to deny that the article's thesis was motivated by white anxieties about the loss of white supremacy in sport, one is hard-pressed to imagine why else such a cover story would be written. Yet, just as *Sports Illustrated*'s story bemoaned the disappearance of white (male) athletes in the ranks of American professional athletes, it simultaneously paid little attention to the continued stronghold of white men in positions of power and authority within the institution of sport—in the coaching ranks, front offices, and league offices, an admission which would have contradicted its thesis. Finally, the *Sports Illustrated* article is germane to the present discussion for the manner in which it skillfully and strategically rendered whites visible both as unprivileged subjects (in relation to the implied unfair and undeserved "natural" athletic superiority of African Americans), and as vulnerable, innocent victims of a sporting version of supposed reverse racism where the success of African American male athletes is portrayed as coming at the expense of white athletes. In short, *Sports Illustrated*'s cover story offered a picture of United States race relations where whites could be imagined as marginalized and unprivileged outsiders, while African Americans were positioned as the dominant, exclusionary, and privileged subjects. Amazingly, the cover story also offered a depiction of race relations in the United States which completely inverted and distorted the history and present reality of the power dynamics of race in contemporary America.

The other notable example of a sporting narrative constituted by, and consititutive of, the logic of white victimization and minoritization is the award-winning feature story titled, *Minority Quarterback*, first produced in a *New York Times* special report on race in America. Written by Ira Berkow (2001), the article tells the story of Marcus Jacoby, a white quarterback who, in 1996, accepted a scholarship to play football at the historically black institution,

Southern University. Just one year after leading Southern to its first black college football championship, Jacoby quit school at Southern, feeling that he could no longer take the extreme isolation, stress, and anxiety he experienced as a racial minority at the university. The tone of this story is sympathy for Jacoby's plight as a white racial minority. But, when it is read back within the broader context during the 1990s of public criticisms of white privilege and whites' cries of "reverse racism" due to affirmative action programs, the story is not only a prime example of a sporting narrative which positions a white male as a victimized and unprivileged racial subject, but it also implicitly promotes a logic of racial equivalence whereby Jacoby's narrated experiences of suffering from black racial prejudice against whites suggest that black people can be racist too (thereby, apparently canceling out any examples of white racism that the critics of white privilege might highlight, as well as the institutional character of white racism/white privilege). At the same time, through the narration of Jacoby's "actual story," the story deftly appears to lend credible empirical evidence that systemic white privilege does not exist (for if it did, how could Jacoby possibly have felt discriminated against at Southern University?). Additionally, the story fails to even mention (and in fact makes it difficult to consider) how the isolation, stress, and anxiety experienced by Jacoby has long been (and in most cases, continues to be) the everyday experience of many black athletes who play Division I football at traditionally white institutions of higher learning. Tellingly, such a contemporary story of a young black male quarterback's experiences of white racial prejudice on the campus of a big-time Division I college football (or basketball) program does not seem to get imagined as a worthy topic for an in-depth story during the 1990s.

Like the 1997 *Sports Illustrated* cover story and the *New York Times'* article, "Minority Quarterback," *Dogtown and Z-Boys*, which conspicuously details the rise of a group of predominantly white male skateboarders to fame from economically unprivileged origins in the margins of American society, as well as, their believed differences relative to mainstream (white) American culture—rehearses similar representational strategies and discursive logics characteristic of this new cultural racism whose implicit goal is the re-securing of white normativity, invisibility, and dominance. Indeed, I will argue below that the documentary about the Z-Boys represents yet another turn of the 21st century American sporting text where white normativity and dominance are subtly endorsed and re-secured through a pleasurable sporting spectacle and narrative which, on the face of things, does not appear to be about race and which urges identification for white viewers in white subjects who seem to be disconnected from institutionalized white privilege.

Making Whiteness Visible in *Dogtown and Z-Boys*

In this section, I map out some of the complex, complicated, and contradictory ways in which whiteness implicitly structures the narrative of *Dogtown and Z-Boys*, as well as, the particular meanings articulated with the white collective identity of the Z-Boys. Although the various meanings of the Z-Boys collective white identity are complex and (at times) paradoxical, they each need to be made visible in order to recognize how, together, they are dependent upon one another to show how the film works to recuperate the cultural normativity, invisibility, and dominance of whiteness in the American imaginary.

First of all, it is important to note that nowhere in the film is the whiteness of the Z-Boys explicitly named or identified. So, on one level, the whiteness of the Z-Boys reproduces a frequently employed representational strategy and way of imagining of whiteness as unmarked, invisible, and unrecognized (at least from a white perspective) (Aanerud, 1997; Dyer, 1997; Shome, 1996). In the film, whiteness is everywhere, yet seemingly nowhere apparent because of the conventional understanding (by most whites) of whiteness as an absence of race (Frankenburg, 1997). In fact, outside of the brief acknowledgments of the influence of *Latino vatos* car culture on the decorative designs of Jeff Ho's surfboards (and by extension the collective identity of the Z-Boys), race and racial difference do not appear to play any significant role in the story of the Z-Boys. Thus, the film abides by, as it perpetuates, the pervasive logic of racial colorblindness which is a central part of the new cultural racism. Of course, by failing to see race in contemporary society, this racial logic implicitly supports the interests of maintaining and reproducing the power of whiteness by denying the social and material influence of race on one's social relations and life opportunities.

Also crucial to my argument here is understanding that although the whiteness of the Z-Boys is never marked in the film, the imagery, narrative, and dominant readings of the film are overdetermined by what Wiegman (1999) would call, "dominant whiteness." That is, the film's implicit celebratory tone of admiration for the Z-Boys—as youth who come from a poor socio-economic background and from broken families, who are connected to drugs, who invade others' private property, and who defend public areas as their "turf"—only makes sense when one considers how the conventional logics of dominant whiteness (where whiteness is associated with purity, innocence, and redemptive possibility and positioned as the invisible social norm) and the conjuncturally specific white desires for stories of particular whites (particularly white men) who are supposedly socially marginalized and economically unprivileged (which implicitly serve to disavow notions of systemic white

privilege) frame and influence how (white) audiences read the story and collective identity of the Z-Boys. The way in which dominant whiteness invisibly structures the filmmaker's construction and audiences' readings of the film gets revealed here; no matter how many stories are told throughout the film of these white man-boys trespassing on other people's property and ruining their pools in order to skate them, or of throwing chunks of concrete at non-local surfers who invaded "their" surf spot (the POP), their white skin (and the political value of the ideas about specific whites and whiteness conveyed through this particular narrative about the Z-Boys) compel the filmmakers and urge viewers to interpret the Z-Boys' criminal acts as relatively innocuous youthful hi-jinks or as acceptable masculine, imperialistic turf building, rather than as alarming expressions of their race in need of social discipline or punishment.

One cannot help but wonder what sort of different interpretive frame would be used to tell and read the story of the Z-Boys if they were black male youth? I think a fruitful question to consider is: Would the Z-Boys' urban, economically depressed origins, juvenile criminal transgressions, and disregard for (white) private property be warmly remembered, celebrated, and pleasurably offered to audiences, or would their story be told through a radically different interpretive frame of suspicion, alarm, outrage, discipline, and punishment?

The Importance of Dogtown: Using Class Difference to Disaffiliate From Whiteness (or, the Politics of White Particularity, Part I)

The film begins the Z-Boys story by providing an abbreviated history of the geographic location in California called "Dogtown." The prominence given to Dogtown, with its foregrounding in the title of the documentary as well as its positioning as the beginning of the story of the Z-Boys, signifies its importance in understanding the white identity ascribed to the Z-Boys. Thus, making sense of the meanings articulated to Dogtown through the film's narrative is a crucial, initial step in deconstructing the racial politics of the collective white identity of the Z Boys (as well as its perceived cultural appeal).

According to the film, Dogtown is the nickname given to the beachfront area spanning Venice, Ocean Park, and Santa Monica, California. Through interviews with many of the principals of the Z-Boys group, Dogtown is repeatedly constituted in the film's narrative as an economically depressed area. Skip Engblom, who is described on the documentary's web site as one of three key mentors to the Z-Boys (Craig Steczyk and Jeff Ho are listed as the others), repeatedly instructs viewers throughout this section of the film that Santa Monica, California is a place with a clearly defined class line (identified as

Wilshire Blvd.), where people who lived north of that line "had money," while those south of that line "wanted their money." He goes on to characterize Dogtown as the "last great seaside slum" and "not the beach people came to vacation at." As viewers listen to Engblom's description of the class parameters and divisions of Santa Monica, they are shown a black and white image of a short, dilapidated concrete wall lined with graffiti warning "Malibus" and "Valleys" not to trespass on this beach. Other clips from interviewers with several former Z-Boys show them warmly remembering how they protected their coveted surf spot on POP, by excluding those not from Dogtown and terrorizing those who dared to "trespass" at POP. Next, viewers are shown black and white overhead shots of a desolate urban area inhabited only by unoccupied buildings at twilight as former Z-Boy, Wentzle Ruml, proudly explains to the viewer how "Dogtown was a place where you had to have eyes in the back of your head [to survive]." Finally, Skip Engblom returns to affirm Ruml's portrayal of Dogtown not only as economically deprived, but as a masculinizing rough and tough stomping ground for the Z-Boys when he states, "It [Dogtown] was dirty, filthy ... it was paradise [followed by pleasurable laughter]."

These particular descriptions of Dogtown combined with the filmmaker's use of grainy, black and white imagery through this part of the film work together to give a realistic authenticity to the idea of Dogtown as a dangerous urban space. Although these representations of Dogtown would seem to cast the area in a negative light, interviews with the former Z-Boys reveal how their connection to Dogtown is held up as a source of pride and badge of honor in their eyes. Through these portrayals of Dogtown as a rough and tough, economically depressed area, the Z-Boys' collective white identity is simultaneously authenticated as lacking affluence and economic privileges of any sort and as conventionally tough, strong, and streetwise white men who not only call such an apparently dangerous urban territory like Dogtown their home, but who imperialistically oversaw and controlled such an area. Thus, the purpose of telling this particular history of Dogtown in the film (especially during the beginning of the film) is not necessarily to substantively locate the Z-Boys in the broader socio-historical context within which their story could be read. Rather, it is to foster a particular (and strategic) first impression about the Z-Boys in the audience, one that is absolutely critical to all subsequent representations of the Z-Boys—that they are economically unprivileged, and that this is the foundational aspect of their (white) identity.

Next, this portrayal of Dogtown as economically depressed is reinforced through an origin story of Venice, California that, in one vein, traces the city

back to the early 1900s, to land developer Abbot Kinney's dream of building a European-like beach community of artists and amusements modeled after Venice, Italy. As audiences hear the history of Venice, California, they see still photos of giant Ferris wheels, rollercoasters, and beaches filled with white families playing and frolicking in the Pacific. Together, this narrative and corresponding images convey to viewers an era of good times, leisure, commerce, and fun experienced by the American (white) masses at Venice Beach until the 1960s. At that time, the narrator, actor Sean Penn, informs viewers that the piers and amusement parks closed down one after the other leaving behind old, fractured steel skeletons of roller coasters and the desolate surroundings of a former community of leisure and good times. Dogtown was the name eventually given to the portion of Venice Beach centered on POP which became a popular, but terribly dangerous place where Dogtown locals surfed. At this point in the film, the initial representation of Dogtown as a dangerous and economically depressed place is reinforced as Penn describes the area during the mid-1960s as becoming "a no-man's land, a place where pyromaniacs, junkies, artists, and surfers could excel in symbiotic disharmony" (*Dogtown and Z-Boys*, 2002).

The inclusion and specific framing of this origin story of Dogtown which recalls a glorious, idyllic past of good times, leisure, and prosperity that abruptly ended in the 1960s is interesting for a number of reasons. First, this origin story of Dogtown subtly disaffiliates the Z-Boys from previous eras of white prosperity and amusement. At the same time, this origin story articulates the Z-Boys with a community of marginalized anti-social outsiders ("pyromaniacs, junkies, artists, and surfers") who work to authenticate a marginal and outsider status for the Z-Boys. So then, as Dogtown is portrayed both as the economic detritus of the amusement park industry and as the crucible of the Z-Boys, the Z-Boys are implicitly coded as an economically unprivileged and socially marginalized group of mainly white male subjects who not only failed to benefit from this era of prosperity and good times but were the ones left behind by the machinery of American capitalism.

Not only are the various ways in which the whiteness of the Z-Boys is inflected throughout the film important to a critical reading of the *Dogtown and Z-Boys* documentary, but so is the recognition of the sequential order of the marking of their white identity as well. The portrayal early in the film's narrative of Dogtown as the social context which incubated the Z-Boys and shaped their collective identity is important because it establishes the idea of the Z-Boys' whiteness as economically unprivileged and socially marginalized. The foregrounding of this image of the whiteness of the Z-Boys is crucial to my

understanding of the racial politics of the film because it shows how important the disaffiliation of the Z-Boys from white privilege or what Wiegman (1999) calls "dominant whiteness" is to their identity (and I would also argue to the broader appeal and popularity of alternative or extreme sports in the late 1990s).

Using Racial Difference to Disaffiliate From Whiteness (or, the Politics of White Particularity, Part II)

Once whiteness is understood to be an unavoidable racial aspect of the film (if one does not already notice the racial contents of the film from the start), one must examine the particular ways in which the Z-Boys' collective identity is encoded (and read) as white throughout the film, while still absolutely depending upon conspicuous signs of racial difference to authenticate their white identity as supposedly different, marginalized, and disaffiliated from whiteness.

In featuring many of the white male members of the Z-Boys throughout the film's narrative and telling the story of the group as a whole through their individual stories, the film centers white (male) identity. This centering of whiteness in the collective identity of the Z-Boys is also seen throughout promotional pictures on web sites about the Z-Boys, movie posters, as well as, the video sleeve where the Z-Boys are represented through action shots of Jay Adams, Tony Alva, and nameless other skaters who would reasonably read at first glance as phenotypically white. This centering of whiteness in the collective identity of the Z-Boys is further reinforced by the corresponding marginalization of racial differences of any sort throughout the film. Although Jeff Ho, Peggy Oki, and Shogo Kobo are people of color (who phenotypically appear to be of Asian descent) whose voices are sporadically used to tell the story of the Z-Boys, their voices are only afforded a limited and peripheral position within the film. In the case of Jeff Ho and Peggy Oki, their marginalization in the film's narrative of the history of the Z-Boys is particularly conspicuous considering that Ho's surf shop was portrayed as the "home" of the Z-Boys "family," and Oki was the only "Z-Boy" (note how the very name Z-Boys itself marginalizes *her* position in the group) who garnered individual champion honors in the famous 1975 Del Ray skateboarding competition featured in another section of the documentary. Yet, the stories of Ho and Oki were largely untold within the film's narrative about the history of the Z-Boys relative to the time given to the stories of the white male members of the Zephyr team, particularly Jay Adams, Tony Alva, and to a lesser degree,

Stacy Peralta (Adams and Alva are explicitly represented in a later section of the film as personifying the spirit of the Zephyr team as I will discuss later).

But at the same time as one observes the ostensible exclusion of the stories of Ho and Oki in the film's narrative, it is important to consider the importance of their "marginalized inclusion" in the film's telling of the Z-Boys story as well. The marginalized inclusion of these people of color is absolutely crucial to how the film constructs the apparently "different" white identity of the Z-Boys. It strategically enables the Z-Boys' story to avoid seemingly obvious critiques of the racial and gender exclusivity of this alternative sport fraternity being glorified through this documentary. As Winant (2004) has argued, this superficial inclusion of racial difference within a predominantly white group is consistent with various expressions of the new cultural racism. People of color are often marginally included in visual or textual representations of various social groups, while whites are still centered in the group and numerically dominant (i.e., think of college and university public relations and recruitment brochures). Such images of multicultural accord are used to foster the ideas of post-civil rights interracial harmony, colorblindness, and the (white) mainstream's embrace of cultural diversity, while simultaneously maintaining the normativity, centeredness, and institutionalized power of whiteness. In fact, this cosmetic change in public racial representations usually substitutes for real, substantive material changes in social institutions (McCarthy, 1998b).

This strategy of articulating the Z-Boys' whiteness with a trace of racial difference in order to attempt to disaffiliate it from dominant whiteness is also reinforced through the film's brief story about Jeff Ho, one of the three mentors of the Z-Boys. Ho's story is important because it shows that one of the central mentors of the Z-Boys, in fact, the one whose shop the Z-Boys called their "home," is a person of color. Thus, any potential criticisms of the racial homogeneity or apparent racial exclusivity of the predominantly white and male Z-Boys again can be challenged by highlighting the significant position which Ho played in the formation of the Z-Boys even as he is only given a superficial place in the film's narrative. In addition, Ho is incorporated into the origin story of the Z-Boys because the graphics he used to uniquely decorate his boards were said to be derived directly from the "culturally mixed neighborhoods" of Dogtown. The bright colors and spray paint-styled design of the surfboards, which are represented as part of the unique contribution of the Z-Boys to the history and culture of alternative sports, were said to be inspired by the urban wall art, graffiti, and diverse traditions of local (Latino) gangs. Skip Engblom, in celebrating Ho's designs as a way of detailing the unique style of the Z-Boys, emphasizes how they were distinctly different from

those mass-produced in the mainstream surf industry represented in the film through images of smiling, comfortable blonde-haired, blue-eyed white teens frolicking on bright, idyllic Californian beaches. Engblom reinforces this purported difference between the white collective identity of the Z-Boys relative to the prototypical (read: white) mainstream surfer through a nostalgic personal memory of how, as a young man, he didn't sexually fantasize about blonde girls named Buffy, but instead daydreamed about big-haired Latinas in low-rider cars. Although whiteness is never explicitly mentioned in these scenes, the referents Engblom employs to constitute the difference of the Z-Boys carry with them clear racial meanings in the context of new millennium America. "Blonde girls named Buffy" is a clear coded referent of dominant whiteness, while Engblom's preference for "big-haired Latinas in low-riders" is mobilized to authenticate the "differentness" of the Z-Boys' whiteness by distancing it from normative or dominant whiteness through identification with a culture of color. Engblom's story also carries the added meaning of reinforcing the Z-Boys' associations with economically unprivileged working class culture as well. So then, the story of Jeff Ho's surf shop and the origins of his board designs effectively facilitate the authentication of the Z-Boys' white identity as being disaffiliated and disconnected from dominant/mainstream whiteness by locating the origins of their collective style in the "culturally mixed neighborhoods" of Dogtown.

Yet, it is important to note that as much as these testimonials of the Z-Boys' style being rooted in the urban, Latino gang and car culture in which they came of age, the only member of the Z-Boys who appears to perhaps be of Latin descent is Tony Alva. Yet, if Alva does have Latin roots, they were not mentioned, let alone substantively discussed, in the film. Nor was the influence of Latino gang culture on the Z-Boys' style given more substantive discussion or contextualization throughout the film. Thus, one might reasonably question the value or function of these stories to the construction of the white identity of the Z-Boys. It seems that part of this new cultural racism is the reduction of racial difference to cultural/esthetic characteristics that can be commodified, traded, and tried on (King & Leonard, 2006). Here, signs of racial/ethnic difference are incorporated into the film's narrative but only on a superficial level which allows them to attempt to authenticate the Z-Boys' collective white identity as seemingly distanced and disaffiliated from dominant whiteness. To more substantively discuss the Z-Boys' connection to Latino gang culture, or the multicultural dimensions of the Z-Boys "family" would disrupt the ideological function of the appearance and prominence of extreme sports figures like the Z-Boys which is to allow particular whites to cloak themselves

within the clothes of "cultural difference," to mask and disguise how their stories are being mobilized to suit the economic and political interests of the white neoliberal emperor who no longer has any clothes (i.e., the perpetuation and extension of whiteness, patriarchy, and global, imperialistic capitalism both within and outside of the United States).

These stories are important to the white identity of the Z-Boys because they effectively encode it, at its origin, as being different from dominant whiteness (which would not be articulated with urban gangs of color) and disaffiliated from white privilege. This strategy of marginalized inclusion of cultural difference also perpetrates a form of symbolic violence on Ho, Oki, and the Latin culture of Dogtown that allegedly had a significant influence on the Z-Boys. That is, as their particular stories within the history of the Z-Boys are displaced (especially Oki's and Ho's), their visible racial difference is superficially appropriated and exploited to afford the Z-Boys' collective white identity with the highly valued cultural capital of "cultural difference" in the "era of the multicultural," as McCarthy called it (1998, p. 339). Thus, this seemingly "different" white identity of the Z-Boys, which appears at first glance to be racially inclusive and comfortable with "diverse" racial others, and thus, disaffiliated from white supremacy, still rehearses and valorizes racial ideologies, social relations, violence, and identities historically used to produce and reproduce a normative and centered position for whiteness in American culture and society.

Recentering Whiteness Through "The Zephyr Spirit"
(or, the Politics of White Particularity, Part III)

In the last quarter of the film, two of the Z-Boys, Jay Adams and Tony Alva, are singled out as the two who "best personify the Zephyr spirit" and viewers are given more in-depth stories about them. Positioning Adams and Alva as the two key figures of the Z-Boys group is particularly interesting because it further exemplifies how the celebration of the Z-Boys in this film involves downplaying ideas of whites as wealthy and privileged, while simultaneously subtextually offering (through the stories of Adams and Alva) conventional notions of whites as pure, good, innocent, dominant, and superior subjects (especially at their core).

The focus on Adams and Alva in this latter segment of the film begs a couple of interrelated questions: Why are these two singled out for special attention in the documentary? Why not Stacy Peralta, the filmmaker, who himself is a former Z-Boy, world champion, and is described in the film as "the most financially successful skater to emerge from Dogtown"? An easy answer is

that Peralta is overlooked because, as the filmmaker, he wants to avoid charges that the film is simply an exercise in his own narcissism. But, this answer comes too easily. Such an answer makes it difficult to see how Peralta's story, unlike the stories of Adams and Alva, could not easily be articulated within the conjuncturally specific ideological dimensions of the new cultural racism whose goal is to render invisible white privilege, while highlighting particular whites as economically unprivileged and socially marginalized, all the while leaving whiteness still firmly centered in American culture and society.

These in-depth accounts of the lives of Jay Adams and Tony Alva begin by stating that the bond between Adams and Alva and which makes them representative of the "spirit of the Z-Boys" is that they, more than any of the other members of the Zephyr team, were crazy and mischievous and refused to obey authority figures and basic social norms of any kind. This initial portrayal of Adams and Alva solidifies their credentials as cool, rebellious, thoroughly masculine, and supposedly anti-establishment skateboarders. But, if read within an optic of race, we can read this portrayal as also celebrating an unconstrained white masculinity which refuses to submit to cultural authorities or social norms of any sort. This white desire to avoid social constraints is symptomatic of the era of political correctness from which it emerges, where whites feel unfairly constrained (in their rhetoric and actions) by pervasive public criticisms of white privilege. This refusal to submit to cultural authorities and to enact an unconstrained agency is a central aspect of the Z-Boys' white identity that is valorized in these stories about Adams and Alva. Additionally, I will show how specific focus is given to the stories of Adams and Alva because, together, they enable a particular white identity that is politically useful to be constructed, an image of white masculinity as victimized, free from social constraints, and athletically superior and dominant relative to all others.

Jay Adams

The in-depth feature on Jay Adams begins with multiple black and white shots of him as a smiling, seemingly innocent, happy boy with long golden blonde locks who appears to find much joy in skateboarding as Neil Young's introspective and contemplative song, "Old Man," plays in the background. The lamentful tone of the music, with the line, "old man take a look at my life, I'm a lot like you were," chosen to accompany these images of the youthful Adams effectively foster an affective (sympathetic) identification between Adams and (white) audiences. The accompanying narration informs viewers that Adams came from a broken home, while it simultaneously explains how Adams was supported in surfing and skateboarding by his stepfather who was

an avid surfer himself. This image of Adams as wide-eyed, youthful innocence, as well as the connection between fathers and sons, starkly contrasts with the next piece of information provided about him—he is currently in prison for trafficking drugs. The specifics of how Adams landed in federal prison are never addressed by the film. Interestingly, when Peralta asks Adams if he has any regrets with the "ride" he took through the skateboarding industry, Adams declares that he only has partial regret over some of the poor decisions which he made in his life. Through his comments, Adams' is able to admirably take personal responsibility for his plight, while still maintaining a masculine illusion of being a self-authoring subject. So even at a moment when Adams' white masculinity could appear as irredeemably criminalized and in need of discipline and punishment, it is amazingly redeemed as he takes responsibility for his poor choices. Not only does this sequence reproduce conventional notions of whiteness as essentially good and pure at its core, but it simultaneously reproduces the contemporary New Right logic that a person's life outcomes are solely the product of one's choices (divorced from broader social conditions).

It is quite conspicuous and peculiar that this in-depth profile of Adams, a convicted felon, begins with shots of a wide-eyed, smiling, and happy-go-lucky Adams as a boy. Such images rely on conventional and mutually reinforcing notions of whiteness and childhood as pure, innocent, and essentially good to activate the affective sympathies of white viewers for Adams. Such representations compel a reading of Adams' white masculinity as—at its core— boyish, pure, innocent, and simply out to have fun. This reading of Adams is reinforced through testimonials from Adams himself and other Z-Boys who each emphasize that all Adams ever wanted to do was to have fun surfing or skateboarding. These representations of Adams also compel the audience to displace and forget the criminal transgressions of the present-day, adult, white male Adams who is currently behind bars in a federal prison. In remembering Adams as an innocent boy, his white masculinity is effectively dissociated from the institutional supports of dominant whiteness that are usually imagined as being conferred only on adult white males. At the same time, the filmmaker's brief but important mention of Adams' current status in prison during this in-depth segment also reinforces the idea of him as an unprivileged white male.

The film's discursive redemption of Adams (where he can be represented as "essentially" good and as a positive representative of the spirit of the Z-Boys) is enabled by the dominant whiteness that implicitly overdetermines the film's representations of the Z-Boys (as well as most white viewers' readings of them). This overdetermined understanding of white people as essentially innocent and pure enables Adams' anti-social and criminal acts to ultimately be

imagined as the relatively innocent acts of rebelliousness performed "universally" and "naturally" by male teens and thus are not necessarily in need of social discipline and/or punishment. In fact, the interpretive frame of dominant whiteness allows Adams' anti-social acts not only to evade punishment and penalty but, quite to the contrary, it serves to construct him as a tragic figure deserving of our collective sympathy.

It is also important to situate this particular portrayal of Adams as a white man-boy that is innocent at its core in the broader socio-cultural context of 1990s America. In this era where white privilege was publicly criticized and an image of white men as always already evil, oppressive, and over-privileged appeared more frequently in mainstream American popular culture, this strategy of constituting white men in a variety of ways as innocent boys who are not quite fully men (think about the films: *Big, Billy Madison, Forrest Gump, About a Boy*, or even *Fight Club*) was yet another popular strategy used to attempt to distance and disaffiliate individual white males from white male privilege, as well as, disavowing its institutional existence (Pfeil, 2002). The subject position of being a boy, which situates the white male in a life-stage where he seems to be not fully invested in, and a part of American institutional life, the machinery of global capitalism, and the American political sphere enables this boyish white masculinity to appear as disaffiliated from the American social system which affords unearned privileges to whites and men. Viewers are told that Adams never skated for the money, that he did not care about the material rewards available through skateboarding. Portrayed as a naïve and overly trusting boy, Adams is ostensibly forwarded as an innocent object exploited by the commercial skateboarding industry. Thus, through this depiction of Jay Adams as a white (unmarked) man-boy who is said to personify the spirit of the Z-Boys, the film reproduces an image of white masculinity as essentially innocent and pure and disconnected from racial (and gender) privileges of any sort. Once again, in a subtle and complexly coded manner, the film effectively produces the Z-Boys' whiteness in ways which constitute it as unprivileged (in this case through the story of Adams' origins from a broken home, his present imprisoned existence, and his man-boy subject position) and distanced and disaffiliated from white privilege.

Finally, the ending of the segment returns to more shots of Adams as a smiling, precocious, happy boy. A voiceover from Peralta informs the viewer that it makes him extremely sad to see that Jay didn't make it because he was "better than all of us (Z-Boys)." Together, the boyhood shots, sullen music, and voiceover from Peralta highlighting Adams' unlimited potential on a skateboard offer him as a cautionary tale. But, what is Adams' story supposed

to caution us about? Clearly, in my mind, the film subtly cautions us not about making poor choices, or of any inherent character flaws, or deviant urges inherent within pale-skinned people as a social group, but rather it implicitly warns viewers about the perils of not providing proper social support to white males—that if this occurs, society will lose out for it will not witness the natural, "god-given" greatness inherent in white man-boys like Jay Adams. Once again, a particular white identity—at once both authentically unprivileged and yet inherently good, pure, innocent, and naturally superior to all others—is forwarded as the (partial) embodiment of the spirit of the Z-Boys.

Tony Alva

Next, the film features an in-depth story of the other former Z-Boy, Tony Alva, who is forwarded as personifying another crucial aspect of the ethos of the Z-Boys. Whereas Adams' story plays an important role in facilitating the articulation of the Z-Boys' white masculinity as being authentically unprivileged in the past and the present (as a means of authenticating the disaffiliation of the Z-Boys' white masculinity from white male privilege), the importance given to Alva during this segment of the film relative to the collective white identity of the Z-Boys is that he reinforces the dominant masculinized superiority of the Z-Boys' "different" form of whiteness. In other words, on one hand, Alva is cast as the cool, hip, unique white skateboarder whose identity is thoroughly and authentically dedicated to skateboarding as a lifestyle (thereby reinforcing the authenticity of the extreme participant's marginalized status). To reinforce this notion of Alva, viewers are shown images both of a young Alva posing as a masculinized, cool hipster in 1970's skateboarding adverts and contemporary footage of the forty-something Alva still carving innovative lines with youths more than half his age in an emptied-out swimming pool. These images draw a line of continuity between the contemporary Alva and his youthful 1970s version of himself and work to authenticate the portrayal of Alva as uniquely different, superior to all other skateboarders of his era, and still (supposedly) refusing to become a part of the American mainstream.

At this point, we should recall that Alva's racial/ethnic identity is both suitably ambiguous and unremarked upon throughout the film. In various images displayed throughout the film, Alva could reasonably be read as Latino, white, black, or bi-racial. But again, it is conspicuous that his racial/ethnic identity is never discussed and that his racial/ethnic identity appears to be thus ambiguous. At the same time, I contend that the black and white footage and lighting used in the contemporary interviews with Alva (which dominate this segment of the film) make it easier to read Alva as white. The omission of any

mention of Alva's racial/ethnic identity not only prescribes to the colorblind ethos of the new cultural racism, but it enables the various elaborations of his identity throughout the film to be read as ideological vehicles supportive of the interests of re-securing dominant whiteness.

The illustration of Alva as a cool and "different" white Z-Boy is also produced through a series of comparisons between Alva and black stars of sport and entertainment, and through the subtle discursive appropriation of codes of racial difference (particularly blackness) to signify his "different" white identity. For example, the first comparison between Alva and a black performer is the explanation of Alva's skateboarding superiority by stating that he was "the Michael Jordan of skateboarding." Later, when describing Alva's skating style, Peralta calls him the "Chuck Berry of skateboarding," a comparison meant to highlight the distinctiveness and transcendent greatness of Alva's style. Alva himself joins in the act when he compares his becoming the 1978 World Skateboarding Overall Champion to Muhammad Ali's victory over Joe Frazier. Contemporary black and white footage of Alva answering questions in interviews and skating also show him wearing dread-locks, a hairstyle predominantly associated with cultures of African descent. Add these black discursive encodings of Alva's white masculinity with the heavy emphasis given to his "style" in showcasing Alva's exceptionality. Of course, "style" has long been stereotypically imagined by whites (at least since the days of Norman Mailer's "The White Negro" (Savran, 1998)) as the distinct province of black culture (and black men) longed for by many white men. And white appropriation of black style has long been a way for whites to (attempt to) distance and disaffiliate themselves from dominant whiteness and white privilege (Lott, 1997; Savran, 1998). So, as this portion of the film articulates Alva's cool and unique white identity via a series of cross-racial comparisons and through a subtly coded emphasis on "style," we see how racial difference is being appropriated here through the constitution of Alva's unmarked (and therefore) white identity to encode it as "different" and strategically dissociated from dominant whiteness.

But, Alva is also singled out in this latter quarter of the film's narrative because his story enables the Z-Boys' white identity to re-inscribe the conventional notions of whiteness as superior, dominant, and culturally centered. Viewers are shown pictures and competition standings clipped from skateboarding magazines of the 1970s as well as video footage of Alva winning downhill slalom races during that era. Such images, along with the accompanying narratives from narrator Sean Penn and the other Z-Boys affirm Alva's ascendant skateboarding success and popularity in the late 1970s. From

Peralta to Jay Adams to Wentzle Ruml to Steve Caballero to Tony Hawk, one accomplished skateboarder after another confirms that Alva is the best all-around skateboarder to ever walk in the planet. Viewers learn that not only was Alva a national skateboarding champion, but his popularity was global. In a brief moment of modesty, Alva conveys his own disbelief in traveling to England in the late 1970s to discover that a popular skating bowl there had been named after him even though he had never been there before. His fame is even represented as transcending the boundaries of skateboarding as he is lauded for rubbing elbows with Hollywood stars back in the 1970s. Such portrayals of Alva produce a very traditional image of white masculinity as dominant, superior, and revered.

Alva is also endorsed in this segment of the film when he is made to embody hyper-competitiveness and a strong desire to always be the best. At times, Alva's desire to be superior to all others is described through a rhetoric of excess as egomaniacal. But, rather than demonizing this desire, it is instead valorized by his contemporaries because Tony can back his boasts with results (results which no one else can come close to topping). Thus, it seems that white male arrogance is seen here as acceptable as long as it is backed by results, because such boasts and results reinforce conventional notions of white male dominance and superiority.

So then, in this latter section of the film, we begin to see how the dual images of white masculinity constructed via stories of Adams and Alva are not just randomly chosen as the essence of the identity of the Z-Boys, rather they are ideologically dependent upon one another. Not only are they both necessary to constitute the appealing features of the Z-Boys in the popular imaginary, but they are dependent upon one another because they are constitutive of, and constituted by, a popular (and politically strategic) new cultural racism with its constitutive representational strategies used to render visible white masculinity in late 1990s America. This segment of the film, like the broader narrative of the film, rehearses a common representational strategy of white male victimization texts produced during this era where white male subjects are initially encoded as economically unprivileged and socially marginalized, yet by the end of that text white masculinity is subsequently encoded as dominant as it is re-centered and its normativity re-secured in American culture. The image of whiteness as unprivileged and de-centered alone would potentially threaten the supremacy and normativity of whiteness, so it can only find a place in American mainstream media culture and will only be embraced by the white power bloc and white audiences if it simultaneously works in some way to reproduce white normativity and supremacy. The coding of white masculinity through the

particular stories told throughout the film and the particular meanings articulated to the collective identity of the Z-Boys fit this formula of first particularizing the white identity of the Z-Boys as economic and social "other," before reconstituting them at film's end as "rock stars" and "kings of the world" who have revolutionized the mainstream. But, where the film seems to assert that the Z-Boys (unknowingly) initiated a cultural revolution of the values and ethos of the American mainstream, I want to reinforce that a more sound interpretation of the mainstream appetite for this documentary on *Dogtown and Z-Boys* (evidenced both in the reviewers' identification with the Z-Boys and the contemporary popularization of extreme sports) is that the mainstream's embrace of these sporting activities and white male figures is grounded in their ability to offer seemingly authentic stories of economically unprivileged and socially marginalized whites, while still re-inscribing conventional notions of whiteness as dominant, superior, and culturally centered. Such "authentic" images of whites carry a distinct and valuable political value for the white power bloc and public in the specific conjuncture of new millennium America.

Epilogue: *Lords of Dogtown*

In the summer of 2005, the Z-Boys' story was re-told on the big screen; this time in the form of a fictionalized Hollywood studio film. My personal interest in watching *Lords of Dogtown* was to note the similarities and differences between how the Z-Boys' story was told in *Lords* when compared to the initial documentary. So, with space enough only to offer some brief observations about the film, I discuss some of the ideological similarities and divergences between the documentary and fictionalized versions of the Z-Boys' story.

Let me begin with the differences between the titles of the two films. As I argued above, the title for *Dogtown and Z-Boys* foregrounds the economically depressed and "culturally mixed" Dogtown as a way of constituting the collective identity of the Z Boys as, at their core, an economically unprivileged group of (mainly) white males. In contrast, the title, *Lords of Dogtown*, carries with it very different racial, class, and gender connotations. Depicted as "Lords," the hard-living and risk-taking Z-Boys, who are overwhelmingly male and white, are immediately introduced as the rulers of Dogtown. The use of the term "Lords" to describe the Z-Boys is peculiar but subtly reveals a shift in the meanings articulated with white masculinity in post-9/11 America. With the connotations of "Lords" steeped in feudalist societies where white patriarchs with supposed naturally endowed rights to rule over all others reigned supreme, *Lords of Dogtown*, rather than attempting to authenticate the Z-Boys as economically unprivileged and socially marginalized, appears more interested in

portraying them as the conventionally masculinized, imperialistic rulers of Dogtown and, by extension, the cultural definers of skateboarding. This change in the title of the film is indicative of the different historical contexts in which each of the films was made. Prior to September 11, 2001 a dominant force in American media culture was the popularization of various representational strategies to disavow white privilege in the era of identity politics. Following 9/11, this move to disavow white privilege has become more of a residual force in American media culture as the terrorist attack on the United States led to the emergence of a discourse in US culture to put aside our so-called "trivial" racial differences which were said to pale in the face of this external, "foreign" terrorist threat to "all Americans." This desire to unite as a nation following September 11, 2001 by displacing and eliding issues of race within American social life was coupled with the cultural circulation of narratives involving heroic and unapologetically conventionally masculine white everymen heartily protecting "US" from this terrorist threat. In addition, more testosterone-laden, imperialistic desires and cultural projects have become popular in post-9/11 America. Interestingly, some of the pre-9/11 "backlash" texts which served to mask, deny, or disavow the existence of white male privilege have been rearticulated so that the types of "unprivileged" white everymen found in those texts are being reborn as either the conventionally masculine heroic protectors of our national present and future or to promote and valorize American imperialistic desires. *Lords* can especially be read as being a product, and generator, of this emergent white male desire to dominate once again.

The film further reinforces this post-9/11 desire of American white men to dominate others by valorizing the Z-Boys' attempts to conquer the 1970s skateboarding world both in the United States and globally which mainly get expressed through Alva's story of traveling the globe to sell skateboarding and himself. What's remarkable about the *Lords of Dogtown*'s story is that it fuels contemporary American imperialistic desires by valorizing the Z-Boys' desire to rule over Dogtown and to dominate all within the world of skateboarding, while not seeming to have anything to do with contemporary US imperialism in post-9/11 America.

Although on one level *Lords* constitutes the Z-Boys in more imperialistic terms, the film does not completely diverge from *Dogtown*'s emphasis on the Z-Boys as economically unprivileged and socially marginalized white man-boys. Through early scenes which detail the broken, distant, and seemingly economically disadvantaged families of the Z-Boys, as well as the boys' efforts to raid the empty swimming pools of wealthier Californians in order to skate them, the Z-Boys are romanticized as cool, rebellious, outsider/outlaw white

man-boys from "across the tracks" yet not seen as the type of true "outsider" who is a threat to white suburbs or middle-class values. What becomes apparent here is that even in 2005, such a white masculine subjectivity, one that can be both marginal and normative at once, is still believed to be a viable commodity and desired subjectivity for white men of various ages. But we should also keep in mind that post-World War II American culture has seen such youthful, rebellious, authentically outsider, white male figures like this from time to time before. So, we should not consider the Z-Boys' unprivileged, marginalized white masculinity to represent a significant reinvention of white identity as much as it represents a just another white man who still loves his red meat while attempting to co-opt the position of the racial and economic "other" (Pfeil, 1995).

It is also apparent in *Lords* that the social world of the Z-Boys is portrayed as more racially homogenous and white than in *Dogtown and Z-Boys*. Even though *Lords* does explicitly portray Tony Alva as Hispanic through scenes of his domineering father berating Tony in Spanish and Jay Adams being drawn to a Latino vatos culture than in *Dogtown*, on the whole it seems that the fictionalizing and mainstreaming of the Z-Boys' story involved the white-washing of their story. Erased from the *Lords'* depiction of the story of the Z-Boys is Jeff Ho, who in the original documentary (and its promotional materials) is forwarded as the owner of the Zephyr's surf and skateboarding shop, innovative creator of the Z-Boys' "urban" style, as well as one of the metaphoric fathers of the Z-Boys' family. Also, in *Lords* the place of Peggy Oki, the lone Z-Boy to win an event at the 1975 Del Ray skateboarding championships, is reduced to brief appearances in panning shots of the action and hi-jinks that went along with the skateboarding competitions. Whereas *Dogtown* seemed to conspicuously highlight Oki and Ho as key (even if secondary) figures in the formation and history of the Z-Boys—almost as a way of giving the Z-Boys' white identity some multicultural and feminist caché— *Lords* framing of the Z-Boys story appears to work to minimize their place within their history.

Finally, *Lords* confirms an interpretive suspicion I gestured at above in my critical analysis of *Dogtown*; namely, that the stories of Peralta, Adams, and Alva are all necessary to constitute the complex and specific contours of the white masculinity being produced and valorized through the Z-Boys' story in new millennium America. In other words, the film would not be allowed a space in the mainstream nor would it be well received by American audiences if it were a story focused on only one of the three skating legends alone. All three Z-Boys are needed to fit the Z-Boys' story within the contours of the conservative

racial and gender discourses which implicitly overdetermine each film's narratives.

But, whereas *Dogtown* centered the story of the Z-Boys on Adams and Alva while downplaying Peralta's place in the history of the Z-Boys, *Lords* seems to center the Z-Boys' story around Peralta and Adams (while pushing Alva more to the margins of the Z-Boys' story). How do we make sense of this change?

We might begin by considering that *Lords*, as a Hollywood studio film, was intended to reach a broader, more mainstream audience, whereas *Dogtown*, as a documentary, was originally directed at a niche crowd who likely see themselves as residing in the social margins, more closely associated with skateboarding, and interested in the Z-Boys' story. As the Z-Boys' story is mainstreamed via the production of *Lords*, one might expect efforts to "normalize" the Z-Boys (without completely ridding them of their authentic marginalized, outsider status) to mainstream audiences. One way in which *Lords* attempts to do this is to make more productive, grounded, and commercially successful Stacy Peralta the central figure of the film's narrative. So, where Peralta was deliberately marginalized in the *Dogtown* narrative, he is strategically re-centered in *Lords*. By constituting Peralta as the center of the film's narrative, the Z-Boys' white masculinity, first and foremost, gets portrayed to the mainstream as: hard working, desiring upward socio-economic mobility, virtuous, innocent, respectful of women, and commercially successful, values better aligned with those of the American middle classes.

Next, and similar to *Dogtown*'s narrative, Jay Adams is the other central figure through which the Z-Boys' white masculinity is mainly constituted in *Lords*. Left out of *Lords* though is any mention of Adams' incarceration as an adult. At the same time, viewers of *Lords* do get to see Adams cast as a troubled kid prone to outbursts of rage, but who underneath it all has a heart of gold. Adams' outbursts of violence are represented as the product of his unstable family life. Yet, the film conspicuously includes a scene (one not shown in *Dogtown*) of Adams showing off his trophy to his mom with pride, and as she works on the line at her manufacturing job, promising her he'll earn enough money through skateboarding to make her life easier as she toils on the manufacturing line. This scene, like some of those from *Dogtown*, urges the audience to see Adams—at his core—as a good, caring, well-intentioned person. Together, the stories of Peralta and Adams enable a particular image of white masculinity to be constituted, one that forwards the outsider white masculinity of the Z-Boys as still reassuredly virtuous, caring, and industrious at its core. At the same time, both are distanced from social or economic privilege

as they are shown coming from rather unstable and economically deprived families (with Adams' family life surely worse than Peralta's).

Now, to be clear, I am not trying to claim that Tony Alva's story has little to do with the way in which the Z-Boys' collective white identity is constituted in *Lords*. Actually, it is quite to the contrary. As mentioned above, in both the films, Alva enables the Z-Boys collective white identity to be read both as hip, cool, brash, and rebellious (that is to be able to discursively occupy the position of racial other to dominant whiteness), and to be seen as uncontainable, imperialistic, and driven by an almost pathological need to be the best. Whereas in *Dogtown* Alva's Latin roots are kept ambiguous (but where he is rather obviously discursively positioned at times as racial other), in *Lords* Alva's Latin roots are made explicit through rather negative portrayals of his father terrorizing him for a variety of reasons. Perhaps this would explain why Alva's story is pushed to the margins of the *Lords'* storylines. In this alleged "post-white" historical moment, where the pre-9/11 expectation of colorblindness has only been intensified in post-9/11 America (up to Katrina's devastating impact on the Gulf coast which made the influence of race and class on one's agency and life outcome once again apparent to many white Americans), Alva's Latin roots can only be mentioned at the expense of his being marginalized in the story of the Z-Boys. We must remember that the Z-Boys story only finds a place in the American mainstream to the extent which it offers a popular mythology—whites as economically and socially unprivileged—used to disavow white privilege and white dominance precisely at the historical moment when it has been rendered visible and undergone significant public critique. So, whereas in *Dogtown* Adams and Alva are forwarded as the embodiments of the Zephyr spirit because their stories give credibility to the authenticity of the marginalized, unprivileged and outsider status of the Z-Boys, Peralta and Adams get thrust to the fore in the Hollywood-ized version of their story because as blonde-haired and blue-eyed phenotypically white (and male) subjects they remind us of the *raison d'être* of *Dogtown* and *Lords*, to both disavow while still reproducing the social and cultural privileges of whiteness.

✄ CHAPTER SEVEN

Lance America: Interrogating the Politics of the National Fantasy of Lance Armstrong

Introduction

When you are Lance Armstrong and you've survived 12 tumors on your lungs, two on your brain, and a cancer-ravaged testicle the size of a lemon, the French Alps start to look like speed bumps. When you are Lance Armstrong and you keep an expired driver's license in your wallet because it shows you in Death's lobby, your face paler than 1% milk, your eyebrows and eyelashes and hair missing, and your eyes as two yellow moons, a six-hour ride up and down murderous mountains sounds like a Tupperware party.

Reilly (2001).

*Announcements of a crisis in white masculinity, and a widely evidenced interest in wounded white men, themselves perform the cultural work of **re**centering white masculinity by **de**centering it.*

Robinson (2000, p.12).

Well it's the combination of those two things in the same sentence that I think is Lance's real legacy: cancer survivor and seven time Tour winner. The two go hand in hand. What Lance proved is that you can not only survive illness, you can thrive afterwards. It can actually be improving ... In Lance's case, it was the making of him. Make him a better racer, make him a better man. And I don't think anyone had ever suggested such a thing before about cancer that it could chisel out a better human being.

Jenkins (2004).

Certain ideas are hammered into the public with such persistence and through so many channels that they are difficult to escape. They become the consensus.

Vera and Gordon (2003, p.192).

As the nation passed from one century to the next, Lance Armstrong's extraordinary story of surviving cancer to go on and win the Tour de France not just once, but a record seven straight times, was enthusiastically celebrated

all across American media culture. The magnitude of the cultural celebration of Armstrong's story is evidenced in a number of ways.

First, his story was featured not only through the usual sites of the American sporting media like *Sports Illustrated*, the Sports section of *USA Today*, and ESPN's programs like *Outside the Lines* and *Sports Century*, but also through non-sporting sites like *People* and *Time* magazines, NBC's *Dateline* and *The Today Show*, ABC's *Good Morning America*, and even hour-long television specials on the *Discovery Channel* and the series, *Lance Chronicles*, on the *Outdoor Life Network*. His autobiography, *It's Not About the Bike* and follow-up book of inspiration, *Every Second Counts* (both co-authored with Sally Jenkins), both instantly became *New York Times* best sellers. Armstrong also quickly became one of the most popular athletic endorsers making sales pitches for numerous corporations like Nike, the United States Postal Service, Subaru, Trek Bicycles, Bristol-Meyers Squibb, Wheaties, and AIM Mutual Funds, among others (Horovitz, 2000). While during 2005 the ubiquitous yellow, "LIVESTRONG" bracelets created by Nike as a symbolic celebration of Armstrong and others' survival of cancer became a huge fad in the United States.

But, perhaps the biggest indication of Armstrong's presumed mass appeal with "the American people" (and how much he's been positioned and imagined as a representative of the American normative) is the number of politicians from both sides of the aisle who have queued up to publicly celebrate Armstrong. Following Armstrong's first victory in the Tour de France, North Carolinian House of Representative Sue Myrick sponsored a bill to honor him with a Congressional Gold Medal. In her introduction of the bill, Myrick highlights how easily Lance Armstrong and his story are articulated with America: "Lance Armstrong's courageous spirit is an inspiration to all Americans. By building upon his exceptional athletic accomplishments to lead the fight against cancer, he is one of the first *true American heroes* of the 21st century" (Myrick, 2000, emphasis added).

Not to be outdone, in 2001, President George W. Bush echoed Myrick's sentiments at a White House news conference acknowledging Armstrong's third straight Tour de France victory. Specifically, the President described Armstrong as "a true champ, a great American ... a story of character and ... class, and an extraordinary human being" (Bush, 2001, pp. 1130). While in 2005, former Democratic Presidential Candidate John Kerry took time out of his busy schedule to fly to France to meet Armstrong and witness what turned out to be his seventh and final victory in the Tour. Subsequent press stories about Kerry's rendezvous with Armstrong focused on Kerry's assessment that Armstrong had all of the tools necessary to become a politician (if, of course,

Armstrong desired such a career choice) in the future. Although Kerry also joked about his concern that Armstrong might run as a Republican!

Time and time again, Lance Armstrong is portrayed through these various sites as the ultimate contemporary symbol of hope, inspiration, and the limitless potential of the human will and spirit to American audiences. In fact, in hyperbole best suited for his company's trademark marketing campaigns Nike's former CEO Phil Knight once declared about Armstrong, "Lance is hope as man." Armstrong's story of surviving cancer to become an athletic champion and all-around better person (both on and off his bike, we are told) is offered to Americans as a popular pedagogy meant to urge each of us, individually, not to take any aspect of our lives for granted, to make the most of every day, to always strive to reach our potential, and to dare to dream big.

At first glance, it would seem that there is little about the above maxims inspired by Armstrong's story that one could or should be critical of. Yet, through this chapter, I will argue that the national fantasy of Lance Armstrong as wounded cancer survivor, the embodiment of the limitlessness of the human spirit, and as "one of the first *true American heroes* of the 21st century" is constituted by, and constitutive of, a conservative cultural politics which enables a number of complex images/effects: a white male occupying the position of the "truly disadvantaged" subject (with his near-fatal bout with cancer trumping all other forms of social disadvantage), the reassertion of whiteness as truly representative of America and as carefully disguised claims of white supremacy, and the unapologetic celebration of the return of an unequivocal "man's man" masculinity (that is conspicuously still acceptably and strategically caring and compassionate).

The amazing part of the national fantasy of Lance Armstrong is that, for most people (especially those unproblematically invested in the dominant and intertwined mythologies of America, whiteness, and hegemonic masculinity), it doesn't seem to be about race, gender, or cultural politics at all. This reading of Armstrong gets produced out of a number of conditions and factors. First, one must consider how the media repeatedly frame Armstrong's story as either a human interest story that transcends cultural boundaries and universally appeals to all people regardless of one's race, class, gender, age, ethnicity, and nationality; a story celebrating the transcendent power of the human spirit; or as another—albeit extraordinary—"rags to riches" story featuring an American dominating an international sport. Framed through these humanist and patriotic tropes, it is admittedly difficult to notice, let alone criticize, the ultraconservative politics which underlie the pleasures that many Americans feel in embracing Armstrong's story.

Such a critical reading of Armstrong's national fantasy is further made difficult by the "ritual of consensus" (Cole, 1996, p. 389) which implicitly structures many of the American media discourses about Armstrong. This "ritual of consensus" assumes and asserts that Armstrong enjoys universal popularity among Americans, thereby making such support appear as an indisputable fact while compelling others to join in the pleasure of his remarkable story.[1] Situate these representational strategies in a new millennium context (especially post-9/11) when Americans have been urged to set aside our "petty" social differences/divisions (i.e., namely those related to race, class, and gender) to unite as "Americans" against the new terrorist threat, and it becomes easier to understand how this national fantasy of Armstrong—which revives, as it reproduces, such conventional ideologies of whiteness, masculinity, and American national identity—appeals to those white Americans who, for at least a decade, have been longing for the affective comforts provided by the story of a "true American hero" like Lance America, as it restores America to "what [they feel] it should be."

But, precisely because the national fantasy of Lance Armstrong seems so apolitical, it functions as an ideal ideological vehicle to disseminate, popularize, and garner consent for a conservative gender and racial politics that attempts to restore a fantasy of white normativity, white supremacy, and the unapologetic return of the hegemony of a particular, unquestionably conventionally masculine white masculinity in contemporary America. And if we fail to disrupt the "ritual of consensus" and humanist frames which structure Armstrong's imaged identity, then we run the risk of missing what Carby (1993) might call, the other "surplus symbolic value(s)" of Armstrong's story which would allow one to see how his story is produced out of, and contributes to, the on-going contemporary struggles to restore whiteness and conventional masculinity as the American normative.

So then, the broad question which organizes this chapter is: How do we make sense of the constituent racial and gender characteristics of Lance Armstrong's much-celebrated nationalized white masculinity in order to comprehend the media spectacle made of his life and athletic accomplishments?

Contextualizing Lance America

The media discourses which celebrate Lance Armstrong in new millennium America are unavoidably produced out of three interrelated perceived crises— the crisis of masculinity, the crisis of whiteness, and the crisis of American national identity brought about by the terrorist attack of September 11, 2001—

and the particular reactionary response which emerged out of this constellation of social forces and historical events.

Beginning with the first, the perceived "crisis of masculinity" was frequently told through stories of white male figures of varying ages and strategically ambiguous class backgrounds—from the working class to the professional managerial class—unfairly suffering from emasculating anxieties about their powerlessness at home, at work, and within the culture at large (Kincheloe & Steinberg, 2000; Robinson, 2000; Weis et al., 1997). Although symptoms of this alleged crisis of masculinity could be found throughout American popular culture during the early and mid-1990s, few outside of academia explicitly constituted these symptoms as a "crisis" of American masculinity until the late 1990s. Not until the publication of Susan Faludi's *Stiffed: The Betrayal of the American Man* (and the resulting media attention given to it) in 1999 was this perceived but largely unspoken "crisis" turned into a media-manufactured crisis. In truth, Faludi's tome only seemed to legitimize an already well-developed "American males in crisis" market. Films of the era like *American Beauty, Fight Club*, and *Vanilla Sky* (among others) provided images of men experiencing existential crises, while pop music performers like *Limp Bizkit* and *Eminem* tapped into and cultivated a resentment toward women and a feminizing US society they felt did not care about them. Following the tragic school shooting at Columbine High School, one could even perceive the discursive logics of this "crisis of masculinity" underlie a number of books focused on the social psychological development of contemporary American boys (who were overwhelmingly coded as white). Repeatedly, the authors of these books often blamed feminism for disrupting boys "proper" social psychological development,[2] or called for the resurrection of social structures (namely in schools) that would "properly" masculinize boys; structures represented in these texts as having been eroded since the women's movement of the 1960s.[3] So, in late 1990s America, there existed not only an increased sense that a perceived crisis of masculinity for American men was in fact real, but a burgeoning desire in growing numbers of white men to be "real" men again.

Perhaps the best examples of this perceived crisis of masculinity and a new emergent desire to reassert a conventional masculinity (i.e., a masculinity which appeared to demonstrate strength, toughness, being in control, and power over others) can be seen in the mainstream cable shows of the late 1990s: Comedy Central's *The Man Show* and MTV's *Jackass*. These shows tapped into, as they allowed the expression of, a desire of white men of varying class backgrounds and ages living in this era to once again perform a very conventional form of

masculinity (one often racist and misogynistic, although these aspects of the show were rarely remarked upon in cultural discussions of the shows). Within these shows, white male viewers were able to, on a weekly basis, take delight in watching white male everyman figures like themselves performing a supposedly "edgy," "new" masculinity which heroically refused to submit to feminizing constraints of any kind, performed crazy, pain-inducing physical stunts to prove one's manhood, and took pleasure in sexually objectifying women. Featured in these shows was a type of white masculinity that had not been so brashly, blatantly, and unapologetically performed in American culture throughout much of the 1990s. To be sure, no one would mistake the men of *Jackass* and *The Man Show* as weepy, wimpy, and indecisive sensitive guys (in fact, many of the comical bits in *The Man Show* were directed toward ridiculing such sensitive male types).

So then, the late 1990s witnessed a shift in the public images of white masculinity in American media culture. These new images still worked in the service of attempting to re-secure a centered and normative position for white masculinity in American culture and society. But, where they differed was the main thrust of white male reaction no longer seemed to be making an authentic and legitimate claim to being unprivileged, disadvantaged, or somehow disaffiliated from white privilege (although this strategy still does play a more minor role in the emergent re-masculinization strategy, as I will discuss with Armstrong below). It appears that as the perceived crisis of masculinity was increasingly accepted as a common sense "truth" by many Americans (instead of an irrational symptom of white male paranoia), mainstream cultural discourses about masculinity were able to shift to a bolder, more assertive, and unapologetic tone and rhetoric that demanded American (white) men be given back their inalienable rights to be "real" men, to stop having to fight their "true" biological nature, and to re-erect social structures eroded by "unfair" and emasculating feminist initiatives and ideologies (Beynon, 2002). Free from the self-loathing guilt which gripped many American white men in the early and mid-1990s, this rhetoric still employs the notion of white men as victims (in this case of a feminizing American culture), but its more prominent aspect is its more confident, defiant, and assertive masculine performance that refuses to feel defensive or apologetic about its desire to re-claim that which some white men perceived as having been lost (and feel as though they are entitled to): a privileged, central, and normative position for white masculinity in American culture and society.

So then, by the late 1990s there emerged a broad-based cultural project involving the re-masculinization of American (white) men. This re-

masculinization effort drew upon, as it re-articulated, some of the backlash ideologies created and popularized in the earlier years of the decade. Frequently, these re-masculinization efforts were expressed through white populist, everyman figures. At the same time, these populist, everyman white male figures often portray themselves as the representative of a majority of "average" Americans whose voices and perspectives are imagined as being marginalized and ignored. The implication being, of course, that their voices have been drowned out by the voices and interests of 'minorities' (namely women, people of color, and gays and lesbians) who they imagine as privileged American subjects today. By assuming a posture of a populist "average Joe" and common man (although almost always coded as white), these white men fit within the new millennial racial imperative that figures of dominant whiteness appear disaffiliated from the system of reproducing white privilege (Weigman, 1999). Finally, this re-masculinization project involved a renewed call for (white) men to re-claim their (self-perceived) inalienable rights to imagine themselves as the natural and best suited representatives of the American disembodied subject.

Although this emergent project of the re-masculinization of American men began in American culture prior to September 11, 2001, the terrorist attacks on the World Trade Center and Pentagon, and especially President George W. Bush's response to those attacks, facilitated the broadening and public legitimation of this re-masculinization project by providing it with a new and crucially important rationale—to protect a "wounded" American nation unfairly attacked by terrorists, to protect civilization from uncivilized barbarism, and to have fundamentalist American good triumph over fundamentalist Muslim evil.

As the body of the President can be read as a symbol of the American nation and American national (white) manhood (Jeffords, 1994), President Bush's performance of his masculinity and his "War on Terror" posturing and policies (both foreign and domestic) helped cultivate a socio-cultural milieu receptive to the heroic return of a strong, powerful, invincible, virile, action-oriented, provider/protector type of white masculinity portrayed as a welcomed and suitable representative of America. Consider some of President Bush's own responses to the terrorist attacks—think of the imagery of the "old West"-style "Wanted" poster which called for the capture of Osama Bin Laden and his self-aggrandizing, thoroughly masculine landing on the USS Lincoln after declaring "victory" in the war in Iraq. Even further, Bush's own inarticulateness, "down home" persona, and conspicuous choice to frequently appear at town hall meetings *sans* sport coat and tie with the sleeves of his dress shirt rolled up, or the photo-ops of him "ranchin" in jeans and flannel shirt (often with his pick-

up truck included in the shot) evidence how the President's handlers attempt to fit him within this white populist everyman subjectivity which is a part of this American re-masculinization project.

A number of observers have argued that a desire to recover a conventional and unequivocal masculinity (one which refuses to apologize to anyone) has implicitly structured the Bush administration's beliefs, ideologies, and policies post-9/11 (Ducat, 2004; Ehrenreich, 2002; Mailer, 2003). In a commentary highlighting the cultural importance of Bush's post-9/11 hyper-masculine posturing, Farrell shows how Bush's role in the re-masculinization of American (white) men should be read not just as a welcomed antidote to the threat of terrorism but as an opportunistic move to turn back the "ruin" feminists supposedly made of American culture (presumably by feminizing men).

> One got the feeling that the manly man image extended to right wingers in general, or at least the kind of males who existed before feminists ruined everything. Shortly after 9/11, Peggy Noonan wrote, "A certain style of manliness is once again being honored and celebrated in our country since Sept. 11. You might say it suddenly emerged from the rubble of the past quarter century, and emerged when a certain kind of man came forth to get our great country out of the fix it was in" (cited from Farrell, 2004).

The importance of Farrell's point, echoed by Mailer (2003) and Ehrenreich (2002) in their own analyses of the gender aspects of Bush's response to 9/11, is the illumination of the surplus ideological work of these hyper-masculinist displays of patriotism and nationalism in American culture. That is, as these commentators point out, these post-9/11 narratives of patriotism which, on the face of things, seem to simply intend to revive American pride and a renewed sense of patriotism in the midst of the threat of terrorism are—quite consciously—being employed to extinguish the initiatives and ideologies of the critics of this white masculinity (namely, people of color and feminists) that have carried significant cultural influence since the 1970s, and in the minds of conservatives, plagued, and weakened American culture and society. Simultaneously, and this other half shouldn't be overlooked, these narratives of patriotism and nationalism, which seem apolitical because they are crafted from what Berlant (1997) calls "the National Symbolic", that is, a matrix of interwoven dominant ideologies about whiteness, masculinity, and America that constitute and orient how Americans are taught to imagine America—revitalize and popularize a paternalistic image of America as a nation proudly represented by tough, strong, protective white men, ideas vigorously contested between cultural conservatives and feminists and critical race scholars since the 1970s.

Thus, following the lead of President Bush (especially considering his

astronomical popularity and approval ratings immediately following the terrorist strikes), it seemed that significant portions of the United States populace desired the return of strong, powerful, dominant, commanding, and seemingly invincible (white) men who were in control (of themselves and the country), would protect the nation, revive our sense of national self-confidence and invincibility in this time of anxiety due to terrorist threats, and were unapologetic in defying "political correctness" and blaming a liberal-created, permissive American culture that supposedly made the nation vulnerable to attack from terrorists in the first place.

At this point in my analysis, we must not overlook the racial aspects of this re-masculinization project. We must keep in mind the work of a number of scholars of race who have argued that whiteness, especially during the 1990s, has also been in crisis, "deeply fissured by the racial conflicts of the post-civil rights period" (Vera & Gordon, 2003, p. 187). This crisis of whiteness is two-fold, the decentering of whiteness in American culture and society (as the unspoken cultural norm) and the illumination and critique of white privilege, has led to various efforts in contemporary American culture and society to bring about "the recovery of white supremacy" (Kincheloe & Steinberg, 2000, p. 191). In the previous chapter, I argued that the award-winning skateboarding documentary, *Dogtown and Z-Boys*, was constituted by, and constitutive of, a new form of cultural racism characterized by its coded, sub-textual expression of conservative (if not reactionary) racial ideologies, its apparent colorblindness to race, and its absence of people of color in its narratives (instead they usually feature and are centered upon collections of white individuals), yet whose effect is to offer particular representations of whites which work in a complicated way "to rearticulate and re-legitimize white supremacy" (Winant, 2004, p. 57) even as that effect is difficult to discern and/or easily disavowed.

In this chapter, I want to argue that the media discourses that venerate Lance Armstrong as a "true American hero" represent another inflection on this new cultural racism which I want to call "white cultural nationalism." On the face of things, this form of cultural racism appears to rather innocently celebrate particular white male populist figures and/or cultural formations (heavily populated and dominated by white men) which most white Americans would presumably see as exemplary representatives of good ole traditional American values and ideologies (mainly because these discourses rely on, as they utilize, conventional ideologies of America, themselves implicitly intertwined with conventional notions of whiteness and masculinity). Unlike the variant seen in *Dogtown and Z-Boys*, this form of cultural racism unapologetically revels in, as it draws upon, very conventional ideologies of

whiteness as unmarked, unquestionably culturally dominant, and as the natural and best representative of America and even humanity. This white cultural nationalism is the expression of a pervasive, yet rarely explicitly conveyed, desire in the new millennium for many whites to guiltlessly envision America as a white nation and to feel pride in celebrating heroic white males whose good deeds, leadership, and dominance are imagined as representing the best of America.

The appearance and widespread cultural embrace of this white cultural nationalism is an effect of both this crisis of whiteness and the reactionary impulses to bring about "the recovery of white supremacy" (Kincheloe & Steinberg, 2000, p. 191). My move to designate this discourse of white cultural nationalism as an cleverly coded and concealed effort to recover white (male) supremacy and normativity in American culture and society draws upon the work of Ferber (1998) and Kincheloe and Steinberg (2000). Both Ferber and Kincheloe and Steinberg argue that the desire of some whites to recover white supremacy (meaning whiteness to return as the unspoken, unquestioned, uncontested, and inherently privileged social position) was not just held by white supremacist groups or other "extremist" white individuals or groups living on the margins of American society but by many whites thoroughly invested, and represented, in the American mainstream. In fact, Ferber (1998) argues that the increased media visibility given to "extremist" white supremacist groups by the mainstream media during the 1990s can be understood as an attempt to mask the alarming similarities between mainstream discourses on race and those of white supremacist groups by attempting to constitute white supremacists as wholly different than whites in the American mainstream.

So then, part of my project here is to show how the cultural discourses which celebrate Lance Armstrong as a "*Real* Sports Hero" (Reaves, 2000, emphasis added) and as "one of the first *true American heroes* of the 21st century" (Myrick, 2000, emphasis added) operate as a cleverly coded form of this white cultural nationalism which re-articulates white masculinity as the natural representative of America while re-securing a central and normative position for white masculinity in American culture at a time when its position has been challenged. In examining these discourses I show how narratives of patriotism and nationalism have in new millennium America—but especially following the terrorist attacks of September 11, 2001—become both the rationale and the medium through which the backlash against feminist and multiculturalists ideologies and initiatives now proceed.

Lance America's Cancer Wound: Reading the Politics of White Men's Wounds

To begin to make sense of the reactionary politics constitutive of, and constituted by, the discourses surrounding Lance Armstrong we must first recognize the importance that his near-fatal bout with cancer has had on his subsequent imaged identities. Put bluntly, we must keep in mind that Americans historically have not paid much attention to the sport of professional cycling or who wins the Tour de France (with the exception being Greg LeMond's three victories during the 1980s). In large part, this is due to the fact that American cyclists rarely win or dominate this international sporting event (thus, they do not reproduce the notion of American dominance which is usually an implicit pre-condition of American interest in international sporting events). Yet, even the rare victory of an American cyclist at the Tour—and the chance to celebrate American international sporting dominance—still doesn't seem to be enough to adequately explain the avalanche of media coverage given to Armstrong's initial and repeated victories in the Tour. And judging by the initial wave of media coverage of Armstrong's victory, the added meaning which created the "buzz" around Armstrong's victory must, at least in part, be related to the story of his amazing recovery from cancer after being told by doctors that he had only a 40% chance for survival from a cancer that originated in his testicle and had spread to his brain and lungs (Armstrong & Jenkins, 2000).

We might also look to his autobiography, *It's Not About the Bike*, where Armstrong's name tops the cover in large print underscored by the important categories through which we are directed to understand him (in order from top to bottom): "Winner of the Tour de France, Cancer Survivor, Husband, Father, Son, Human Being" (Armstrong & Jenkins, 2000). Here, the book cover subtly reveals how Armstrong is most importantly rendered visible through the intertwined categories of cancer survivor *and* athletic champion. Undoubtedly, both these identities are dependent upon one another to explain and comprehend Armstrong's cultural appeal and conservative political value in the United States. But, I want to suggest that the production of *the national fantasy of Lance America* depends less on his status as an athletic champion, than on his having survived a near-fatal bout with cancer. This point is supported by the comments of sports marketing consultant David Carter who states, "Even if he [Armstrong] finishes dead last—or doesn't finish at all—he's endeared himself to the public" (Horovitz, 2000, p. 2B) and even by Armstrong himself, who proclaims, "I'm prouder of being a cancer survivor than I am of winning the Tour de France. Believe me" (Montville, 1999, p. 70). If we take the comments

of Carter and Armstrong seriously and consider how Armstrong's initial appeal to American audiences is not necessarily predicated on his continued athletic success but rather on his inspirational recovery from cancer (a story that requires detailed narratives about his affliction with cancer and recovery), then the question becomes: What role does Armstrong's affliction with cancer—or his cancer "wound"—play in making his story and symbolic white masculinity so appealing to the American media and public?

In *Marked Men: White Masculinity in Crisis*, Robinson (2000) argues that in response to the critique of white male privilege forwarded by the women's liberation and civil rights movements, representations of white masculinity as victimized and wounded became prominent in post-1960s mainstream American culture in an attempt to mask and disavow the privileges of being white and male in American society. While others like Giroux (1997a), Pfeil (1995), and Savran (1998) have written about the cultural politics of the "white male as victim," the originality of Robinson's argument is her insight that narratives of white male victimization often feature spectacular stories and imagery of individual white males with wounded bodies. Such graphic representations of white males' wounds are emphasized, according to Robinson, because "white men can most persuasively claim victimization by appealing to representations of bodily trauma" (p. 6) and "displaying [white men's] wounded bodies materializes the crisis of white masculinity [and appears to] make it more real" (p. 9).

For Robinson, the spectacular character of these wounded bodies "draws not only on the persuasive force of corporeal pain" but demonstrates how white men in post-1960s America have also participated in identity politics, what she calls the "identity politics of the dominant[4]" (p. 6). This "identity politics of the dominant" refers to any mainstream cultural project—not entirely deliberate nor innocent—which re-articulates white masculinity as the American normative and has the effect of displacing the oppositional voices, identities, and politics (i.e., those of people of color, women, and gays and lesbians) that seek to illuminate structural inequalities and power asymmetries that continue in new millennium American society while still demanding a rightful and equal place in the center of American culture, society, and politics (Robinson, 2000).

So then, Robinson's work highlights how a key aspect of the currency of cultural representations of white men's bodily wounds is that they appear to be a more meaningful form of disadvantage than the largely invisible social limits, constraints, and oppressions suffered by historically marginalized subjects whose effects do not always manifest as dramatically on their bodies or can be

too easily interpreted as a product of their own poor choices or lack of personal initiative. In other words, such narratives which feature the dramatic bodily wounds of white men create an impression that these wounds are far worse for white men than the oppressive effects of societal discrimination and oppression on historically marginalized subjects. At the same time, such narratives are employed by white men within the context of identity politics, which still has a residual influence in post-9/11 America, to cultivate a seemingly "authentic" form of disadvantage or lack of privilege in order to compete with (and displace) the more authentic or legitimate disempowerment of those historically marginalized "others" within American society.

Now Robinson focused her attention on "middle-brow" white masculinities which were produced mainly in the 1970s through the late 1980s. But, I think her work is a necessary starting point to make sense of the initial groundswell of media attention given to Lance Armstrong's story of surviving his near-fatal cancer wound after his first victory in the Tour de France. As his story quickly spiraled into a media spectacle—spurring television programs, sponsorship deals, a number of books by Armstrong and his associates, the LIVESTRONG bracelet phenomenon—it became perhaps the quintessential example of a "middle brow" white masculinity constitutive of, and constituted by, the representational strategies illuminated by Robinson's work. The importance given to Armstrong's struggle with cancer in various cultural narratives about his Tour victories revealed that tales of a white man's wounded body still represent a key discursive strategy for backlash politics at the turn of the 21st century.

To demonstrate this, I call attention to the fact that most of the media coverage of Lance Armstrong's first couple of victories in the Tour de France (especially through 2000) began their accounts with details about his battle with cancer. For example, a 1999 *Time* magazine article reporting on his first victory in the Tour de France began by describing Armstrong as just three years removed from "suffering from testicular cancer that had spread to his brain and lungs...[Noting that his] prognosis [at the time] could not have been grimmer" (Sancton, 1999, p. 66). Just a year later, another *Time* story described him as being "more than halfway dead" upon his cancer diagnosis (Stein, 2000, p. 60). This sentiment is echoed in a *Sports Illustrated* article, from the same year, which emphasized how "Lance Armstrong almost died four years ago" (Thomsen, 2000, p. 42). Later, the same article describes him as "the young man who suffered so much to stay alive" (p. 42). And perhaps most importantly considering its best-seller status, half of the chapters of his autobiography, *It's Not About the Bike*, were dedicated to describing, in intimate detail, the various

aspects of his cancer diagnosis and recovery efforts. The book also included dramatic pre-operation pictures of Armstrong with his shaved head full of marks signifying where the tumors in his brain were to be removed as well as others of a "brooding," weak, but always hopeful Armstrong suffering in the middle of his chemotherapy treatments.

So then, the American media spectacle about Armstrong (particularly during the first three years, through 2001) provided readers with details about his near-death encounter with cancer, the number and positioning of cancer tumors all over his body, the disappointment he experienced by being unceremoniously dropped by his main racing sponsor, Cofidis, when they learned of his cancer diagnosis, and the pain and suffering which Armstrong endured through the course of the aggressive chemotherapy treatments he chose to hopefully eradicate the cancer from his body (a treatment chosen to increase the odds that he could make a full recovery to elite cycling).[5] In each of these stories, Armstrong's white masculinity is rendered visible through dramatic and intimate narratives and imagery of his body wounded by cancer. These representations of Armstrong's wounded body not only elicited public sympathy for his unfortunate plight, but they also become the pre-condition which enabled corresponding feelings of public admiration for his remarkable recovery from cancer to win the Tour as well as the guiltless celebration of him as an apt and deserving embodiment of America and the "indomitable" human spirit.

But perhaps the most interesting example of how these narratives and imagery of Armstrong's body wounded by cancer are strategically used to constitute his white masculinity as disadvantaged and disaffiliated from social privileges of any sort (in perpetuity) can be found in the *Sports Illustrated* story detailing his first Tour de France victory. Here, the importance of Armstrong's cancer wound on his public identity is evidenced in the quote: "Armstrong is one of them [part of the community of cancer survivors], part of this *multitude of the damned. He always will be*" (Montville, 1999, p. 70, emphasis added). The import of this statement is the manner in which Armstrong's cancer wound is portrayed as an immutable part of his identity in the present and future, thereby effectively essentializing this "wound" as the unique and central core of Armstrong's white masculinity. By essentializing this cancer "wound," Armstrong's white masculinity is not only constituted as disadvantaged, but he is simultaneously represented as a cancer survivor and part of an exclusive community of cancer survivors who are imagined as being forever disadvantaged ("part of the multitude of the damned"). The rhetoric used here echoes that used by historically marginalized groups in the era of identity

politics, where distinct lines are often drawn between in- and out-group members so that only those within a minority group are said to be able to truly and fully understand what it's like to be disadvantaged. As this line gets drawn, the moral and political authority to really know what it is like to suffer in this life and to dissociate one's self from those in society who are privileged is given to those who are said to be part of the minority in-group. So then, once Armstrong gets constituted as part of the "multitude of the damned" (and remember this distinction includes lifetime membership) his disadvantaged identity (even as a white male) is virtually insured once and for all. It becomes difficult to contemplate or suggest that Armstrong could be imagined in any way as a privileged social subject. Nonetheless, in reality, Armstrong is a benefactor of many racial, gender, and class privileges (the latter being particularly influential in enabling his survival from cancer as it allowed him access to the very best cancer doctors) which cannot be denied simply because of his momentary struggle with cancer. Armstrong himself reinforces the logics of the immutability of his cancer wound by publicly dedicating his victories in the Tour de France to cancer survivors everywhere and repeatedly declaring that he will always be a member of, and advocate for, cancer survivors until the day he dies.

So then, these dramatic stories and imagery of Armstrong's cancer wound enable his white masculinity to be "particularized" in such a way that he is differentiated from the always already privileged white male who was publicly castigated throughout much of the 1990s (see Gates, 1994). Even further, his cancer "wound" encodes his white masculinity not only as authentically and legitimately disadvantaged, but as having suffered perhaps the "ultimate wound." In other words, because of its reported severity, Armstrong's cancer wound, becomes what might be called an identity card (the cancer wound card?) that seemingly trumps any competing claims of disadvantage that could possibly or potentially be made by any other minority subject. The comments of sportswriter, Jack McCallum, provide a glimpse at how these sorts of comparisons get made when he unfavorably compares Michael Jordan's laudable performance in his last NBA Finals with Armstrong's recovery from cancer to win the Tour, "We remember Jordan fighting off the flu to play heroically during the playoffs. Armstrong? He fought off death!" (McCallum, 2001). Thus, the story of his battle with cancer—featuring dramatic details about his bodily wounds—needs to be constantly re-told again and again because this white male's ultimate disadvantage is the necessary pre-condition upon which the popularization of the other aspects of Armstrong's white

masculinity (particularly its inspirational story of hope and its explicitly masculinist and implicitly white supremacist articulations) depend.

Stories of Armstrong's wounded body and struggle to survive cancer also distance Armstrong's white masculinity from the notion of white masculinity as always already privileged in yet another way. Armstrong's diagnosis of cancer is frequently depicted in the media discourse about Armstrong as "an unexpected gift" and "a special wake-up call"[6] for him to evaluate the direction of his life and to make the most of the present moment. Within such narratives about Armstrong, especially the narrative offered through his autobiography (which in many ways is the basis, and has a strong influence on, the other media stories produced on Armstrong), his white masculinity gets split at the moment of his diagnosis of having cancer. The pre-cancer Armstrong is portrayed as angry, brash, cocky, and arrogant (code words of the much-maligned, privileged white male in the context of 1990s American culture), while the post-cancer Armstrong is portrayed as being "given the chance to fully appreciate the blessings of good health, a loving family and close friends."[7] When situated within the socio-historical context of the interrelated perceived crises of whiteness and masculinity, it is easy to see that an often unspoken part of the appeal of Armstrong's white masculinity is his redemptive transformation from cocksure, arrogant white male to a new, enlightened, and "better" (white) man who is keenly conscious of, and thankful for, his "blessings" in life (code for his socially privileged position) and who does not take them for granted because he has seen how quickly they can be potentially lost through the threat of death from cancer.

These particular representations of Armstrong's white masculinity also reveal how white male privilege can be rather easily excused, overlooked, disavowed, or avoid criticism if a white man simply publicly demonstrates a self-reflective awareness of, and/or appreciation for, his privileged position in society. Armstrong's wealthy position and extraordinary athleticism in bicycling in society even allows his self-reflexive awareness and appreciation of his 'blessings' to be perceived as a social class statement or as reifying notions of natural athleticism, thereby eliding the racial and gender ways in which this performance of humility works. At the same time, this performance of self-reflexivity about his socially and economically privileged position strategically allows Armstrong to be distanced from the caricatured image of a cocky, arrogant, wealthy white male who seems oblivious to, or unwilling to acknowledge, his socially privileged subjectivity.[8] But obviously, such stories of individual white men which appear to distance and disaffiliate them from white male privilege—although appearing to be seemingly laudable displays of

humility and appreciative declarations of one's "blessings"—do little to disrupt, oppose, and/or transform a social system which affords such social, economic, and psychic privileges to the white men. Instead, such stories of wounded, yet redeemed white men simply mask (and thus reproduce) such privileges by obscuring the social conditions of their production and mystifying these privileged socio-economic dispensations as products of individual will and desire and/or random luck, fate, or faith.

So, Armstrong's story of surviving of his cancer wound is a key factor in understanding his widespread popularity. Not only does his bout with cancer set the stage for his inspirational and heroic story of surviving cancer to win the Tour de France a record seven straight times, but it reveals how part of his story is constitutive of, and constituted by, what Robinson calls an "identity politics of the dominant" which in new millennium America still trades on authentic representations of white men as disadvantaged, as a means to recenter white masculinity in American culture and society.

Lance America as Survivor, the Human Spirit, and Recentering White Masculinity in New Millennium America

Yet, even as Armstrong's white masculinity was repeatedly portrayed as wounded by cancer, interestingly (and importantly) he was not popularly portrayed as a *victim* of cancer. Instead, Armstrong was celebrated as a *survivor* of cancer. Indeed, much of the media and public's valorization of Armstrong is related to his identity as a cancer survivor. Armstrong is represented not only as belonging to the cancer survivor community, but as perhaps the most public representative of this community. Each of his seven victories in the Tour de France is represented by himself and others as a symbolic victory for cancer survivors all across the globe. And he has established The Lance Armstrong Foundation which, through the help of several corporate partners, provides community, services, and advocacy for those attempting to survive cancer.

The distinction between the categories of a *victim* and a *survivor* is hardly arbitrary or unimportant. To understand its political significance, we must first situate the emergence of the survivor in new millennium America. Then, we must recognize how the use of the category of a survivor in the media spectacle of Armstrong enables the revival and re-popularization of a very conventional notion of whiteness as representative of humanity (an articulation some have said was no longer tenable in the multicultural era), and white people as possessing what Dyer (1997) calls a "spirit" and "enterprise"; ideas which have historically been instrumental in erecting racial hierarchies and inequalities, while establishing and rationalizing white supremacy.

The survivor emerged as a popular figure within late 1990s and new millennium America "out of a conjuncture of relatively autonomous, yet mutually implicated, social forces that gained strength in the last two decades of the twentieth century" (King, 2000). In order to understand the conjunctural meaning of the celebration of Armstrong's as a cancer survivor, one needs to understand that the individual survivor identity implicitly gains its meaning over and against its "other," the social victim.

The subject position of a victim of society has been a loaded term in social and political rhetoric in the era of identity politics. From the 1970s to the present, historically marginalized groups like women and people of color have successfully employed the subjectivity of a social victim to expose and illuminate the social inequalities, discriminations, and stereotypes which unfairly limit and constrain their opportunities in American society. As Savran (1998), Robinson (2000), and others have shown, this strategy has been so effective for historically marginalized "others" that white men increasingly attempted to claim the position for themselves during the 1990s as a way to counter historically marginalized groups' relative success in destabilizing and challenging white male privilege.

A goal of conservative backlash forces over the past two decades has been to find a way to undercut the moral and political currency of women and people of color, namely their subordinate "victimized" status in post-1960s America. In the 1980s, conservatives attempted to accomplish this by demonizing single women and African Americans (particularly caricatured images of single mothers, drug addicts, and welfare recipients which relied on black stereotypes) for their supposed deficient will, dependency on the State, and lack of personal initiative. Such discourses were uttered through a negative and resentment-laden tone which demonized already vulnerable social populations by blaming them for their social and economic problems. These efforts to demonize these "social victims" were a key aspect of a conservative backlash politics intent upon arresting the gains made by women and people of color following the social movements of the late 1960s and early 1970s (Reeves & Campbell, 1994).

The cultural celebration of individual survivors whose amazing and seemingly limitless wills allow them to overcome obstacles or adversity of any sort—like Armstrong's tale—represents a re-articulation of this earlier conservative discourse of resentment (so popular and effective in the 1980s and early 1990s) (McCarthy, 1998). Whereas the earlier discourse was mean-spirited in its rhetoric, admonishing so-called "lazy, whiny" minorities for preferring to live idly off of the State,[9] this new discourse of resentment strategically avoids

taking a derogatory tone. Instead, in this era of neoliberal hegemony, this new discourse of resentment is crafted through a tone of hope and optimism as it celebrates the "feel-good" stories of the efficacy of a "human spirit" (which seems to have no specific racial, gender, class, sexual, or national markings or boundaries) which can transcend all obstacles and forms of adversity. Such stories are meant to offer hope and optimism to millions of Americans especially in this era of increasing social and economic anxiety for many.

The political "genius" of this veneration of survivors is that its underlying resentment goes unspoken. The celebration of extraordinary individual survivors, on the face of things, seems to have no negative underbelly. Nonetheless, the dark side of the celebration of the survivor is its implicit attempt to erase and negate any talk of social privileges or inequalities. The survivor becomes the perfect figure to peddle the idea that self-empowerment and self-determination are possible if one makes the right choices and has the right will, spirit, and enterprise. Thus, the affectively appealing popular celebration of survivors implicitly attempts to discredit and demonize all those willing to point out that social conditions such as race, class, and gender do matter and that these social forces still do have significant effects on one's opportunities in life which cannot be denied or wished away. Yet these stories of survivors—especially those of women and people of color—are so effective in dismissing such critical or dissenting views because of the authenticity of the stories of these exceptional survivors.

Additionally, in using rhetoric like overcoming "obstacles" and "adversity" (instead of "social barriers" or "systemic inequalities") the discourse of survivors is able to universalize and individualize struggle. This language promotes the idea that every person regardless of race, class, or gender faces obstacles and adversities in one's life. This point is perhaps best made in a FoxSports.com article which conjectures about Armstrong's legacy following his seventh Tour victory and announcement of his retirement from cycling, "Armstrong's greatest achievement as an athlete and as a human being has been to give the world the gift of hope ... but his message of hope transcended age, gender, class, race ... It spoke to everyone ... More than 50 million people around the world now wear Livestrong bracelets ... But, whatever happens, Armstrong's story will continue to inspire people to fight harder to live life to the fullest and to never give up in the face of adversity" (Vontz, 2005). This discourse thereby fails to assign different weight or value to the kinds of obstacles and struggles that various social groups face (i.e., a demanding parent or teacher and systemic racism or sexism are both seen as "obstacles" or "forms of adversity," with no difference in weight given to their different

intensities). Even further, because survivor groups (like cancer survivors or the more recent survivors of Hurricane Katrina in Louisiana and Mississippi) often cut across lines of race, gender, class, sexuality, and age they enable the production of an image of America as a "conflict-free and integrated nation" (King, 2000) which further negates the influence of social inequities and privileges from people's horizon of thought.

So then, Armstrong's story, as it is crafted through affectively appealing themes which celebrate a human will which appears as inclusive and emphasizing a universal sameness and unity between people of all races, genders, classes and creeds, operates as a sincere fiction of unity and sameness which has the violent effect of minimizing the material reality of cultural differences and failing to bear witness to the deepening social divisions and hierarchies of contemporary America. At the same time, it offers stories of the heroic and transcendent "human spirit" which imply that we are all individually responsible for our lot in life and only the strongest individuals achieve great heights, while the weak are the only ones to blame for their lower socio-economic position in life. Finally, through these extraordinary stories of the apparent amazing will of various individual survivors, moral and political currency is able to be shifted over to the side of cultural conservatives as these heroic survivors with extraordinary wills and spirits are deemed worthy of every advantage or "blessing" they receive.

Armstrong's individualist identity as a heroic survivor is produced through the particular way in which his story of recovering from cancer is articulated. It is repeatedly implied in the media discourse of Armstrong's recovery, that his successful survival was largely the product of his strong will, unwavering optimism, and personal initiative to proactively educate himself on testicular cancer and the treatment options available to him. In essence, his survival was ostensibly represented as a product of his own personal responsibility. Obscured in this particular portrayal of his recovery efforts is how his survival is undeniably influenced by the options made available by his affluent class position and social status (as an elite athlete) which undeniably allowed him to procure access to the very best medical treatments and doctors (Butryn & Marsucci, 2003). In this tale, Armstrong is rendered worthy of recovery (and public admiration) because, as a good survivor, he refused to resign himself to the position of a victim by actively battling the cancer with his strong and determined will and by rapidly educating himself on how to effectively treat the cancer. Thus, America's admiration of Armstrong as a "cancer survivor" is predicated on his apparent investment in, and affirmation of, traditional American liberalist ideals of unconstrained agency, overcoming obstacles, and

personal perseverance which have been revived in neoliberal discourses. Rather than passively accepting his cancer diagnosis as a death sentence (as an insurmountable obstacle) and passively lamenting or whining about his disadvantaged state, Armstrong is portrayed as bravely (and actively) taking on the cancer through educating himself on the ailment as well as seeking the best medical help. It is important to note here how Armstrong's survivor identity is still predicated on his initial cancer wound. Interestingly, Armstrong's cancer wound further enables the subsequent celebration of him as a survivor and as a white male that embodies a "human spirit" that can purportedly transcend any social limit or constraint which I turn to next.

Following Armstrong's seventh and last victory in the Tour, President George W. Bush's public congratulation represented Armstrong's victory as an inspiration to all people and an example of the transcendent power of the "human spirit." In the President's own words, "Our country and the world are incredibly proud of you ... [Armstrong's victory represents] *a great triumph of the human spirit*" (AP wire, 2005, emphasis added). Bush goes on to say, "Lance [Armstrong] is an incredible *inspiration to people from all walks of life*, and he has lifted the spirits of those who face life's challenges. He is a true champion" (AP wire, 2005, emphasis added). These portrayals of Armstrong as the embodiment of the human spirit are repeated throughout the media discourses about him.

In his seminal book, *White*, Dyer (1997) discusses the importance of the idea that white bodies are attributed a "spirit" which resides "in" white bodies but is not "of" the body to understand how racial hierarchies and exclusions are (re-)produced throughout history. Dyer's distinction that this spirit resides "in" white bodies rather than being "of" them is crucial for it allows the acts and experiences of whites not to be reduced to "their bodies and to race" (as people of color are in white-dominant cultures). Instead, white bodies are imagined as "something else," which allows them to avoid the stain of racial particularity. These interrelated ideas of the white spirit and conventional Western racial ideologies thus allow whites (but not any other racial group) to occupy the subjectivity of being fully human (Dyer, 1997, p. 14). The importance of recognizing this "spirit" attributed to white men's bodies for Dyer is its "enterprising" character, that is, how the idea of white people's possession of this special "spirit" has historically been employed to carry out the interests and needs of the (re-)production of white supremacy and normativity in the name of simply being human.

Part of the work of critical race scholars and critics of whiteness has been to show how "white power secures its dominance by seeming not to be

anything in particular" (Dyer, 1988, p. 44). An important component of this critical project involves "denormalizing whiteness" (Kincheloe & Steinberg, (1998, p. 18). On one hand, this means critically exposing the long history in Western civilization of the articulation of whiteness as uniquely "human" and the material and symbolic violence produced in its wake. This articulation of whiteness with humanity relies on the production of ideas of people of color as non- or sub-human. Such representations have the material effects of producing social and ideological exclusions, material violence, and social inequalities between the so-called "races." In short, the celebration of white men as symbols of an enterprising human spirit has long facilitated the production of white superiority and normativity by representing whiteness (often white masculinity) both as embodying the best of humanity and as the unspoken, unraced norm in society.

With this history in mind, we must be wary of this widespread public celebration of the white male Lance Armstrong as a symbol of an "enterprising" transcendent human spirit who inspires *all people* for the ways in which it implicitly functions as a mechanism of restoring white normativity and superiority in new millennium America. As Armstrong's identity is rendered visible as the embodiment of "human spirit" it is crucial to note that his racial, gender, and class identities and locations go unmarked and his white masculinity escapes "the confines of time and space" and is "naturalized as a universal entity" (Kincheloe & Steinberg, 1998, p. 5). As the racial and gender particularities of Armstrong's white masculinity are displaced, it becomes difficult to contemplate his popularity being the product of any particular political project. Indeed, any political aspect of these representations— particularly those of gender, race and class—seem to be easily displaced or denied as Armstrong's only political constituency is imagined as "humankind."

The "tyranny of cheerfulness" (King, 2000) of this national fantasy of Armstrong's transcendent human spirit conquering all is how it celebrates a hyper-individualism that denies the influence of structural privileges and inequalities on people's lives (particularly historically marginalized groups), while simultaneously reviving Social Darwinist ideas of "Survival of the fittest" and "Everyone gets what they deserve." Part of the enterprise of the national fantasy of Armstrong as embodied human spirit is how it creates a vision of American society (if not global society) where social hierarchies of race, class, gender—and all of their resulting privileges and inequities—either no longer exist or no longer matter. This narration of American social life is consistent with conservative discourses that assert that racial and gender barriers no longer exist as well as neoliberal ideologies that suggest that divergent life outcomes

are a solely the product of one's will, agency, and personal initiative rather than significantly influenced by one's race, gender, or socio-economic position.

At the same time, through this national fantasy Armstrong's white masculinity is also encoded as the *ideal* embodiment of the human spirit. He becomes a pedagogical ideal whom all people should admire and attempt to emulate as his white masculinity is positioned at the apex of a social hierarchy of humanity. Thus, what also becomes apparent is how these celebratory portrayals of Armstrong as the embodiment of a limitless human spirit work to reproduce the idea of white masculinity as a supreme being to all others.

But, what I find peculiar about this particular aspect of the media spectacle made of Armstrong's story is how it allows the articulation of whiteness with humanity at a time when a number of critics of whiteness have argued that this sort of easy articulation can no longer be easily made in multicultural America. They argue that as whiteness and white privilege have been made visible and undergone significant critique in post-civil rights America (but particularly in the multicultural era of 1990s to the present), the "same-old" conventional representational strategies used to naturalize whiteness as the unraced social norm or as representative of humanity cannot be readily employed. Yet, in the hundreds of pages of magazine articles, books, web sites, television commercials and programs I've read about Armstrong (and even the two academic journal articles produced on Armstrong), none has even explicitly mentioned his racial identity, let alone criticized this articulation of whiteness as representative of humanity and how it corresponds with the conservative racial and gender politics of the day.

So then, I contend that what we are seeing with this particular rendering of Armstrong as the embodiment of humanity is the troubling revival or re-emergence of this conventional strategy of representing whiteness as humanity so that it can implicitly colonize the American normative once again. We should recall that one of the goals of the conservative backlash throughout the 1990s to the present has always been to develop representational strategies through which white masculinity can legitimately be recentered as the normative within American culture. This rather extraordinary tale of Armstrong's survival of a near-fatal encounter with cancer to go on to win a record seven straight Tour de France races appears to be an ideal ideological vehicle for reviving this conventional notion of whiteness as humanity while still avoiding public criticism for redeploying this rather blatant strategy for recentering whiteness in American culture and society because Armstrong's story does not appear at all to have any racial component. Yet, it also reveals to us that the strategy of producing authentic and legitimate representations of white men as either

victimized, disadvantaged, or unprivileged is no longer the main, or perhaps even dominant, strategy being used to recenter white masculinity in American culture and society. So, as Armstrong's white masculinity is initially coded as wounded/disadvantaged and then is celebrated as the embodiment of a transcendent human spirit, his mediated identities allow us to see the specific and complex ways in which "whiteness is constantly shifting in light of new circumstances and changing historical conditions" (Kincheloe & Steinberg, 1998, p. 5) in new millennium America.

Lance America as Revival of a White National Manhood

As the years rolled by and Lance Armstrong won multiple Tours de France he was repeatedly rendered visible both as a symbol of America (and its liberal humanist ideals), and as a populist figure overwhelmingly embraced and admired by the American people. The images of Armstrong which accompany press stories, television programs, and adverts often display Armstrong in a red, white, and blue aesthetic or pictured in close proximity to the American flag, whether he or others around him are waving it. A number of pictures frame him in shots where he is surrounded by mobs of people just dying to get close to him. But, this articulation of Armstrong as a populist American figure is nowhere more apparent than in two particular popular representations. The most recent is a commercial made by Nike in 2004 that featured Armstrong as a pied piper-like figure riding on his bike through a plethora of American landscapes (urban, suburban, and rural) followed by individuals of various ages, races, genders, and social classes. The other is a United States Postal Service print advert produced following his second victory in the Tour de France represented here

> He won.
> The Team won.
> America won.
> Congratulations! [Presented in bold letters superimposed on a picture of Armstrong laboring his way up a hill].
>
> Lance Armstrong and the entire US Postal Service Pro Cycling team made America proud. Thanks, from your 800,000 teammates at the United States Postal Service, for your inspiring leadership and courage. We all share the same appreciation for the power of teamwork. (In smaller font in the lower right corner of the advert) (United States Postal Service, 2000).

Through these portrayals, Armstrong's white masculinity is portrayed not only as an embodied symbol of America, but as a rallying point and source of

national pride that all Americans can take pride in. In such depictions, Armstrong's extraordinary heroism and athletic accomplishments allow white masculinity to be recentered in American culture, while the racial and gender particularities of this articulation are left unmarked.

Frankenburg (1997) notes that throughout the history of the United States "notions of race ... [have been] closely linked to ideas about legitimate 'ownership' of the nation, with 'whiteness' and 'Americanness' linked tightly together" (p. 6). Shome takes Frankenburg's idea of observation one step further urging the reader to understand that "for every story told about the national subject, and about who is imagined as that subject, there is some story that is not being told, that is not allowed to emerge, and that is lost or forgotten in the politics of remembering" (2001, p. 325). Shome's point highlights that the production of images and narratives of national identity is always unavoidably political.

This re-articulation of Armstrong's white masculinity with American national identity takes place, especially prior to September 11, 2001, within a "post-American" moment where various social and political forces have supposedly disrupted and de-stabilized any easy articulation of whiteness and masculinity with American national identity (Cole & Andrews, 2001; Sobchack, 1997). Within new millennium America, following numerous multicultural critiques of the long history of American nationalist narratives that essentialize the articulation of whiteness (particularly white masculinity) with "America" (Rodriguez, 1998), one would think that the media spectacle made of the white male Armstrong as the symbolic representative of America (reinforced by the repeated depiction of him as supported by the American people) would be contested. Yet, such objections have not been made publicly. This situation begs the question: What are the conditions which enable this articulation of white masculinity and American national identity to be so easily and un-problematically made?

On one hand, these representations of Armstrong's Americanized white masculinity make visible the particular ways in which white masculinity must be encoded in this post-American moment if it is to be articulated as the symbolic embodiment of America. This portrayal of Armstrong as a most deserving representative of America is dependent upon Armstrong's wounded cancer identity. It is his essentialized wounded cancer identity and selfless care for others that obfuscate how this media celebration of Armstrong's athletic achievements represents just another instance of a long history of cultural celebration of white masculinity for its dominance, superiority, and extraordinary will and the articulation of it as uniquely, definitively, and

deservingly representative of "America." The absence of criticism I believe speaks not only to the ideological effectiveness of how Armstrong's wounded identity as a cancer survivor protects from criticism this blatant and highly public re-articulation of white masculinity with America, but it also reveals the affective appeal of his story of survival (especially as it rehearses and revives conventional ideologies of whiteness, masculinity, and America) as well as the strength of many whites' desire to re-secure a natural link between whiteness (particularly white masculinity) and American national identity.

The easy articulation of Armstrong's white masculinity with America also reveals that the structure of feeling in American culture has shifted slightly; the ideological imperatives of the conservative backlash have changed too, no longer is the prominent strategy of ultraconservatives to constitute authentic and legitimate victimized or disadvantaged white men (that strategy is still in play but not primary), instead—especially post-9/11—it is the attempt to re-naturalize the articulation of white masculinity with American national identity by reviving conventional notions of whiteness and masculinity within national narratives steeped in patriotism. Yet, it cannot be forgotten that this emergent strategy still depends upon the ideological effectiveness of Armstrong's cancer wound (as a sign of his apparent lack of privilege) as a way to protect from criticism this very conventional narrative linking of a superior, dominant, and invulnerable white masculinity with America.

This relatively easy articulation of Armstrong with America is also facilitated by the implicit logic of American populist consensus where it is asserted and assumed that all Americans find pleasure in the story of Armstrong's extraordinary recovery from cancer and repeated victories at the Tour de France (with the implicit pleasure of these stories related to their apparent confirmation of humanist and liberalist ideals). In fact, when one consumes these media texts, framed as they are through this ritual of consensus, it is difficult not to find Armstrong's personal and athletic achievements amazing and to be inspired by them. Since such pleasure can be derived from Armstrong's story, the media's easy articulation of Armstrong as a symbol of American national identity is commonly imagined as an apolitical act of their "just reporting" the news and ostensibly staves off any potential criticism of the racial, gender, and nationalistic aspects of the media's reporting of his story (for to criticize the representational politics of these stories would mean being regarded as a cynic who is needlessly politicizing this "feel-good" story which anyone, regardless of their racial, gender, class, or political allegiances, should be able to enjoy). Yet, such an argument assumes that the initial media representations of Armstrong are somehow non-political, which

surely is never the case. In fact, in this era where media representations of Tiger Woods are portrayed and frequently imagined as symbols of a progressive multicultural present–future for the United States (see Cole & Andrews, 2001), how can we not read these representations of the dominant, "incomparable," and "superman" Armstrong (whose whiteness and masculinity are rendered invisible)—steeped as they are in gushing, celebratory rhetoric—as part of a broader late 1990s resurgence of conservative white nationalism different only in degree, rather than in kind, to the White Patriot or White Supremacist movements (which surged in this era) or the race-baiting populist rhetoric of a Pat Buchanan or Rush Limbaugh (pre- and post-9/11)?

Armstrong's Americanized white masculinity also seems to parallel that of President Bush as described in the beginning of this chapter. The distinctly American, "man's man" masculinities of both Bush and Armstrong are clearly constituted by, and constitutive of, the emergent remasculinizing force which began in late 1990s America but has been intensified in post-9/11 America as such white male figures (like the NYPD and NYC firefighters) are heralded as the heroic protectors of a wounded nation. Yet, the potential excesses of their hyper-masculinity are contained and strategically managed by the occasional stories which illuminate a more caring and compassionate side.

The media portrayals of Armstrong also take great delight in celebrating him as the return of a conventional and unequivocal white masculinity; the triumphant cultural revival of the "man's man;" that is, a strong, dominant, invulnerable, hard working white male who is in control of himself and his surroundings. For example, much media attention was given to his now legendary bluff of physically laboring during a key mountain stage in the 2000 race only to speed away from his main rival, Jan Ullrich, minutes later. This tactic was portrayed in one article as a "cagey poker move" made by a "gentleman gunslinger." In several other places Armstrong's imaged identity is constituted through updated codes of the American Western and white male cowboy figure. One obvious site where this can be seen is a *Sports Illustrated* cover story where Armstrong is featured as the magazine's Sportsperson of the Year. The cover features Armstrong in a domineering, yet stoic pose (shot from below) standing alone with his trusty bike at his side on a dusty, desolate road ready to conquer the American frontier displayed in the background. In such portrayals, Armstrong's white masculinity rehearses conventional American codes of white masculinity long celebrated through figures like the cowboy. In these sites he is revered for his bravado, courageousness, unshakable confidence, and his willingness to suffer on his bike through training rides that are portrayed as exceptionally grueling and unrivaled by his competition.

In several articles, Armstrong is represented as "the most dominant figure in his sport" and is said to be "superhuman," "unbeatable," and "incomparable." Armstrong's white masculinity is also imbued with an extraordinary agency and sovereignty. Many media stories describing his struggle with cancer imply that Armstrong's strong determined will was a vital ingredient to his recovery. Other press reports seemed to revel in the notion that the only thing that could have stopped Lance from winning more Tours was himself; that he is the master of his fate. It would seem then that part of Armstrong's cultural appeal resides in the type of masculinity which we are invited to admire through him and his performances—one that displays strength, self-confidence, dominance, invulnerability, and possesses an unconstrained agency over self and circumstances. This is a form of white masculinity that many white men find desirable in this era of much publicized and widespread white male anxieties generated by recession-laden economic conditions as well as changing racial and gender ideologies and relations that many white men feel have chipped away at their socially privileged position. Cast in this manner, it is difficult not to read Armstrong as a male fantasy figure, as the apparent embodiment of an unequivocal male ideal.

At the same time, press articles in *Sports Illustrated, People*, and *USA Today* frequently included seemingly contradictory representations of a more, tender, caring, and compassionate Lance as father and husband blissfully celebrating his Tour victories with both his former wife Kristin and former fiancé, Sheryl Crow (who during Armstrong's last two Tour victories seamlessly took the place of Armstrong's ex-wife in media discourses about Armstrong) and his miraculous children. In countless stories during his riding days, Armstrong identified his wife (or Crow) and kids as instrumental to his athletic successes—his victories were represented as achieved for, and shared by, them. In the *Sports Illustrated* story reporting on his 2001 victory in the Tour de France where much of the article constructed Armstrong as the "master of the peloton" (the figure who controls and dominates the pack of lead riders), he is simultaneously described in the article as reluctant to accept such a title. The article's labeling of Armstrong as the "master of the peloton," along with his humble disavowal of the title, subtly enabled him to occupy both the dominant position in his sport and to seemingly deny any interest in occupying such an elite position. Thus, Armstrong's white masculinity was conspicuously constructed in such a way that he became perhaps the perfect embodiment of white masculinity in the late 1990s and into the new millennium. That is, he unquestionably was understood by virtually everyone as the dominant figure in his profession, yet by publicly denying any interest in occupying such a privileged, dominant, and

controlling position, he avoided appearing as the much criticized figure (in the 1990s) of the alpha white male who must be on top, in control, and dominate others at all times.

Armstrong's white masculinity is also able to avoid being read as an imperialistic white masculinity through the occasional (yet strategic) telling of stories which strategically feminize his masculinity. The *Sports Illustrated* article mentioned above demonstrates this point by detailing how Armstrong stopped during a training run in preparation of the Tour de France to weep at a roadside memorial where one of his former teammates had died during the previous year's Tour race. Through these stories and others featuring his generosity in giving back to cancer survivors (whether in terms of time or money) Armstrong's white masculinity is depicted as caring, in touch with his emotions, and benevolent. So although Armstrong's white masculinity is most frequently coded in distinctly masculine terms, it is also strategically feminized in ways which allow his white masculinity to avoid occupying the much-criticized subjectivity of the arrogant, white male figure who is either ignorant or in denial over his structural advantages and resents those who publicly highlight those privileges. Ironically, such occasional feminized portrayals of Armstrong also ironically allow him to on other occasions unapologetically project a hyper-masculine masculinity.

In sum, these media representations of Armstrong reveal a complexly and contradictorily coded white masculinity which at each and every turn, reflected and responded to the fears, desires, and anxieties that white men were said to be feeling in new millennium America; he was the consummate family man who scheduled his training rides around the time he dedicated to his family; he dedicated his victories to his (then) wife (or fiancé) and children; he was a team leader who publicly expressed his appreciation for the work of his teammates; he is still a selfless symbolic leader of cancer survivors who endlessly gives back to his followers (not just by giving money, but by creating his own foundation); he is the cowboy-like rugged individualist who always appeared in control of self, others, and his environs; and finally, he was a man who worked ridiculously hard and had an extraordinary will to win (just recall the Nike commercial that emphasizes that Armstrong is not on performance enhancing drugs, he's on his bike training for eight hours every day) which makes him the most deserving athlete of his success and celebrity-endorser status (and riches).

One of the main themes in a *Sports Illustrated* article reporting Armstrong's victory in the 2001 Tour, took great delight in detailing his power and authority over the peloton, giving him the moniker of "the master of the peloton" (Murphy, 2001). In such narratives about Armstrong, emphasis is not given

merely to his victories in the prestigious Tour, but they simultaneously construct and valorize Armstrong's white masculinity for his mastery and consummate control over himself, the race, and even his competitors.

In other media representations, Armstrong's white masculinity is revered for his bravado, courageousness, unshakable confidence, and his willingness to suffer on his bike through training rides that are portrayed as grueling and unrivaled by his competition. In several articles, Armstrong is represented as "the most dominant figure in his sport" and is said to be "superhuman," "unbeatable," and "incomparable" (Murphy, 2001). For example, on the August 5, 2002 cover of *Sports Illustrated*, a picture of a determined Armstrong motoring up a hill is accompanied by the caption, "SuperMan" (Reilly, 2002). Readers of the August 6, 2001 cover of *Sports Illustrated* encounter a smiling Armstrong perched victoriously on his Trek bike next to the caption: "He Delivers: The Incomparable Lance Armstrong" (Murphy, 2001). On the December 16, 2002 cover of *Sports Illustrated* where Armstrong is introduced as the Sportsman of the Year, he is once again shown resting on his bike, only this time he's displayed alone, cowboy-like on the open plains, ready to ride—alone—off in the sunset. Unlike the smiling Armstrong on the 2001 cover, this Armstrong, reminiscent of John Wayne and fantasies of American cowboys, perhaps the quintessential reassuring (at least to white American men) American symbol of conventional masculinity, offers the reader a self-assured, almost cocky stare that gives the impression he feels fully deserving of the title of "Sportsman of the Year."

Lance America as Recovery of White Male Supremacy in Contemporary American Sport (and Culture)

In the 1990s, cultural discourses about American professional athletes have operated as an often overlooked reservoir for the expression of white (male) fears, desires, and anxieties about changing race relations and ideologies in contemporary America (Shields, 1999). More specifically, the American sports media are sites where white fears and anxieties about an emergent wealthy and athletically superior black masculinity which challenges and destabilizes the central, superior, and normative position of white masculinity in sports are expressed regularly. These sport discourses of white anxiety—which can be witnessed daily on the airwaves of AM sports-talk radio, or on sports television broadcasts (where they are more sophisticatedly disguised yet still apparent), or even in a number of sport-related films—often take the form of scathing rants or more seemingly reasonable castigations about the off-the-field indiscretions and criminal activities of contemporary professional athletes or their excessive

greed, selfishness, and narcissism. Within these narratives, although the race of these athletes is rarely ever mentioned, the publicly derided contemporary professional athletes are usually named or implicitly racially coded as African American. In addition, these black athletes are often demonized through a comparison (that is either explicit or implicit) with a nostalgia-laden and/or fictitious glorification of pre-1960s American athletes (usually racially coded as white) or with contemporary white athletes who are coded as family oriented, wholesome, team-oriented, and said to play for the love of the game (i.e., Cal Ripken Jr., Kurt Warner, or film figures like Rudy Roettiger from *Rudy* or Kevin Costner's Billy Chapel from *For Love of the Game*). These sports media sites—often imagined as apolitical sites of popular culture (sites of escape and diversion separate from "real" social issues and problems)—should instead be understood as strategically involved in re-securing a central, normative, and superior positioning of white masculinity in American culture by constituting these white male athletes as ideal athletes (humble, hard working, family oriented, team-oriented) who are defined over and against an unruly, criminalized, hyper-individualistic, and greedy image of black athletic masculinity. The conspicuous appearance of so many sport films during the late 1980s and 1990s which lionize white male athletes variously depicted as unprivileged outsiders or underdogs (i.e. *Bull Durham*, *The Natural*, *Field of Dreams*, *Eight Men Out*, *61**, *Tin Cup*, *For Love of the Game*, *Rudy*, *Hoosiers*, *BASEketball*, *Without Limits*, *Prefontaine*, etc.) also signals to me this racial project at work here. Which is to say that in this historical moment when white male superiority and normativity are being challenged on the actual playing fields by the superior athletic achievements of African Americans in the "big-three" mainstream American sports as well as a shift in the racial demographics of the players, it seems that the American sport media has become a cultural site for the production of white male fantasies which allow the superior and normative position of white masculinity to be re-claimed and re-secured (even if only to the big screen).

With this context in mind, I contend that part of the appeal and media's public celebration of Lance Armstrong's story and his admittedly amazing athletic feats are their predication on the same white anxieties (about the destabilization of the central and normative position of white masculinity in the American commercial sports formation and American culture writ large) and desires (to re-claim and re-secure such a central, normative, and superior position for white masculinity) mentioned above. But as one would expect in this "race is over"/colorblind historical moment, this desire to recover a central, normative, and superior position for white masculinity within sports is

hardly expressed in explicit or straightforward ways. Rather, it is conveyed subtly, almost inconspicuously through seemingly innocent, inconsequential, and even flattering comparisons between white and black athletes. For example, within a handful of media stories about Armstrong, his victories in the Tour de France are compared with the athletic accomplishments of Tiger Woods and Michael Jordan. In every single one of these comparisons between the athletic accomplishments of these athletes, Armstrong's physical feats are rationalized as more significant and worthy of the public's respect and admiration than Woods' and Jordan's. For example, note the hierarchy of achievement created by this comparison between the athletic feats of Armstrong and Woods by Time.com's Jessica Reaves (2000):

> If anyone deserves to be on the front page of every major newspaper and sports magazine, it's Armstrong. He has a very strong case to make America's Greatest Sports Figure. This guy powers himself up mountains using only his quadriceps and bicycle. Most Americans would get winded *driving* these peaks, for Pete's sake. But instead of following Armstrong and his teammates over the cragged peaks of Europe, we're treated to ad nauseam stories about Tiger Woods, whose accomplishments are myriad, to be sure, but whose claim to greatness lies more with skill and mental determination rather than those combined with true athletic prowess.

This narrative positioning of Woods as athletically inferior and undeserving in the face of Armstrong and his accomplishments is further reinforced in a *USA Today* article where Woods is depicted as the most excited "sporting superstar" to ever meet Armstrong. Although such a story seems to positively portray Woods (aligning him with an American public who is said to overwhelmingly admire Armstrong as well), in the very next sentence, the author subtly takes a dig at Woods by depicting him as self-aggrandizing and arrogant through a contrast with a humble Armstrong who "doesn't think of himself as an immortal, not like Woods" (Associated Press, 2000). Additionally, this seemingly positive portrayal of Woods as an admirer of Armstrong still serves to position him as a subordinated and deferential person of color in the face of the incomparable, "truly" immortal white male ideal Armstrong.

Similar comparisons, which always define Armstrong in superior terms over his black athletic counterpart, are also made between Armstrong and Michael Jordan. For example, in a CNNSI.com story, Jack McCallum writes, "Michael Jordan's singular supremacy, while jaw-dropping, was explicable ... But Armstrong? The guy seems off the charts on all levels" (McCallum, 2001). Later McCallum reinforces this comparison between Jordan and Armstrong by recalling Jordan's legendary night in the NBA Finals where he fought off the flu

to drop 40+ points on the Utah Jazz. McCallum writes, "We remember Jordan fighting off the flu to play heroically during the playoffs. Armstrong? He fought off death!" In each of these comparisons between MJ and Armstrong, Armstrong's athletic accomplishments are constructed as superior to, and more amazing and deserving of public admiration than, Jordan's. It is through these seemingly benign and innocent comparisons between Jordan and Armstrong that the cultural admiration of Armstrong subtly, yet distinctly, becomes an expression of an often overlooked form of cultural racism that desires and discursively recovers a superior and normative position for white masculinity in American (sport) culture.

Even further, various media stories on Armstrong repeatedly constitute his white masculinity through notions of superiority. He is frequently described as "unbeatable," "incomparable," "superhuman," "supernatural," and, in one article, simply as "superman." Through the use of these superlatives Armstrong's white masculinity is situated at the apex of the contemporary American sports scene. Supplemented by celebratory tales of Armstrong's superhuman work ethic and strong connection and dedication to his family,[10] Armstrong's white masculinity is simultaneously coded as hard working, wholesomely invested in family values, and as deserving of every cent of his athletic riches and sporting celebrity. This implicit desire to reassert white male supremacy through the celebration of Armstrong's accomplishments might further be seen in the widespread discussions and debates which have emerged within American sport media (i.e., on *Sportscenter*, *Pardon the Interruption*, or *The Sports Reporters*) where Armstrong's accomplishments in the Tour are said to be unequalled and unparalleled by any other sport performances in the present (if ever). In 2004, ESPN.com created a "March madness" type of bracketed competition pitting one contemporary elite athlete against another in a series of "battles" where winners were determined by an on-line vote of the public. In the end—surprise, surprise!!—Lance Armstrong was voted as "the best of the best" in this unavoidably subjective poll. In the final "match," Armstrong's athletic accomplishments were deemed to be better than those of the Atlanta Falcons' African American quarterback, Michael Vick, whose athletic gifts are commonly described as "freakish" and "god-given" (adjectives which represent some of the contemporary racial codes used to dismiss the hard work, training, and cultivated skill of contemporary black athletes while rationalizing their athletic excellence through the age-old explanation of a natural black athleticism that marks black male athletes as something other than human).

The other, alarming, and often overlooked aspect of these media discourses which celebrate not only Armstrong's athletic exceptionalism but also portray

him as the contemporary embodiment of what a professional athlete should be (both on and off the field) is that they depend upon the aforementioned demonization of the "contemporary professional athlete" who is almost exclusively portrayed as a black man who is depicted as child-like, not invested in family values, prone to criminality, greedy, self-interested, hampered by an over-inflated sense of entitlement, and as not having deserved/earned his wealth and high social status. For example, in an article which celebrated Armstrong's 2001 victory in the Tour de France, *Sports Illustrated* sportswriter, Jack McCallum, defined the virtue of Armstrong's victory and story by comparing it to the disappointing stories coming out of the then current Atlanta Gold Club trial of black athletes like Patrick Ewing, Andruw Jones, and others who allegedly received sexual favors from the women who stripped at the club. This same racial contrast was repeated visually in ESPN's *Outline the Lines* program celebrating Armstrong's sixth Tour de France victory. So then, the underbelly of the cultural celebration of Armstrong's "incomparable," "superhuman," and morally deserving white masculinity is the demonization of this emergent youthful, athletically superior, wealthy black masculinity in order to contain the challenge it poses to the reproduction of white male superiority in American culture and society.

Conclusion

As the work of a number of critical sport scholars has noted,[11] the spectacular narratives told of iconic athlete-celebrities like Lance Armstrong "offer unique points of access to the constitutive meanings and power relations of the larger worlds we inhabit" at particular moments in time (Birrell & McDonald, 2000, p. 5). The media spectacles made of the lives of these popular figures often become seductive national fantasies onto which the deepest and darkest desires, fears, and anxieties of the American normative class at this time in history are projected. At the same time, these national fantasies, like those of "Lance America," must be critically understood and examined not only as contemporary cultural hieroglyphs which, when decoded, can inform us about what sentiments, affects, and ideologies are popular at a given moment in history, but as unavoidably pedagogical and political sites being used to advance particular conservative agendas aimed at re-securing, re-consolidating, and extending white male privilege in American culture.

More specifically, I've argued here that the various incarnations of Lance Armstrong's mediated white masculinity together represent a new combination of representational strategies used in a conservative cultural politics interested in re-securing a central, normative, and dominant position for white masculinity

in American culture and society. This particular version of this backlash politics involves the coupling of a set of images of white masculinity that enable white masculinity to be encoded both as authentically unprivileged, disadvantaged, or victimized (through his identity as a cancer victim/survivor), *and* as unquestionably heroic, powerful, invulnerable, strong willed, unconstrained, dominant, and superior. The importance of this dual strategy of rendering visible Armstrong's white masculinity is recognizing how the cultural valorization of Armstrong as a symbol of the triumphant cultural return of a conventional "man's man" masculinity, as a unique and deserving representative of America, and the quiet maintenance of white male supremacy in American sports is that it depends on, and must always begin with, his often-repeated story of surviving a near-fatal brush with cancer. This story of Armstrong's surviving cancer, where his cancer wound is represented as the defining essence of his post-cancer identity, functions to constitute his white masculinity as forever disaffiliated from dominant whiteness (white male privilege). In fact, it is Armstrong's cancer "wound" which prevents most from being able to see how the media spectacle made of his life serves as the perfect ideological tool to manufacture consent and consensus for ideologies supportive of hegemonic masculinity and white normativity and supremacy in American culture and society. Whereas, this backlash desire to recover a superior and dominant masculine position for white males that is more easily recognized (and criticized) through the displays and rhetoric of the frat-boy white masculinities of Jimmy Kimmel, Adam Corrola, the *Fight Club* crew, the *Jackass* fraternity, or more recently of the films of the frat-pack of Will Ferrell, Vince Vaughn, Ben Stiller, and Owen Wilson (i.e., *Old School, Anchorman: The Life of Ron Burgundy, The Wedding Crashers*, or *Dodgeball*), it seems more difficult to see how the public celebration of Armstrong's reflects, and is also constituted through, a similar set of implicit desires and goals. I think it is more useful to see Armstrong as the cleaner, more seemingly family-friendly version of these other popular white guys during this historical conjuncture. The only difference (which when you think about it is quite disturbing) is that the discourse on Armstrong promotes this backlash agenda in a much less obvious and seemingly more virtuous and honorable way. Whereas the easily criticized white frat-boy contingent mentioned above secures their superior position through the misogynistic treatment of women and sadistic acts against parents and friends (and even self), Armstrong's white masculinity earns his position of dominance and superiority through his athletic victories (which we are constantly told demand family sacrifices and inordinate amounts of hard work and effort) and supposedly selfless charity work. Yet, even in these seemingly

laudatory discourses about Lance America, women and people of color always are positioned "in their proper places" as subordinate to Armstrong's all-powerful, dominant white masculinity and there for his beneficent and heroic care and concern. Thus, Armstrong's white masculinity simply appears more honorable, respectful, and acceptable than these other white guys even as he is constituted through remarkably similar mythologies of whiteness, masculinity, and America to become the national fantasy of "Lance America."

✠ CHAPTER EIGHT

Conclusion: Notes on Some White Guys in Post-9/11 America

As I conclude this book, I realize that, by now in 2006, some of the American athletes and sport formations I have analyzed in the preceding chapters might be considered old news. Andre Agassi called it quits following his 3rd round exit in the 2006 US Open; Lance Armstrong announced his retirement from competitive cycling following his record seventh straight triumph in the Tour de France in 2005; and the X Games—the preeminent event borne out of the emergence of extreme sports—while still marketing itself as an "edgy" and "rebellious" sporting formation has ostensibly lost its edge and its resistive potential (if it ever really existed at all), and it has grown comfortable with its corporate support and integration into the American mainstream. At the same time, discussions of Generation X—those so-called lazy, twenty-something slackers coming-of-age in the early 1990s—which were so central to the constitution of media representations of Agassi and extreme sports seem to have largely disappeared from American culture. The strategy of representing white guys as disadvantaged and/or unprivileged as a new and effective cultural means of disavowing the continuing existence of white privilege and white supremacy in post-civil rights America is no longer novel even if it is still widely deployed. Some cultural critics and social observers have even argued that the era of identity politics has now passed; that the struggles over the meanings and politics of something, such as white masculinity in American culture and society that I have tried to detail here (as they have played out in discourses of sports) no longer represent the key, crucial issues of the day for our nation in the aftermath of the tragic events of September 11, 2001. But, I share Winant's (2004) disagreement with this "denunciatory attitude toward 'identity politics' so evident on both the right and left today" (p. 176). He adds, "In my view, the matrices of identity are ineluctably political, for they involve interests, desires, antagonisms, and so on in a constant interplay with broad social structure" (p. 177).

So then, in this final chapter, by way of example, I want to briefly make a case for the ways in which identity politics and some of the ideas and observations about the cultural politics of white masculinity I've offered in this book are still germane and relevant to an understanding of post-9/11 America. In fact, perhaps now more than ever, at this time when the Bush administration's reactionary "war on terror" response to 9/11 has created a domestic cultural and political context where dissent and criticism of any aspect of President Bush's foreign or domestic policies are often regarded as unpatriotic, defeatist (code for "un-American"), or even more ridiculously, as siding with the terrorists, the conditions are in place for conservative and reactionary forces to "take back" America to re-secure a central and normative position for white masculinity in American culture and society in the name of love of country. In each of their examinations of the place and role of anxious (white) masculinity in shaping the Bush agenda, Ehrenreich (2002), Mailer (2003), and Ducat (2004) have shown that such efforts "to challenge democratic and egalitarian social movements" are already clearly underway (Winant, 2004, p. 123).

The first place to look to see how identity politics, which here means the mobilization of racial and gender issues and representational strategies to both mask and advance the particular interests of some groups over others, still play a vital role in cultural politics in the post-9/11 era is the cultural discourses through which the war on terror is rendered visible to Americans. We cannot forget how one of the key rationalizations for the "war on terror" (and by extension, the public celebration of the good and noble deeds of the America wishing to bring freedom and democracy to all those who we claim desire it across the globe) has, from its beginning, been the appropriation of feminist critiques of the repression experienced by women in some of these fundamentalist Islamic regimes which had previously been largely ignored by conservatives and the Bush administration (Winant, 2004). Or, more recently, the Bush Administration's decision to send Secretary of State, Condoleeza Rice and First Lady Laura Bush as representatives of the United States to the swearing-in of Ellen Johnson Sirleaf as the first female president of Liberia. This move is surely good PR that anticipates and seeks to stave off the critiques of feminists and African Americans who strongly believe that the Bush administration has little care or concern for the interests of women and African Americans (consider hip-hop artist Kanye West's unscripted declaration, "George Bush doesn't care about black people" on NBC's live Katrina benefit program). Additionally, to the extent in which patriotic and nationalistic

displays revive and call for the return of manly (white) men (representations of multiracial groups led, of course, by white men can be even more effective as they foster the illusion of colorblindness) who protect America's women and children, they represent what Robinson (2000) might call, "identity politics of the dominant."

So, in the rest of this chapter, I want to offer some thoughts on what I want to call the rise of the discourse of "white cultural nationalism" in the American mainstream (since 9/11) and its connections with the logics and representational strategies of the era of identity politics which preceded it. This white cultural nationalism is expressed through nationalist narratives, symbols, and imagery drenched in patriotism which revive comforting and familiar images of white men who are at once common and exceptionally heroic leading the fight to protect the freedoms and rights for all Americans today and in the future. The political brilliance of this white cultural nationalism is that it appears to be colorblind even as it recenters and normalizes whiteness and conventional forms of masculinity in the American imaginary. Indeed, as the discourse is crafted in the name of reflecting and cultivating American patriotic pride in a time of crisis, these narratives hardly seem concerned about advancing a reactionary racial and gender politics at all. If the racial or gender aims or effects of such national narratives are critically questioned at all, such racial and/or gender intentions seem to be easily denied by the producers of these representations, while, ironically, such inquiries often lead to the condemnation of those who would dare pose such an pessimistic or defeatist question in this age of terror.

The main feature of this post-9/11 white cultural nationalism is the forwarding of a white male, who is said to have an "average," everyman quality, as the quintessential embodiment of America. He usually claims to, or is made to, represent all those Americans invested in the "traditional" values and fundamental ideologies for which America has always stood (individualism, freedom, and meritocracy are mentioned most often). Another key aspect of this discourse is that it reasserts and celebrates the return of a conventional masculinity on the American cultural landscape who very often unapologetically decries political correctness and special interests while speaking for those unnamed white folk "wondering what happened to the free America that my forefathers fought for" as Larry the Cable Guy, an immensely popular comedian, puts it on his web site (Whitney, 2005).

In a variety of clever and at times disguised ways, this white male American populist figure is also often coded as disadvantaged or seemingly disaffiliated

from dominant whiteness or lacking class privileges of any sort. Although the average, everyman white guy cast in this white cultural nationalism often appears to be inclusive and non-discriminatory because of his mass appeal or following, this white masculinity is actually quite exclusive and exclusionary in the pleasures it offers as they rely on gender and racial stereotypes and either explicitly or implicitly reproduce social hierarchies with working, average white men always on top. Time and time again, in obvious and not-so-obvious ways the identities of these white male cultural nationalists gain their racial and gender meanings over and against traditional notions of women as subordinate, sexually objectified, and seen but not heard and people of color as greedy, materialistic, self-centered, infantilized, uneducated, and unpatriotic to gain its central and normative cultural position.

So then, the effect of this discourse of white cultural nationalism which has become a popular means of cultivating patriotic and nationalistic fervor in American culture following the tragic events of 9/11 should sound remarkably familiar by now—the recentering and normalizing of white masculinity as the central and most vital figure in American culture and society. Of course, as I've attempted to show throughout this book, this has been the implicit goal or effect of white male backlash politics throughout the 1990s and into the new millennium, whether expressed through *Sports Illustrated*'s 1997 cover story, "Whatever Happened to the White Athlete?" the mainstreaming of extreme sports, or the media spectacle made of Lance Armstrong's amazing story of surviving cancer to become a cycling legend.

It also bears mentioning that white cultural nationalism is not necessarily new or unique to the post-9/11 American context; its roots extend at least as far back as the early 1990s through the rhetoric espoused by those on the Far Right, such as Pat Buchanan and David Duke, or the Patriot movement of the early 1990s. But, one notable difference between the post-9/11 incarnation of white cultural nationalism and that of its notorious forbearers is the post-9/11 version rests squarely and comfortably in the center of the American mainstream and does not seem to be regarded as an extreme ideological expression at all. Interestingly, this white cultural nationalism appears to have found a comfortable home in the cultural realms of sports and comedy. Perhaps this is because these cultural spaces, which are often popularly imagined as supposedly trivial and apolitical cultural sites, allow the expression of ideas and sentiments that otherwise couldn't be easily expressed in polite and civilized conversations and whose politics can be easily disavowed by the speaker.

So, in the limited space I have left, I want to briefly discuss four of these sites through which this white cultural nationalism is expressed: (1) the *National Review*'s articulation of "NASCAR Nation" as a "very American sport" (Derbyshire, 2003, p. 32), (2) the persona of the self-professed Southern redneck comic, Larry the Cable Guy, (3) the media spectacle made of Pat Tillman—the former NFL player who walked away from his lucrative life as a professional football player to serve his country (and later lose his life) in the war on terror in Afghanistan, and finally, (4) the surprising mainstream popularity of *Murderball*, the documentary about the experiences of the men of the United States Paralympic quad rugby.

With "NASCAR Nation" sprawled across its cover in bold letters, the November 10, 2003 issue of the *National Review* represented this newly nationalized sport as one "in which physical courage is admired, family bonds are treasured, the nation's flag honored, and the proper balance between courteous restraint and necessary aggression is constantly debated … I'm glad to have made the acquaintance of a thrilling, noisy, colorful, commercial and very American sport" (Derbyshire, 2003, p. 32). This representation of the United States as "NASCAR Nation" is the most explicitly politicized of the expressions of white cultural nationalism I discuss here.

This *National Review* cover story is perhaps the greatest example of the way in which this discourse of white cultural nationalism is able to create, project, and celebrate a racially exclusive image of America while simultaneously disavowing its racial exclusivity and relation to white supremacy. Put most bluntly, the *National Review*'s creation of "NASCAR Nation" is simply the latest form of the Republican's "Southern strategy" of using cultural reasons as wedge issues which allow "corporate fat cats" to create and maintain alliances with "key lower-strata socially conservative constituencies" (Winant, 2004, p. 123). As these racial bonds trump the divergent economic interests of these disparate groups of whites, the Right is able to protect white privilege and dominance while strategically denying the racial content of the strategy.

One thing that is new in this Southern strategy is its appropriation of sport to promote its politics. But perhaps sport, thought of as it is as wholly separate and distinct from the realm of politics, is precisely one of the best cultural vehicles for promoting its reactionary politics while not seeming to be ideological at all.

The article reveals the discursive gymnastics necessary to capitalize on the racial exclusivity and overwhelming whiteness of the sport to promote their politics (which is the reason NASCAR was chosen as a vehicle of this strategy

in the first place), while denying the sport's racial value to Republicans. These discursive maneuvers ironically involve making certain facts of whiteness visible as a means of denying that the discourse has any racial/racist implications. For example, the article readily acknowledges the sport's history of virtual racial exclusivity and offers up the detail that all of NASCAR's forty-three drivers in 2003 are white. But then it follows these admissions up with a story of how Jesse Jackson's RAINBOW/PUSH Coalition is supposedly involved in a "self-enriching shakedown scheme" against NASCAR. As part of this supposed blackmailing scheme, a board member of RAINBOW/PUSH made a public declaration that NASCAR represents "the last bastion of white supremacy" (Derbyshire, 2003, p. 32). Here, the racial order is amazingly turned on its head as Jackson and his organization are made out to be powerful "thugs" unfairly blackmailing NASCAR, while the white sport (with its intimate connections to corporate America) is portrayed as an innocent victim of an expansive "racial guilt industry" (p. 32). Obviously, this portion of the chapter reveals how the sorts of racial inversions and white claims of victimization frequently made during the era of identity politics are still being mobilized in post-9/11 America.

Next, any potential racism within NASCAR is denied by highlighting how NASCAR involved the then current Miss America and the late football player, Reggie White—two African Americans—in their pre-race festivities. Attention is brought to NASCAR's Diversity initiatives. Here, racism is implicitly conceived as a matter of racial representation; if people of color are present in an organization or put on display by an organization, then racism can't exist. Superficial racial imagery is strategically displayed to avoid a deeper, more substantive, and important understanding of racism as institutionalized.

The seemingly undeniable (and virtually complete) white-only participation pattern in the sport (even if white-only rules were never officially codified in the sport's history) is conveniently explained away not as a product of white supremacy, but as nepotism and the high cost to create a racing team in order to participate. Intergenerational displays of fathers and sons involved in the sport are a matter of pride in the sport's discourse. They enable the celebration of the continuity of white patriarchy expressed through generational rhetoric which, on its face, seems to be about valuing strong family bonds. And surely everyone would agree that enormous economic wealth, nepotism, and intergenerational privilege have little to do with the history of white supremacy and continued divergent patterns of wealth, power, and opportunity between whites and African Americans in the United States today (note sarcasm here).

As every effort is made to contain the sport's NASCAR's troubling relation to white supremacy, even as the author admits to the great number of Confederate flags which fly free in the raucous infield at the races (I'll return to the "pleasures" of the infield in a moment), an equal amount of exertion is expended attempting to establish NASCAR's credentials as a national sport. We are told that only half of the season's races take place in the South (defined as "the Old Confederacy plus Kentucky" (Derbyshire, 2003, p. 32), only half the drivers come from the South, and its attendance numbers and national television contract rival those of the other "big three" sports (baseball, football, and basketball). The "old boys" NASCAR, the article informs us, is a thing of the past; today's NASCAR is inclusive and family oriented.

Yet, this particular part of the article's description of NASCAR then seems to contradict Derbyshire's observations and experiences in the infamous infields of NASCAR where he finds himself surrounded by a crowd that is "noisy and beery. They wear denim shorts and t-shirts, baseball caps or bandannas. I see a lot of tattoos and a lot of Confederate flags" (Derbyshire, 2003, p. 30). He details how the infield has seen its share of shootings in the past and includes a "small jail" (p. 30). Another tradition of the infield is— following Mardi Gras customs—to induce women to show their "chests" (interestingly, not "breasts") in exchange for beads. So, even as Derbyshire attempts a number of rhetorical contortions to contain the racist excesses of this apparently laudable "American sport," he doesn't seem too ashamed of its blatant sexism, patriarchal relations, or unapologetic displays of male dominance and hyper-masculinity that borders on being out of control. Indeed, these seem to be the goals of white cultural nationalism—to rearticulate whiteness as the legitimate racial identity of America, to proudly reassert conventional forms of masculinity, and to make it seem as if these desired racial and gender outcomes are merely arbitrary and hardly the product of anyone's intentions.

Next, I would like to discuss the comedian, Larry the Cable Guy, as an expression of this emergent white cultural nationalism in post-9/11 America. Larry the Cable Guy, whose real name is Dan Whitney, holds the distinction of being "the highest-grossing road comedian" in 2005 with ticket sales reaching the $15 million mark (Curtis, 2005). Whitney, humbly got his start playing Larry the Cable Guy on a local radio in Jacksonville, Florida, where he would perform his Southern redneck persona while offering commentaries on political correctness and terrorism among other topics. His famous trademark "Git-R-Done" phrase can be found in convenient stores all across the United States

plastered on merchandise from baseball caps to lighters and even in women's panties. Due to his explosive popularity (he is not only a popular touring stand-up comic, but can be seen regularly on television in *Blue Collar TV*, heard in the film, *Cars*, and seen in the film, *Larry the Cable Guy: Health Inspector*), he is arguably the most visible expression of this emergent white cultural nationalism.

Assuming a populist, unsophisticated persona akin to Forrest Gump's more mischievous and rednecked relative, Larry the Cable Guy's performance, which is an admixture of Old South ideologies and contemporary sensibilities, offers a rallying point for whites of various classes as it revives humor grounded in the sexist objectification of women and the belittling of terrorists, immigrants, and "the pygmies in New Guinea." The unity of white people across classes achieved through his comedy is forged by the glue of sexism, racism, and his performance of a Southern redneck. It is Whitney's deeply caricatured performance of the Southern redneck which not only enables him to be read as a socially and economically unprivileged, if not disadvantaged (by his hillbilly roots) white male but enables white audiences to delude themselves that they are different than him ("we are not rednecks like that"), and that his act has little to do with the reproduction of white supremacist and patriarchal ideologies and relations.

As Curtis (2005) explains, Larry the Cable Guy is the contemporary version of a brand of "redneck comedy" that became popular in the 1960s at the beginning of the desegregation of the South. Then, redneck comics frequently railed against communists and Northern liberals who in their minds were trying to ruin the South's way of life. Today, Whitney's targets are similar: the "evil commie libs and politically correct uptight crybabies" and the empowered blacks and white liberals supportive of affirmative action, political correctness, and multicultural programs whom he sees as trying to ruin American culture and society.

Not only does Larry often claim to speak for American working people today, but he takes it one step further by proudly displaying the Confederate flag virtually every chance he gets. He assumes a masculinized position to gain support for his act and political position by feminizing those who may criticize his act as scaredy-cat PC-types who, in his book, are too "uptight" and/or crybabies (which, it bears repeating, was the strategy uncoincidentally employed by Californian Governor Arnold Schwarzenegger against his "girly-man" opponents). These postures and modes of self-presentation that Larry performs are a reaction against the more feminized "caring, sensitive guy" who

was forwarded as a post-feminist male ideal from the 1970s to the early 1990s as well as white men's anxieties about being publicly criticized as always already the evil oppressor of women and people of color. In these poses, Larry the Cable Guy is applauded by white audiences, particularly white men, for his refusal to apologize or to change "who he is and [he] doesn't give a damn what anybody thinks" (Curtis, 2005).

The Americans who are said to be drawn to Larry's act are described as the "unhip," those who, as comedian and fellow *Blue Collar Comedy Tour* mate, Jeff Foxworthy, puts it, "feel as though they've been left out, the ones who wake up every morning and go to work and go to war, and, dadgum, there's a whole lot of 'em out there" (Curtis, 2005). So, as Larry is positioned with, and embraced by, the white American mainstream, his white audiences are constructed as the forgotten majority of hard-working Americans (which is a code for working white Americans—which is suitably broad enough to appeal to middle-class, working class, and poor whites) who are disconnected from the "special interests" who are imagined as getting all of the social advantages and privileges over the past 15–20 years. In short, the white mainstream gets constructed as the socially and culturally unprivileged ones deserving of recognition and whose beefs, supposedly expressed through figures like Larry, are legitimate and need to be heard. At once, Larry's redneck white masculinity is able to be cast as both a different white male from the social margins, yet he is still adequately representative of the overlooked "silent majority" of hard-working (white) Americans. Remarkably, white supremacist and patriarchal ideas are expressed freely and made popular while they evade any sort of cultural critique. White people can delight in Larry the Cable Guy's humor—usually in racially homogenous audiences or in the safety and security of their homes—while still being able to disavow all of it because it is just comedy after all, right?

The "base" Larry the Cable Guy is perhaps the best example of the complex ways in which the logics, representational strategies, and struggles of the era of identity politics are still being played out in post-9/11 America. In this version of Robinson's (2000) "identity politics of the dominant," the racist and sexist aspects of his act are too often overlooked or dismissed as just a joke, as Whitney offers himself as a representative of hard-working, overlooked Americans and dutifully wraps himself in the American flag. But, we shouldn't forget that he is often wearing a trucker cap with the Confederate flag stitched on the front.

Following his death on April 22, 2004 while honorably serving his country with an elite Army Ranger unit in Afghanistan, Pat Tillman, the former

undersized and unlikely NFL All-Pro with a strong will who gave up his lucrative life as a professional athlete to serve his country, was instantly turned into America's most prominent hero of the "war on terror." Interestingly, despite the Bush Administration's ban on media images of dead American soldiers returning in coffins, Tillman's funeral was broadcast live on the ESPN networks, hosted by the testosterone-infused sports talk personality, Jim Rome. In spectacular fashion, Tillman was eulogized and valorized across American media culture for the next few weeks. Senator John McCain, himself a famous prisoner of war, is eulogized Tillman by saying, "There is in Pat Tillman's example, in his unexpected choice of duty to his country over the riches and other comforts of celebrity, and in his humility, such an inspiration to all of us [Americans] to reclaim the essential public-spiritedness of Americans that many of us, in low moments, had worried was no longer our common distinguishing trait" (Smith, 2003, p. 46). In a *USA Today* report Tillman is described as a symbol of "the best of our nation" and as the "ultimate American" (Boeck, 2004). Not to be outdone, the NFL fans who attended the 2004 NFL Draft, put aside their team loyalties and united to chant "U-S-A … U.S.A. … U.S.A." when Tillman was remembered by the league at the event.

In researching the media spectacle made of Tillman's life and decision to give up football to serve his country, it was particularly interesting to read the details of the narratives about Tillman and his life in the sporting press following his unfortunate death. A couple of themes and motifs stand out in particular. Time and time again, Tillman was cast as the inverse of the much-maligned greedy, overprivileged selfish pro athlete of the contemporary American sporting world. One article put it this way, "The playing fields abound with prima donnas who hire themselves out to the highest bidder, with no mind to the fans who put them there on the pedestal. … The fans are tired of these prima donnas. Tillman was the exact opposite, a man of honor and dignity and morals" (Roberts, 2004). Media reports lauded him for his loyalty to the team that believed in him enough to draft him as a supposed long shot out of college, the Arizona Cardinals, virtually reveling in explaining how he turned down a multimillion dollar contract with the much more successful St. Louis Rams to stay with Arizona for much less money. He is repeatedly portrayed as a team-first guy who shunned the spotlight and never bragged about himself and always looked out for his teammates and others. Details portray him as never really being too interested in the socially and economically privileged lifestyle that being a professional athlete afforded him. Whereas his teammates are said to have ridden to work in high-priced sports cars and sport-utility vehicles,

Tillman is said to have arrived to the Cardinals training camp riding his bicycle in flip-flops with his cleats dangling by their shoelaces over his handlebars.

As discussed in the previous chapter, the comparisons made here between the humble Pat Tillman who's disinterested in the material privileges and trappings of the professional athletic life and contemporary *prima donna* athletes is implicitly a racial discourse where, in many cases, the actual racial order is inverted as it is perceived through the prism of professional sports. In this vision, black male athletes like Terrell Owens or Kobe Bryant get cast as the embodiments of excessive (and undeserving) socio-economic entitlement and privilege, while white men like Tillman hardly appear socially and economically privileged; in fact, they are portrayed as uninterested in such privileges. Such representations make it difficult to bear witness to the actual racial and gender privileges which structure American society. Even further, post-mortem, as Tillman's white masculinity get constituted as the embodiment of the essence of American ideals and a man of the American people, his white masculinity gets rendered visible as moral, unselfish, willing to sacrifice himself for the greater good, distanced from privileged life, and without a sense of entitlement.

One article describes him as "Forrest Gump with smarts," while others make note of the fact that his boyhood hero was Arnold Schwarzenegger and his nickname was "Brave Heart" when he played at Arizona State University. We are told that Tillman had always been a non-conformist who was "his own man" and lived by a higher set of principles. We're told he cared little about what others thought about his position on an issue or an aspect of his lifestyle. At his nationally televised funeral, perhaps in tribute to Tillman's non-conformity, male friends and one of his brothers, in hyper-masculine fashion, drank beers to celebrate his life, while speaking intensely to those there to mourn Pat's tragic death about his extraordinariness and the countless ways in which Tillman taught them how to take life by the balls and live it to the fullest. Interestingly absent from the podium were Tillman's mother and wife.

So then, this media spectacle which honored Pat Tillman's sacrifice for his country operates as a site of the white cultural nationalism that has proliferated across American culture since 9/11. In this particular variant, Tillman's white masculinity is able to be coded as both American underdog and white, masculine American ideal; he is ironically both everyman and a non-conformist whose "non-conformity" is actually over-conformity to America's dominant mythologies; he is invested in family defined in particular by strong patriarchal male figures and women who are seen on the margins and not heard. Finally, the spectacle made of Tillman's heroic sacrifice produces (and is produced out

of) a subtle and strategically coded racial hierarchy where his patriotism, heroism, and articulation as an American body and symbol gains its meaning over and against the greed, selfishness, and excessive sense of entitlement that is often projected onto the bodies of African American male athletes.

Finally, I turn to the last contemporary expression of white cultural nationalism in sport and popular culture I would like to discuss. *Murderball*, is a documentary about the experiences of a group of quadriplegic men as they attempt to make the US Paralympics quad rugby team. In 2005, the documentary enjoyed an incredible wave of grassroots popularity to earn national release in mainstream cinemas. Oddly enough, after the film generated some "buzz" it was marketed through a half-hour show on MTV before its national release. The show featured a couple of the best players from the US team hanging out with Johnny Knoxville, Steve-O, and some of the other key figures of the *Jackass* crew as the group participated in the kinds of sadomasochistic stunts and pranks that made the *Jackass* show and crew so popular. I want to set aside this rather peculiar articulation of these paralympic athletes with the *Jackass* crew to discuss its implications for detailing the connections between identity politics in pre-9/11 America and white cultural nationalism in post-9/11 America to first outline some of the ways in which the film can be read as an expression of post-9/11 white cultural nationalism.

At first glance, *Murderball* tells the stories of (mainly white) men who have survived paralysis to now struggle to make the US Paralympics quad rugby team. But, one of the things that immediately struck me upon my initial viewing of the film is the heavy emphasis it puts on demonstrating how, despite their paralysis, these men are still adequately masculine; they are still driven by seemingly natural inclinations to enjoy athletics and still need to be rough, tough, strong, and athletic. Perhaps the most peculiar way in which the film stresses this theme of masculinization is through scenes of some of the (white) male athletes telling us about their sexual conquests with able-bodied women. This motif of hyper-masculinity is reinforced through the other significant storyline of the film—the intense rivalry between the United States current best player, Mark Zupan, and a former top American player and recently dismissed coach of the US side, Joe Soares, who now coaches the United States' biggest rival, Canada.

For the purposes of my discussion of the film as a sporting example of white cultural nationalism, I want to focus on the film's main character, Mark Zupan. The audience is told that the goateed Zupan (who interestingly sports the tattooed and pierced stylings often associated with the stereotypical

Generation Xer/extreme athlete) is not only the United States' best player, but arguably the best quad rugby player in the world. Formerly a cocky, if not arrogant, college soccer player prior to the tragic accident which caused his paralysis, the post-paralysis Zupan is portrayed as much more humble, yet still driven by a fiery love of athletics that appears as the essential core of his being. He is a man's man; even while he sits in his chair he is still physically imposing, his muscular arms immediately catching one's attention. He's always eager to play the types of pranks on his friends one often associates with those of fraternities (whether college, military, sports teams, or the *Jackass* crew, of course!). Zupan is one who sweats competition out of his pores; a man who, despite his disability can still pull a gorgeous, blonde bombshell as his girlfriend. And, of course, his story has meaning for national audiences because he is an international athlete who represents the United States.

The similarities between the narratives and representational strategies used to render visible the white masculinities of cancer survivor and seven-time Tour de France winner, Lance Armstrong and Zupan are too uncanny to dismiss as mere coincidence. Zupan seems to garner public interest as he is forwarded as another white male who has suffered a bodily wound—in this case, his becoming paralyzed. Yet, the other crucial part of Zupan's story is his refusal to assume the position of a victim. Like Armstrong, we are urged to like Zupan because he too is a cast as a survivor. His injury, which he suffered when he got drunk and passed out in the bed of his friend's truck only to have his friend get into a car accident while driving home from a party, produces a representation of an authentically "wounded" and unprivileged/disadvantaged white male. Through implication, the film suggests that one's racial or gender privileges mean little when one is thrown out the back of a truck and stuck holding onto a tree branch for fourteen hours in a stream of freezing water in order to survive. At the same time, Zupan explains that he doesn't ask for anyone's sympathy and doesn't whine and complain about his plight.

I think *Murderball* is such an interesting text to examine because of the way in which it emerged out of relative obscurity to find a place in the American mainstream in 2005. I don't believe one can offer an adequate explanation of the rise and cultural appeal of this rather small-budget documentary which doesn't attend to the film's intertwined racial, gender, and nationalistic meanings and politics (although additional arguments about other aspects of the film such as how the film can be connected with a contemporary cultural fetishization of the stories of disabled athletes can surely be made). Once one recognizes the representational strategies being used to celebrate and honor the

stories of Armstrong and Tillman through the discourse of white cultural nationalism, it is difficult not to notice the way in which Zupan's Americanized, wounded white masculinity articulates with this representational "mold" almost to a tee. Each of these "wounded" white men who are connected to, and can be easily read as symbols of America, can be read as allegories of the US in post-9/11 America. One day each is alright, comfortable, whole, and secure, but all that changes in an instant when each is rendered vulnerable, fragile, and wounded. Of course, none ever resigns himself to become a passive victim. Instead, each chooses to become a strong-willed, defiant, resilient, and self-reliant survivor determined to overcome his adversity and to survive. The stories of Zupan, Armstrong, and Tillman can each easily be made to fit within this narrative frame. Interestingly, the narrative is also a popular one we have been urged to tell ourselves about America following September 11, 2001.

But, not only does Zupan's story parallel the dominant narrative of a wounded United States on 9/11, but it is imbued with an added value: it offers a particular hyper-masculine response that both reflects and generates the racial, gender, and class desires, codes, and pleasures of the discourse of white cultural nationalism. Like Armstrong, Tillman, Larry the Cable Guy, and the simulated "NASCAR Dad," Zupan is both everyman and masculine ideal; he is unprivileged, if not, disadvantaged, yet he refuses to play the role of a victim. And finally, he is unequivocally a guy's guy who loves his sport (and women) and is willing to smack down any fool who gets in his way. In sum, he is both a symbol of the national wound experienced by the United States, and offered as a pleasurable, manly imagined solution to that wound.

Together, the stories of these four white male figures—whether sentimental, tragic, humorous, or just (supposedly) reporting 'real' stories—reflect and help to generate a white cultural nationalism whose effect is to naturalize the link between whiteness and America, recenter the interests of white men in American culture and society, and usher in the triumphant return of "real men" to American culture and society. Indeed, identity politics are still alive and well in post-9/11 America, even as conservative and reactionary forces attempt to strategically deny their continued importance and progressives attempt to find ways of reviving a class consciousness in Americans while not forgetting and setting aside the lessons learned from identity politics. And perhaps it shouldn't be too surprising that sport—a socio-cultural institution that has long played a key role in the maintenance and reproduction of white male hegemony AND been a site, that at times has played a key symbolic (and to a lesser extent, material) role in counter-

hegemonic struggles—is playing a leading role in racial and gender struggles today. I hope this book has helped make visible the roles which seemingly banal and apolitical cultural discourses and media stories about specific sports and athlete-celebrities are playing in producing a "revolt of the white athlete" whose goal is to reproduce and extend the power and privileges of whites and men not only in sport, but in American culture and society.

⌗ NOTES

Chapter 2

1. The Grand Slam tournaments are the Australian Open, French Open, Wimbledon, and the US Open.
2. Nike's decision to invest more money in Agassi demonstrates that sports celebrity and commodity-sign status is not necessarily, nor simply, a function of superior athletic achievements as many people often believe, athletic success is surely a key factor. Instead, Agassi's more prominent status (in relation to Sampras) suggests that there is a certain something, no doubt difficult to articulate, but nonetheless present, that makes Agassi a more appealing figure than the rather bland Sampras. Throughout this essay, I argue that the "certain something" is the ability of Agassi's biography and actions to meld well with the ideological imperatives of a white male backlash politics which mobilizes white male figures to promote and naturalize particular ideas, identities, relations, and views which either implicitly or explicitly work to re-secure the normative and central position of white masculinity at a time when its position has been publicly challenged.
3. In describing the categories of a "teen idol" and "rebellious youth" as "relatively generic and transhistorical" I do not mean to suggest that they do not have a history. In fact, Palladino's (1996) book, *Teenagers: An American History* is a great text which demonstrates how these categories were invented in the post-World War II United States. Instead, I describe these categories in this way in order to emphasize how these early stories about Agassi, produced prior to the formation of a cultural discourse about Agassi, really reveal more about the ideas associated with these categories than they do any conjuncturally specific rendering of Agassi's identity at that time period.
4. To fully understand the motivating forces of the popular resentment directed toward Agassi for Canon's "Image Is Everything" campaign, one must also consider how the increasing commodification and astronomically

rising salaries of professional athletes at this time were also forces which produced this popular resentment of Agassi.

5. In these pre-1989 articles, Agassi's identity was constituted mainly through the category of a "teen idol." He was explicitly marked as a distinctly American white masculinity and celebrated as a productive and docile professional athlete through the category of an "athletic throwback."

6. I would argue this appetite is evidenced in the production and popularity of films such as *Jerry Maguire*, *Good Will Hunting*, and *For the Love of the Game* in late 1990s America.

Chapter 3

1. My conceptualization of the politics of white male redemption draws heavily on Pfeil's (1995) reading of the politics of white male redemption in some popular early 1990s films, while it is also significantly influenced by Savran's (1998) readings of the discursive dynamics of white masculinity in post-1960s America.

2. See Lipsitz (1998) for a great explication of the way in which civil rights legislation of the 1960s and early 1970s was enacted into law, but often contained no enforcement mechanisms necessary to eliminate the racial and gender inequalities highlighted by the social movements of that era. Lipsitz convincingly demonstrates how media stories about such legislation were often employed by whites to make the claim that social inequalities had been eradicated in American society, while such whites knew that such legislation lacked the necessary legal and civic mechanisms to eliminate such inequalities.

3. I put "moments of suffering" in quotations to point out how such moments for white men during the 1990s are often fantasmatic rather than real. Or, their moments of suffering cannot be equated with those minority subjects who have experienced substantial economic oppression or social discrimination within their lives. Contemporary films like *Fight Club*, *Vanilla Sky*, and *A Beautiful Mind* which showcase narratives of white men undergoing crises of identity who cannot discern the differences between their fantasies and reality represent celluloid versions of the cultural manifestation of this desire of many white men to constitute themselves as victims in order to disavow their relation to white male privilege.

4. Fred Perry, Don Budge, Rod Laver, and Roy Emerson are the other four men who have captured all four Grand Slam titles. But, unlike Agassi,

they played at a time when the US Open was played on grass rather than hard courts (Price, 1999).

Chapter 4

1. BASE jumping is an acronym for building, antenna, span (bridges), and earth (cliffs) jumping. In most cases these jumps are illegal.
2. By "Extreme sports" I mean the mass-mediated construction and articulation of a wide range of physical activities like skateboarding, BMX bike riding, in-line skating, sky surfing, street luge, snow boarding, etc., that were spearheaded by ESPN in 1995 through the creation of the "Extreme Games." So, by stating that Extreme sports were formed in 1995, I do not mean to suggest that these sport activities did not exist or had no previous history prior to 1995. Instead, I merely want to highlight how these physical activities only became articulated under the sign "Extreme sports" at this time. In other words, these sports would not have been referred to as "Extreme sports" prior to their construction and articulation in 1995. Thus, I contend that the history of "Extreme sports" extends only as far back as 1995 when this sports formation was constructed (both in material and media terms).
3. For a more detailed discussion of the politics of the Generation X discourse, see Kusz (2001a).
4. Though it should also be noted that by the late 1990s, the popular discourse about "Generation X" was significantly re-contoured so that this formerly apathetic and wayward generation was now said to be strongly invested in the contemporary American virtues of hard work, family, and upward mobility (see Hornblower, 1997).
5. It should also be emphasized that this decline in white men's median income does not mean that men lost their earnings advantage over women and people of color during this time period. So, despite these declines in their median income, on average, men still earned comparatively more money than women and people of color. Thus, arguments of white men's economic disadvantages in contemporary America are gross over-exaggerations which function merely as backlash mechanisms to protect the social and economic privileges of white men.
6. The comments of women's tennis player, Martina Hingis, at the beginning of the 2001 US Open regarding the advantages that the (African American) Williams sisters get in garnering endorsement deals because of their race exemplify the way in which whites perceive the leveling of

economic opportunities for African Americans as a disadvantage to them.

7. It should also be noted that white males were not the only public embodiment of white privilege. Feminist and lesbian scholars like Frankenburg (1997) and Davy (1997) have illuminated how the normativity of whiteness operated even in more progressive pro-feminist and pro-lesbian political efforts. But, in attempting to explain why white males became the most frequent imagined figure of white privilege, perhaps it is because they were often the ones who spearheaded the white backlash against progressive racial initiatives.

8. See Kimmel (1996), or Faludi (1999) or Giroux (1997a) for evidence of white men's reactions to the public critiques of their privileged structural position.

9. White men appropriated this strategy from those historically marginalized groups (people of colour, women, gays, and lesbians) who had previously employed the strategy not only as a means of identifying the privileges and oppressions structured into the very fabric of American culture and social life (at both an interpersonal and institutional level) but also to expose, challenge, and eliminate such structural inequalities.

10. It should be noted that the *U.S. News & World Report* cover story begins with a story about a female "radical skier" who is highlighted for her perilous cliff jumps and six knee operations. Otherwise, women are excluded from this magazine's representation of Extreme sports.

11. By extreme skiing I mean those skiers and snowboarders who are often air-lifted to the summits of mountain ranges to ski on dangerous terrain for the purpose of shooting a for-profit video. Such feats are highly dangerous activities which hold the threat of producing avalanches or other complications which put the lives of the skier and his accompanying personnel—camera persons, helicopter operators, etc.—in danger.

12. Although my discussion of Extreme sports focuses exclusively on how Extreme sports and its practitioners are rendered visible in these two mainstream cover stories, I think this argument about the way in which Extreme sport athletes symbolize an ideal white masculinity applies also to the way in which skateboarders, BMX bike riders, and Motocross riders who perform extraordinary aerial tricks and jumps are also revered in popular cultural sites like ESPN telecasts of the X Games.

13. For a critical analysis of the racial politics constitutive of (and constituted by) the December 6, 1997 *Sports Illustrated* cover story, "Whatever Happened to the White Athlete?" see Kusz (2001b).

14. See Kusz (2001b).

15. Although this categorical difference between Extreme sports and mainstream American sports is often asserted, Rinehart (1995) has shown how the mainstreaming of Extreme sports has involved a process of recoding and incorporating the meanings of mainstream sporting activities, so that Extreme sports better fit the cultural and economic imperatives of the mainstream American sports formation (this recoding, of course, also requires conforming to and reproducing the norms and values of the historically specific hegemonic (white) masculinity of the moment as well as American and capitalist ideologies).

Chapter 5

1. *Total Request Live* is a show in which mainly teen viewers can call and email to vote for their favorite songs and videos.

2. Of course, it should be noted that Green Day's "Minority" chorus also contains the line, "Down with the Moral Majority," which could suggest that the song is meant to resist the contemporary conservative backlash politics. Nonetheless, rather than trying to pin down the song's meaning, I want to emphasize that it is precisely the polysemic character of the song, allowing many meanings both reactionary and resistive to be articulated to it, that allows it to be embraced unproblematically by mainstream radio and MTV as simply a recurrent expression of teen rebellion against adult authority. Perhaps more germane to my present discussion, the desire to be a minority expressed in the song allows it to fit nicely within the discursive boundaries of the white male backlash by reproducing images and narratives of white males as minorities, as disadvantaged, and as victims.

3. White male artists and bands like Beck (with his song, "Loser" and its popular chorus, "I'm a loser baby, so why don't you kill me"), Pearl Jam (with their lamentful ballad, "Nothin' Man"), the Offspring (with their Top 40 hit, "Self-Esteem" and its signature line, "I'm just a sucker with no self-esteem"), and Nirvana (with their so-called Generation X

anthem, "Smells Like Teen Spirit") make up the key contributors to this alternative musical trend.

4. I thank Dr. Cheryl Cole on this point. Our discussion helped me to see how the events of Columbine make the articulation of white boys with "innocence" and "hope for the future" a more fervently politicized representation.

5. *Men Behaving Badly* was an NBC sitcom that aired in the mid- to late-1990s and whose humor was predicated on watching two white, male twenty-somethings attempt to reclaim their masculine privileges. CBS' show *Becker* (1998) was one of the first to bring the "angry white male" (who, in 1998, can be constructed to elicit laughter and identification in its audience rather than discomfort and abjection) into American living rooms.

6. The white male backlash of the 1990s was also precipitated by the severe recessions of the late 1980s and early 1990s that even affected the middle classes (if not materially, at least psychologically). White working- and middle-class men's fears about downward economic mobility due to these recessions and the increasingly globalized, post-Fordist American economy led to an intensification of racism for white men as they tried to draw distinctions between themselves and Black men, imagined as an inferior Other (Weis et al., 1997, p. 217).

7. By identity politics, I mean the political practices and mobilizations based on cultural and social identities that involve marking one's group as a victim of discriminatory practices in the past or present (Clarke, 1991).

8. See Berlant (1997), McCarthy (1998b), and Savran (1998), for analyses of how contemporary films like *Forrest Gump, Disclosure, Falling Down*, and so forth can be read as crucial cultural, pedagogical sites in producing, authorizing, and gaining momentum for this conservative white male backlash politics.

9. Giroux (1997a,b) argued that talk radio, specifically Rush Limbaugh, is an important site through which this white male backlash politics is constructed, popularized, and made desirable to the (white middle class) public.

10. I use "simulated" in the Baudrillardian (1983) sense to mean a copy for which there is no original. Thus, I am not trying to argue that there is sufficient empirical proof to say that "real" American men espoused the views attributed to the angry white male. In fact, I think such evidence is inconsequential. What I argue is that the very ambiguity of the actual existence of the angry white male (his simulated quality)

enabled the complaints of real American white men to be publicly expressed, yet simultaneously denied, because real white American men did not exactly fit the extreme, paranoic profile of a D-Fens or the angry white male figure constructed in the *Newsweek* cover story.

11. The simulated character of the angry white male even allowed "real" white men like Rush Limbaugh to express such "angry" racist or sexist or homophobic sentiments, and later disavow them by claiming that he was just performing this alleged angry white male to the delight of his audience.

12. By citing these films, I do not claim that they reflect a pre-given reality or provide a transparent window on contemporary Black urban life. Instead, as these films were very often interpreted as mirror images of the lives of young Black male youths in the early 1990s, such interpretations did not produce a mainstream discourse that called for compassion and understanding of the lives of urban Black male youths. In addition, within mainstream discourse, the films did not call for changes in the culture that produced such violence in urban American like this "discourse about boys" (which focused on white boys) did.

Chapter 6

1. Based on a survey of over twenty film reviews collected from Movie Review Query Engine (www.mrqe.com).

Chapter 7

1. Let me also be clear that this imagined consensus about Armstrong's story as a rare "feel-good" story in American sports at this particular time in history is a consensus which, to the extent in which it exists at all, exists only within the geographic boundaries of the United States. Although I do not discuss the issue much here, I am aware of the differences in media coverage and public perceptions of Armstrong and his athletic accomplishments which exist between the American and foreign media (i.e., take the French media).

2. See Hoff Sommers' (2000) *The War Against Boys: How Misguided Feminism Is Harming Our Young Men.*

3. For examples of this discourse about the social psychological development of American boys in the 1990s, see Gurian (1997, 1998, 1999), Garbarino (1999), and Pollack (1998). See Kusz (2001b) for a substantive critique

of how this concerned discourse about the social psychological development of boys is crafted through crisis rhetoric and works, whether intended or not, as a cultural site promoting backlash aims of re-securing social structures that privilege and re-center white masculinity.

4. By "identity politics of the dominant," Robinson (2000) means the specific and calculated ways in which white men who embody a normative social position strategically mark and particularize their identities at times when it facilitates the maintenance of their central and normative position within American culture and society. I also want to stress that this strategic particularization or marking of white masculinity is not necessarily done for political purposes for which the actor is conscious; nonetheless, such particularization or marking of white masculinity often works to dissociate specific white men from their complicity in perpetuating the material and symbolic advantages of being white and male in American society.

5. In terms of the press articles which detailed Armstrong's story, see Kosova, 1999; Montville, 1999; Sanction, 1999; Stein, 2000; Thomsen, 2000; Tresniowski, Benet, & Trischitta, 2000.

6. Quote taken from www.worldsportsmen.f2s.com/Armstrong.html

7. Quote taken from: www.worldsportsmen.f2s.com/armstrong.html

8. This rhetorical recognition and thankfulness for one's "blessed" privileged position is frequently used by Hollywood actors, pop music artists, professional athletes, politicians, and even white members of the professional middle class to distance themselves from the position of being a privileged member of the socio-economic elite.

9. It bears noting that after President Clinton finished off the neoliberal project of dismantling of the welfare state (began by Reagan in the 1980s), conservatives could no longer demonize welfare dependents of the State to promote its neoliberal ideas of celebrating individual self-reliance, personal initiative, competition, and free market solutions to social problems.

10. Ironically, even though Armstrong and his former wife divorced in 2004, he has still been able to be cast as a dedicated father to his kids. In fact, after his relationship with pop singer, Sheryl Crow, went public (until the end of their relationship in February, 2006), Crow was rather easily inserted into his wife's former position in the imagery and narratives produced about Armstrong. In particular, one might consider the images of Crow holding and looking after Lance's children while he

was on the victory stand having earned his record seventh straight Tour de France victory.

11. For examples, see Andrews (1996); McDonald and Andrews (2001); Carrington (2001); Cole (1996); Cole and Andrews (2001); Jackson (2001); King (1993); and Spencer (2001).

╬ BIBLIOGRAPHY

Aanerud, R. (1997). Fictions of whiteness: Speaking the names of whiteness in U.S. literature. In R. Frankenburg (Ed.) *Displacing whiteness: Essays in social and cultural criticism* (pp. 35-59). Durham, NC: Duke University Press.

Allen, T. (1990). *The rise and fall of the white republic.* London: Verso.

Amdur, N. (1989, October). The real thing?, *World Tennis,* 24-8.

Andre Agassi biography. Retrieved July 18, 1996, from http://www.nike.com /athletes /Agass_1003/1003_bio.

Andrews, D. (1996). The facts of Michael Jordan's blackness: Excavating a floating racial signifier. *Sociology of Sport Journal, 13,* 125158.

Armstrong, L. & Jenkins, S. (2000). *It's not about the bike.* New York: Penguin Putnam.

Araton, H. (1994). A grungy showman: 'Uh, wow! and cool. *New York Times* (national edition), B9, September 12.

Associated Press. (2000). USA's twin victory overseas. Retrieved August 2, 2001 from http://www.usatoday.com/sports/ssun55.html

Associated Press. (2005). Bush calls win 'triumph of the human spirit.' Retrieved July 25, 2005, from http://msn.foxsports.com/cycling/story/ 382 4962?print=true.

Baudrillard, J. (1983). *Simulations.* New York: Semiotext(e).

Beatty, J. (1994, May). Who speaks for the middle class? *The Atlantic Monthly,* 65–78.

Bederman, G. (1995). *Manliness and civilization: A cultural history of gender and race in the United States, 1880–1917.* Chicago, IL: University of Chicago Press.

Bennett, W. (1992). *The de-valuing of America: The fight for our culture and our children.* New York: Touchstone.

Berkow, I. (2001). Minority Quarterback. In *Correspondents of The New York Times* (Eds). *How race is lived in America* (pp. 189–210). New York: Times Books.

Berlant, L. (1996). The face of America and the state of emergency. In C. Nelson, & D. P. Gaonkar (Eds.) *Disciplinarity and Dissent in Cultural Studies.* New York: Routledge.

Berlant, L. (1997). *The queen of America goes to Washington City: Essays on sex and citizenship* (pp. 1–24). Durham, NC: Duke University Press.

Beynon, J. (2002). *Masculinities and culture.* London: Open University Press.

Birrell, S. & McDonald, M. (2000). Reading sport, articulating power lines: An introduction. In S. Birrell & M. McDonald (Eds.) *Reading sport: Critical Essays on power and representation* (pp. 3–13). Boston, MA: Northeastern University Press.

Bodo, P. (1999, March). The 'Tennis' interview: Andre Agassi, *Tennis Magazine, 34–36, 38, 94, 96, 100, 102, 103–104.*

Boeck, G. (2004). Hero leaves legacy of virtue. Retrieved September 29, 2004, from www.usatoday.com/sports/football/nfl/2004-04-26-tillman-cover_x. html.

Brooks, D. (2001). *Bobos in paradise: The new upper class and how they got there.* New York: Simon & Schuster.

Bush, G.W. (2001). Remarks in a ceremony honoring Tour de France champion Lance Armstrong. *Weekly Compilation of Presidential Documents, 37(31),* 1130-1131).

Butryn, T. & Marsucci, M. (2003). It's not about the book: A cyborg counternarrative of Lance Armstrong. *Journal of Sport and Social Issues, 27,* 124 – 144.

Carby, H. (1993). Encoding white resentment: *Grand Canyon*—A narrative for our times. In C. McCarthy & W. Crichlow (Eds.) *Race, Identity and Representation in Education* (pp. 236–250). New York: Routledge.

Carrington, B. (1998). 'Football's coming home' but whose home? And do we want it?: Nation, football and the politics of exclusion. In A. Brown (Ed.) *Fanatics!: Power, identity and fandom in football* (pp. 101–123). London: Routledge.

Carrington, B. (2001). Postmodern blackness and the celebrity sports star: Ian Wright, 'race' and English identity. *Sport stars: The cultural politics of sporting celebrity.* New York: Routledge.

Clarke, S.A. (1991). Fear of a black planet. *Socialist Review, 21(3/4),* 37–59.

Clover, C. (1993). "Falling Down" and the rise of the average white male. In P. Cook & P. Dodd (Eds.) *Women and film: A sight and sound reader* (pp. 138–147). Philadelphia: Temple University Press.

Cole, C.L. (1996). American Jordan: P.L.A.Y., consensus, & punishment. *Sociology of Sport Journal, 13,* 366–397.

Cole, C.L. & Andrews, D. (2001). America's new son: Tiger Woods and America's multiculturalism. In D. Andrews & S. Jackson (Eds.) *Sports stars: The politics of sport celebrity* (pp. 70–86). New York: Routledge.

Collins, B. (1991, March). What's it all about Andre? *World Tennis,* 22–6.

Corber, R. (1997). *Homosexuality in Cold War America.* Durham, NC: Duke University.

Curtis, B. (2005, Nov. 2). Larry the Cable Guy: America's favorite redneck. Retrieved November 4, 2005, from http://www.slate.com.

Davies, J. (1995) Gender, ethnicity and cultural crisis in *Falling Down* and *Groundhog Day. Screen,* 36(3): 214–232.

Davy, K. (1997). Outing whiteness: A feminist/lesbian project. In M. Hill (Ed.) *Whiteness: A critical reader* (pp. 204–225). New York: New York University Press.

deJonge, P. (1995). Cocky, foulmouthed champ vs. insecure, born-again champ. Sampras and Agassi on Agassi and Sampras. *New York Times Magazine,* 44–9, 60, 68, 72, August 27.

DeLauretis, T. (1987). *Technologies of gender: Essays on theory, film, and fiction.* Bloomington, IN: Indiana University Press.

Denzin, N.K. (1991). *Images in postmodern society.* Newbury Park, CA: Sage.

Derbyshire, J. (2003, November 10). NASCAR Nation. *National Review,* 29–32.

Dogtown and Z Boys. (2002). Sony Pictures Classics. Retrieved March 20, 2003, from http://www.sonyclassics .com/dogtown/.

Ducat, S. (2004). *The wimp factor: Gender gaps, holy wars, and the politics of anxious masculinity.* Boston, MA: Beacon Press.

Dunn, S. (1994). *The official slacker handbook.* New York: Warner Books.

Dyer, R. (1988). White. *Screen, 29(4),* 44–65.

Dyer, R. (1991). Charisma. In C. Gledhill (Ed.) *Stardom.* London: Routledge.

Dyer, R. (1997). *White.* New York: Routledge.

Dyson, M. (2004). *The Michael Eric Dyson reader.* New York: Basic Civitas Books.

Economist, The. (1994, March 19). Games plans, 108.

Edwards, H. (1970). *The revolt of the black athlete.* New York: Free Press.

Ehrenreich, B. (1989). *Fear of falling.* New York: Harper Perennial.

Ehrenreich, B. (2002, November/December). Masculinity & American militarism. *Tikkun Magazine.* Retrieved February 23, 2004, from http://www.tikkun.org/magazine/index.cfm/action/tikkun/issue/tik0211/article/021113d.html.

Faludi, S. (1999). *Stiffed: The betrayal of the American man.* New York: William Morrow & Co.

Farrell, W. (1994). *The myth of male power: Why men are the disposable sex.* New York: Simon & Schuster.

Farrell, M. (2004, April 21). Peggy Noonan's Pearl Harbor. Retrieved March 27, 2006, from http://www.buzzflash.com/farrell/04/04/far04013.html.

Ferber, A. (1998). *White man falling: Race, gender, and white supremacy*. Lanham, MD: Rowman & Littlefield.

Fine. M. and Weis, L. (1998). *The unknown city: The lives of poor and working-class young adults*. Boston, MA: Beacon Press.

Finn, R. (1999). Just in time, a rivalry gets hot again. *New York Times Vol. 148*, Issue: 51623, D7.

Flax, J. (1998). *The American dream in black and white*. Ithaca, NY: Cornell University Press.

Frankenburg, R. (1997). Introduction: Local whitenesses, localizing whiteness. In R. Frankenburg's (Ed.) *Displacing whiteness: Essays in social and cultural criticism* (pp. 1–33). Durham, NC: Duke University Press.

Garbarino, J. (1999). *Lost boys: Why our sons turn violent and how we can save them*. New York: Free Press.

Gates, D. (1993). White male paranoia, *Newsweek, 121(13)*, 48–53.

Giles, J. (1994). Generalizations X. *Newsweek*, 63–71, June 6.

Giroux, H. (1994). Living dangerously: Identity politics and the new cultural racism. In H. Giroux & P. McLaren (Eds.) *Between borders: Pedagogy and the politics of cultural studies*. New York: Routledge.

Giroux, H. (1997a). Rewriting the discourse of racial identity: Towards a pedagogy and politics of whiteness. *Harvard Educational Review, 67(2)*, 285-320.

Giroux, H. (1997b). White noise: Racial politics and the pedagogy of Whiteness. In *Channel surfing: Race talk and the destruction of today's youth* (pp. 89–136). New York: St. Martin's Press.

Giroux, H. (1997c). White squall: Resistance and the pedagogy of whiteness. *Cultural Studies, 11(2)*, 276–289.

Granger, D. (1996). My winner with Andre. *Gentlemen's Quarterly*, 126–31, 178.

Greenfeld, K.T. (1998, Nov. 9). A wider world of sports. *Time*, 152, 19: 63.

Greenfeld, K.T. (1999, Dec. 6). Life on the edge. *Time*, 154, 10: 29–36.

Gross, D. & Scott, S. (1990, July 16). Proceeding with caution. *Time*, 56–62.

Grossberg, L. (1992). *We gotta get out of this place: Popular conservatism and postmodern culture*. New York: Routledge.

Gurian, M. (1997). *The wonder of boys*. New York: Jeremy T. Parcher/Putnam.

Gurian, M. (1998). *A fine young man*. New York: Jeremy T. Parcher/Putnam.

Gurian, M. (1999). *The good son*. New York: Jeremy T. Parcher/Putnam.

Hartigan, J. (1997a). Establishing the fact of whiteness. *American Anthropologist, 99(3)*, 495–506.

Hartigan, J. (1997b). Unpopular culture: The case of 'white trash.' *Cultural Studies, 11(2)*, 316–343.

Hartmann, D. (2004). *Race, culture, and the revolt of the black athlete: The 1968 Olympic protests and their aftermath.* Chicago, IL: University of Chicago Press.

Harvey, D. (1990). *The condition of postmodernity.* Cambridge, MA: Blackwell.

Harvey, D. (2002). Dogtown and Z-boys. Retrieved March 25, 2003 from http://www.filmmonthly.com.

Higdon, D. (1994). Taking care of business. *Tennis, 32–40.*

Hill, M. (2004). *After whiteness: Unmaking an American majority.* New York: New York University Press.

Hirsch, E.D. (1988). *Cultural literacy: What every American needs to know.* New York: Vintage Books.

Hirshey, G. (1989, September). The frosted flake. *Gentlemen's Quarterly,* 416–21, 492–5.

Hoff Sommers, C. (2001). *The war against boys: How misguided feminism is harming our young men.* New York: Simon & Schuster.

Hornaday, A. (2002, May 3). Skateboarding U.S.A.: 'Dogtown and Z-Boys' makes sheer poetry of a sport that soared. Retrieved March 20, 2003, from http://www.washingtonpost.com/ac2/wp-dyn?pagename=article&node= &contentId=A24764-2002May2¬Found=true.

Hornblower, M. (1997, June 9). Great expectations. *Time,* 151, 28: 58–69.

Horovitz, B. (2000, May 4). Armstrong rolls to marketing gold. *USA Today,* 1B–2B.

Howe, N. & Strauss, W. (1993). *13th Gen.* New York: Vintage Books.

Howe, S. (1997). *(Sick): A cultural history of snowboarding,* New York: St. Martin's Press.

Jackson, S. (2001). Gretzky nation: Canada, crisis, and Americanization. In D. Andrews & S. Jackson's (Eds.) *Sport stars: The cultural politics of sporting celebrity* (pp. 164–186). New York: Routledge.

Jeffords, S. (1994). *Hard Bodies: Hollywood masculinity in the Reagan era.* New Brunswick, NJ: Rutgers University Press.

Jenkins, S. (1992, May 11). Image is not everything. *Sports Illustrated,* 35–7.

Jenkins, S. (1993, July 5). Comic strip. *Sports Illustrated,* 20–3.

Jenkins, S. (1994). As real as he gets. *Sports Illustrated, 80(12),* 45–51.

Jenkins, S. (1995, March 13). Love and love. *Sports Illustrated, 82(10),* 52–61.

Jenkins, S. (2004, July 26). Tour de France: Future of Lance Armstrong. Retrieved March 27, 2006, from http://www.washingtonpost.com/wp-dyn/articles/A9742-2004Jul23.html?nav=headlines.

Kellner, D. (1995). *Media culture.* London: Routledge.

Kennedy, L. (1996). Alien nation: White male paranoia and imperial culture in the United States. *Journal of American Studies, 30(1),* 87–100.

Kimmel, M. (1996). *Manhood in America: A cultural history*, New York: The Free Press.

Kincheloe, J. & Steinberg, S. (1998). Addressing the crisis of whiteness: Reconfiguring white identity in a pedagogy of whiteness. In J. Kincheloe, S. Steinberg, N. Rodriguez, & R. Chennault (Eds.) *White reign: Deploying whiteness in America* (pp. 3–30). New York: St. Martin's Press.

Kincheloe, J. & Steinberg, S. (2000). Constructing a pedagogy of whiteness for angry white students. In N. Rodriguez & L. Villaverde (Eds.) *Dismantling white privilege: Pedagogy, politics, and whiteness* (pp. 178–197). New York: Peter Lang.

Kindlon, D., Barker, T., & Thompson, M. (1999). *Raising Cain: Protecting the emotional life of boys*. New York: Ballantine.

King, S. (1993). The politics of the body and the body politic: Magic Johnson and the ideology of AIDS. *Sociology of Sport Journal, 10(3)*, 270–285.

King, S. J. (2000). *Civic fitness: The politics of breast cancer and the problem of generosity*. Unpublished doctoral dissertation, University of Illinois at Urbana-Champaign.

King, C.R. & Springwood, C.F. (2001). *Beyond the cheers: Race as spectacle in college sport*. Albany, NY: SUNY Press.

King, C.R. & Leonard, D. (2006). *Visual Economies of/in Motion: Sport and Film*. New York: Peter Lang Publishing.

Kirkpatrick, C. (1989, March 13). Born to serve. *Sports Illustrated*, 65–74.

Koerner, B. L. (1997, June 30). Extreeeme. *US News & World Report*, 122(25), 51–60.

Kosova, W. (1999, July 26). The leader of the pack. *Newsweek, 72*.

Kusz, K. (2001a). Andre Agassi and Generation X: Reading white masculinity in 1990s America. In D. Andrews & S. Jackson (Eds.) *Sport Stars: The Politics of Sport Celebrity*. New York: Routledge.

Kusz, K. (2001b). 'I want to be the minority': The cultural politics of young white males in sport and popular culture. *Journal of Sport and Social Issues, 25(4)*: 390–416.

Kusz, K. (2001c). *Jerry Maguire*: Reading the politics of white male redemption. *International Review of Sport Sociology, 36(1)*, 83–88.

Kusz, K. (2002). *Fight Club* and the art (or politics) of white male victimization and reflexive sadomasochism. *International Review of Sport Sociology, 37 (3-4)*, 531-536.

Leand, A. (1996, September/October). Sampras, Agassi, Chang, Courier: All grown up. *Tennis Match, 38–42*.

Leerhsen, C. (1988, September 12). Teenage courtship. *Newsweek, 82*.

Leland, J., Monserrate, C. & Senna, D. (1993, Oct. 11) Battle for your brain. *Newsweek,* 42–46.

Lieber, J. (1996, December 24). Driven star steps back. *USA Today,* 3C.

Lipsitz, G. (1998). *The possessive investment in whiteness: How white people profit from identity politics.* Philadelphia, PA: Temple University Press.

Litwin, S. (1986). *The postponed generation: Why America's grown-up kids are growing up later.* New York: William Morrow & Co.

Lott, E. (1997). All the king's men: Elvis impersonators and white working-class masculinity. In H. Stecopoulos & M. Uebel (Eds.) *Race and the subject of masculinities* (pp. 192–227). Durham, NC: Duke University Press.

Lowe, D. (1995). *The body in late-capitalist USA.* Durham, NC: Duke University Press.

Lupica, M. (1990a, July). Tennis without balls. *Esquire,* 39–40.

Lupica, M. (1990b, September). Here's to the wieners! *Esquire,* 83.

Maharidge, D. (1996). *The coming white majority.* New York: Vintage Books.

Mailer, N. (2003). The white man unburdened. *New York Review of Books, 50(12).* Retrieved February 23, 2004, from http://www.nybooks.com/articles/16470.

Martin, D. (1993, November). The whiny generation. *Newsweek,* 10, November.

McCallum, J. (2001). Giving Lance the benefit of the doubt. Retrieved July 31, 2001, from www.sportsillustrated.cnn....jack_mccallum/news/2001/07/30/hot_button/html.

McCarthy, C. (1998a). Living with anxiety: Race and renarration of public life. In J. Kincheloe, S. Steinberg, N. Rodriguez, & R. Chennault (Eds.) *White reign: Deploying whiteness in America* (pp. 329–341). New York: St. Martin's Press.

McCarthy, C. (1998b). *The uses of culture.* New York: Routledge.

McDonald, M. & Andrews, D. (2001). Michael Jordan: Corporate sport and postmodern celebrityhood. In D. Andrews & S. Jackson (Eds.) *Sport Stars: The cultural politics of sporting celebrity.* New York: Routledge.

McGurk, M. (2002, May 24). 'Z-Boys' jumps into skateboarding lore. *Cincinnati.com.* Retrieved March 20, 2003, from http://www.cincinnati.com/freetime/movies/mcgurk/052402 _dogtown.html.

McIntosh, P. (1997). White privilege and male privilege: A personal account of coming to see correspondences in work in women's studies. In Richard Delgado & Jean Stefancic (Eds.) *Critical white studies: Looking behind the mirror.* (pp. 291–299). Philadelphia, PA: Temple University Press.

Messner, M. (1997). *Politics of masculinities.* Thousand Oaks, CA: Sage Publications.

Mishel, L., Bernstein, J., and Schmitt, J. (1996). *The state of working America*. Washington, D.C.: Economic Policy Institute.

Montville, L. (1999, August 9). Tour d'Amerique. *Sports Illustrated, 91(5)*, 68–73.

Murphy, A. (2001, August 6). Magnifique! *Sports Illustrated 95(5)*, 34–40.

Myrick, S. (2000). Myrick introduces bill honoring Lance Armstrong. Retrieved August 3, 2001, from http://www.house.gov/myrick/pr092100.html.

Nakayama, T. & Krizek, R. (1995). Whiteness: A strategic rhetoric. *Quarterly Journal of Speech,* 81: 291–309.

Nelson, D. (1998). *National manhood: Capitalist citizenship and the imagined fraternity of white men*. Durham, NC: Duke University Press.

Newberger, E. (1999). *The men they will become: The nature and nurture of male character*. Cambridge, MA: Perseus.

Newitz, A. (1997). White savagery and humiliation, or a new racial consciousness in the media. In M. Wray & A. Newitz (Eds.), *White trash: Race and class in America* (pp. 131–154). New York: Routledge.

Newitz, A. & Wray, M. (1997). What is 'white trash'? Stereotypes and economic conditions of poor whites in the United States. *The Minnesota Review, 47,* 61–77.

Okimoto, J. & Stegall, P. (1987). *Boomerang kids: How to live with adult children who return home.* New York: Little Brown & Company.

Palladino, G. (1996). *Teenagers: An American history*. New York: Basic Books.

Pfeil, F. (1995). *White guys: Postmodern domination and difference.* London: Verso.

Pfeil, F. (2002). Getting up there with Tom: The Politics of American 'nice.' In J. Kegan Gardiner (Ed.) *Masculinity studies & feminist theory: New directions* (pp. 119–140). New York: Columbia University Press.

Pollack, W. (1998). *Real boys*. New York: Owl Books.

Price, S. (1994). Anarchy and Agassi. *Sports Illustrated, 81(12)*, 30–9.

Price, S. (1997, December 6). Whatever happened to the white athlete? *Sports Illustrated, 87(23)*, 32–51.

Price, S. (1999). String quartet. *Sports Illustrated, 90(24)*, 32–37.

Reaves, J. (2000). Tiger who? Lance Armstrong is the real sports hero. Retrieved August 3, 2001, from http://www.time.com/time/nation/article/0,8599,49763,00html.

Reeves, J.L. & Campbell, R. (1994). *Cracked coverage: Television news, the anti-cocaine crusade, and the Reagan legacy*. Durham, NC: Duke University Press.

Reilly, R. (2001, July 30). Mountain lion. *Sports Illustrated, 95(4)*, 88.

Reilly, R. (2002, Dec. 16). Sportsman of the year: Lance Armstrong. *Sports Illustrated, 97(24)*, 52–54, 56, 58–62, 71.

Rinehart, R. (1995). Cyber-sports: Power and diversity in ESPN's The Extreme Games. Paper presented at the North American Society of the Sociology of Sport, Sacramento, CA.

Ritchie, K. (1995). *Marketing to Generation X*. New York: Lexington Books.

Roberts, L. (2004). Tillman's life is an example that should inspire others to follow. Retrieved December 6, 2004, from http://www.usatoday.com.

Robinson, S. (2000). *Marked men: White masculinity in crisis*. New York: Columbia University Press.

Rodriguez, N. (1998). Emptying the content of whiteness: Toward an understanding of the relation between whiteness and pedagogy. In J. Kincheloe, J. & S. Steinberg (Eds.) *White reign: Deploying whiteness in America*. New York: St. Martin's Press.

Rodriguez, N.M. & Villaverde, L.E. (2000). *Dismantling white privilege: Pedagogy, politics, and whiteness*. New York: Peter Lang.

Roediger, D. (1994). *Towards the abolition of whiteness: Essays on race, politics, and working class history*. London: Verso.

Roediger, D. (1999). *The wages of whiteness: Race and the making of the American working class* (2nd ed). London: Verso.

Roediger, D. (2002). *Colored white: Transcending the racial past*. Berkeley, CA: University of California Press.

Sacks, D. & Thiel, P. (1995). *The diversity myth*. Oakland, CA: The Independent Institute.

Sancton, T. (1999, July 26). The ride of his life. *Time, 154(4)*, 66.

Sanger, T. (2001). Dogtown and Z-Boys. Retrieved March 25, 2003 from www.filmthreat.com.

Savran, D. (1998). *Taking it like a man:* Princeton, NJ: Princeton University Press.

Scott, E. (1996, Feb. 8). Vantage point. *Tennis Week,* 6.

Scott, J. (1995). The campaign against political correctness: What's really at stake. In C. Newfield & R. Strickland (Eds.) *After political correctness: The humanities and society in the 1990s*. Boulder, CO: Westview Press.

Shapiro, J. (1993). Just fix it! *U.S. News & World Report,* 50–6, February 22.

Shields, D. (1999). *Black planet: Facing race during an NBA season*. New York: Crown.

Sherill, M. (1995, May). Educating Andre. *Esquire,* 89–96.

Shome, R. (1996). Race and popular cinema: The rhetorical strategies of whiteness in *City of Joy*. *Communication Quarterly, 44(4),* 502–518.

Shome, R. (2001). White femininity and the discourse of nation: Re/membering Princess Diana. *Feminist Media Studies, 1(3),* 323–342.

Shuster, S. & Felsen, D. (2000, June 12). *Real Sports*. Interview with Andre Agassi. Episode 39, Season 6.

Smith, G. (2004, May 3). Code of honor. *Sports Illustrated, 100(18), 40–47.*

Sobchack, V. (1997). Baseball in the post-American cinema, or life in the minors. In A. Baker & T. Boyd (Eds.) *Out of bounds: Sports, media, and the politics of identity.* Indianapolis, IN: Indiana University Press.

Spade, D. (1998, April). White man blues. *George, 52.*

Spencer, N. (2001). From 'child's play' to 'party crasher': Venus Williams, racism and professional women's tennis. In D. Andrews & S. Jackson (Eds.) *Sport stars: The cultural politics of sporting celebrity.* New York: Routledge.

Sports Illustrated. (1999, July 5). Importing X Sports. 24.

Stein, J. (2000, July 24). Uphill racer. *Time, 156(4),* 60.

Sterling, M. (2001). Worldsportsmen.com: Lance Armstrong. Retrieved: August 3, 2001, from http://www.worldsportsmen.f2s.com/armstrong.html.

Stouffer, J. (1998, Nov.9–15). X faithful may be young, but they're smart and savvy about their sports. *Street & Smith's Sportsbusiness Journal,* 1(29): 24.

Strauss, W. & Howe, N. (1991). *Generations.* New York: William Morrow and Company, Inc.

Sullivan, R. (1987). The teen dream who could wake up U.S. tennis. *Sports Illustrated,* 22–3.

Tennis Match (1995, Sept.-Oct.). Andre Agassi: The metamorphosis of a champion, 32–5.

Terry, J. & Urla, J. (1995). *Deviant bodies.* Bloomington, IN: University of Indiana Press.

Thomsen, I. (2000, July 24). Heavenly ascent. *Sports Illustrated, 93(4),* 41–42, 45, 48.

Tresniowski, Benet, & Trischitta (2000). More than a game. *People Weekly, 54(12),* 56–7.

United States Postal Service (2000). Advert featuring Lance Armstrong.

Vera, H. & Gordon, A. (2003). *Screen saviors: Fictions of whiteness.* Lanham, MD: Rowman & Littlefield.

Vontz, A. (2005). Lance's legacy is hope. Retrieved July 29, 2005 from http://www.foxsports.com.

Walker Smith, J. & Clurman, A. (1997). *Rocking the ages: The Yankelovich report on generational marketing.* New York: Harper Business.

Wallach, G. (1997). *Obedient sons.* Amherst, MA: University of Massachusetts Press.

Weis, L., Proweller, A. & Centrie, C. (1997). Re-examining 'A moment in history': Loss of privilege inside white working-class masculinity in the 1990s. In M. Hill (Ed.) *Whiteness: A critical reader.* New York: New York University Press.

Weiskind, R. (2002). 'Dogtown and Z-Boys': 'Dogtown' looks back at Santa Monica skateboard scene. Retrieved March 25, 2003, from http://www.post-gazette.com.

Wellman, D. (1997). Minstrel shows, affirmative action talk, and angry white men: Marking racial otherness in the 1990s. In R. Frankenburg (Ed.) *Displacing whiteness: Essays in social and cultural criticism.* Durham, NC: Duke University Press.

Wenner, L. (1995). The good, the bad, and the ugly: Race, sport, and the public eye. *Journal of Sport and Social Issues, 19(3),* 227–231.

Wertheim, J. (2001). One of the aged. *Sports Illustrated, 94(15),* 64–66.

Wetzsteon, R. (1989, July). I was a teenage U.S. hope. *Sport,* 60–3.

Whitney, D. (2005). Larry the Cable Guy website. Retrieved July, 29, 2005 from http://www.larrythecableguy.com.

Wiegman, R. (1999). Whiteness studies and the paradox of particularity. *boundary 2, 26(3),* 115–150.

Williams, R. (1997). The future of cultural studies. In J. Storey (Ed.) *What is cultural studies?: A reader* (pp. 168–177). London: Arnold.

Wilmington, M. (2002, May 8). Movie review, Dogtown and 'Z Boys.' *Metromix.com.* Retrieved March 20, 2003, from http://metromix.chicagotribune .com/movies/mmx-16560_lgcy.story.

Winant, H. (2004). *The new politics of race.* Minneapolis, MN: University of Minneapolis Press.

Wray, M. & Newitz, A. (1997). *White trash: Race and class in America.* New York: Routledge.

Yudice, G. (1995). Neither impugning nor disavowing whiteness does a viable politics make: The limits of identity politics. In C. Newfield & R. Strickland (Eds.) *After political correctness: The humanities and society in the 1990s* (pp. 255–285). Boulder, CO: Westview Press.

╬ INDEX

Intersections in Communications and Culture

Global Approaches and Transdisciplinary Perspectives

General Editors: Cameron McCarthy & Angharad N. Valdivia

An Institute of Communications Research, University of Illinois Commemorative Series

This series aims to publish a range of new critical scholarship that seeks to engage and transcend the disciplinary isolationism and genre confinement that now characterizes so much of contemporary research in communication studies and related fields. The editors are particularly interested in manuscripts that address the broad intersections, movement, and hybrid trajectories that currently define the encounters between human groups in modern institutions and societies and the way these dynamic intersections are coded and represented in contemporary popular cultural forms and in the organization of knowledge. Works that emphasize methodological nuance, texture and dialogue across traditions and disciplines (communications, feminist studies, area and ethnic studies, arts, humanities, sciences, education, philosophy, etc.) and that engage the dynamics of variation, diversity and discontinuity in the local and international settings are strongly encouraged.

L I S T O F T O P I C S

- Multidisciplinary Media Studies
- Cultural Studies
- Gender, Race, & Class
- Postcolonialism
- Globalization
- Diaspora Studies
- Border Studies
- Popular Culture
- Art & Representation
- Body Politics
- Governing Practices

- Histories of the Present
- Health (Policy) Studies
- Space and Identity
- (Im)migration
- Global Ethnographies
- Public Intellectuals
- World Music
- Virtual Identity Studies
- Queer Theory
- Critical Multiculturalism

Manuscripts should be sent to:

Cameron McCarthy OR Angharad N. Valdivia
Institute of Communications Research
University of Illinois at Urbana-Champaign
222B Armory Bldg., 555 E. Armory Avenue
Champaign, IL 61820

To order other books in this series, please contact our Customer Service Department:
 (800) 770-LANG (within the U.S.)
 (212) 647-7706 (outside the U.S.)
 (212) 647-7707 FAX

Or browse online by series:
 w w w . p e t e r l a n g . c o m